Picturing the Times of Your Life

Picturing the Times of Your Life

Don Nibbelink

Monica Nibbelink

Edited and published for
EASTMAN KODAK COMPANY

AMPHOTO
American Photographic Book Publishing Co., Inc.
New York, N.Y.

Our special thanks...

to all those from Eastman Kodak Company
who helped produce this book:

 Bill Souvé, *editorial coordinator*
 Bob Brink, *color reproduction quality coordinator*
 Charlie Styles, *printing production coordinator*
 John Fish, *project sponsor*

Photographs by the author except where otherwise credited.

Library of Congress Cataloging in Publication Data:

Nibbelink, Don D.
 Picturing the Times of Your Life.
 Includes Index.
 1. Photography of families. **I. Nibbelink, Monica, joint author.**
 II. Eastman Kodak Company. **III. Title.**
TR681.F28N5 **770′.23′3** **79-29734**

ISBN: 0-8174-2468-7

Manufactured in the United States of America

Table of Contents

8 INTRODUCTION

18 HOW MUCH ARE MEMORIES WORTH?

30 CAMERAS ARE MEMORY MACHINES

32 YOU ARE THE PHOTOGRAPHER

37 Camera and Film Care

39 ALBUM AND SLIDE-SHOW BUILDING BLOCKS

40 Tell a Story With Your Camera

46 GROWING UP

46 Jennifer and How She Grew

64 A First-Grader's Day

76 The Prom

82 All About Me

88 Graduation

100 HOLIDAYS

100 Halloween

104 Thanksgiving

112 Christmas

122 Photographic Christmas Cards

124 FAMILY EVENTS

124 The Engagement

128 Weddings

136 Anniversaries

138 Parties

146 HOUSES AND HOMES

146 Moving Day

152 The Renovation

164 IT'S MOVIES FOR ME

166 OTHER OCCASIONS

166 Sports Events

172 Recitals

174 The Solo Flight

180 Religious Milestones

182 The Visitor

186 VACATIONS

186 Fun With a Recreational Vehicle

194 Walt Disney World

204 Night Exposure Suggestions

206 That Once-in-a-Lifetime Overseas Trip

206 Before You Go

217 Pictures of the Family

237 AFTER THE PICTURES HAVE BEEN TAKEN

237 You Are the Album Layout Artist

243 Captions

244 Decorating With Pictures

248 THE LEGACY

254 INDEX

In the following pages, look especially at the "red-letter days." Think of them as an important list of memory-saving occasions. We'd like to share them with you and to show you how you can photograph your own special occasions—the times of your life!

Introduction

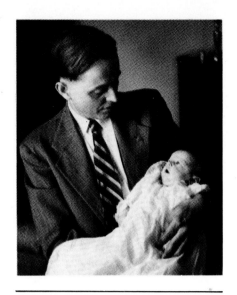

HOW MUCH ARE MEMORIES WORTH?

There is only one first time for everything we do—the first steps, first haircut, first day at school—and these firsts continue throughout our lives. If these picture opportunities are missed, they are gone forever. Good memories are priceless!

CAMERAS ARE MEMORY MACHINES

You never forget anything; it's just that you can't always remember it. Mental images fade in time. Most impressions get crowded further and further back in your mind as thousands of new impressions enter each day. A photograph is a tremendous aid to your recall mechanism. Want to remember something better? Then picture it!

YOU ARE THE PHOTOGRAPHER

Picturing the times of your life is much like being a staff photographer for a picture magazine or a Sunday supplement. Like the staff photographer, you're going to witness an important one-time event. Your assignment is to produce an outstanding photo essay. You'll have to find, create, and catch storytelling moments with your camera. You'll have to be patient, persistent, or assertive. You'll have to determine the best time to push the shutter release . . . whether you want closeups . . . and what to do about scene stealers. *Camera and film care* will be important to your success.

ALBUM AND SLIDE-SHOW BUILDING BLOCKS

You can really impress others with sequences and interestng picture collections that aren't afflicted with picture sameness. The challenge is to communicate the complete idea effectively by telling a story with your camera. Step-by-step picture sequences let you relive, appreciate or understand an occasion. Exhaust your photographic possibilities. Think of what you want to tell your audience as you make your picture story. One way to do this is shown in a boy's visit to Circus World.

GROWING UP

Jennifer and How She Grew

There's something really miraculous about the birth of a child—and about recording its life and growth with memory-saving pictures. Jennifer's father, in a capable, artistic, dedicated way, used available light to document her christening, birthdays, and Christmases. But hear his advice: "A camera shouldn't be something that is dragged out only on special occasions, because the results tend to be contrived pictures. The ordinary day-to-day things children do in their growing-up process should also receive the photographic emphasis. It's these routine events that shape the kids into what they eventually will become. The important thing is to keep your camera loaded and ready."

A First-Grader's Day

Jeannie's father decided to use available light to document a typical day in the life of his first-grader. Planning the coverage, riding the school bus, crawling around the homeroom floor, Jeannie's friends and teachers, art class, library, cafeteria—all required different exposure considerations to produce a really superb collection of slides. Why "daylight" film in the school and "tungsten" film for home? Dave, an excellent photographer, tells about available light, too.

10

The Prom
"This is Carolann speaking. I was asked to tell you how I ended up with a terrific picture sequence of my senior-high prom. The idea was for me, my date, my family, a professional photographer, and even the other kids at the dance to help with the picture-taking. Because I wanted a picture series of the prom from start to finish (After all, it was the highlight of my senior year!), I had to act as director of photography. But everybody had a great time helping. They called us the 'photo couple' all evening."

All About Me
Calling all teenagers! Why not use a camera to document this important time of your life? Your likes and dislikes, your friends and hobbies, where you live, places you go, things that are important to you, someone special—all these things will change with time, and the memories of them will be fun to recall. You don't really need to know much about photography to make a good picture record. Use any camera, but capture those important memories!

Graduation
Come along with us. We'll show you, moment by moment, a graduation day's worth of wonderful picture-taking ideas. "It's 10 A.M. and here comes Aileen, back from rehearsal with her graduation gown. It's worth a long shot as she gets out of the family car. Now it's 10:02 A.M. The same scene is worth a closeup too. . . ." We'll take you right through to 10:30 P.M. for a continuous lesson in ideas for flash photography. We'll show you how to be inventive, the importance of taking many pictures, and the advantage of a little luck.

HOLIDAYS

Halloween
Once a year witches, goblins, white-sheeted ghosts, scarecrows, and comic characters come to life. It's trick-or-treat night, when we all respond to repeated rings of the doorbell to be confronted with these mini-monsters and their bags of loot. What's in it for you? Would you settle for memorable fun? We gave each gang an instant picture of themselves. They dashed off while it was still developing so we never saw the results, but they were some of the happiest pictures we ever took.

Thanksgiving
Thanksgiving is a special time for renewing family relationships. It's also an excellent occasion for pictures of the new baby . . . trading canning secrets . . . helping get dinner ready . . . getting a

kiss in the kitchen . . . carving the turkey—and relaxing when it's all over. It's a time for being thankful for all these good things—and what's more, for being thankful later that you can recall it all with pictures. All of this is served on a special platter featuring bounce lighting.

Christmas
Let's follow Tom and Chris Burns and their three children through their Chrismas holiday preparations and activities. We'll watch them cut their own tree, visit Santa Claus at a shopping mall, and open their presents early Christmas morning. You'll see the importance of taking closeups at Christmastime; receive tips on photographing "Santa's" face, tree ornaments, and cleverly wrapped packages that will soon be eagerly opened; and look briefly at photographic greeting cards. We think they're the best kind.

FAMILY EVENTS

The Engagement
Mood pictures can be more memorable than formal poses.

Weddings—Large and Small
Of all the wonderful *times of your life,* weddings surely lead the list in which a good series of pictures is a must, and no one has to be reminded to take them. But are you *sure* your collection will be complete? Check the helpful suggestions we provide. It's hard to beat modern available-light techniques that can record even candlelight ceremonies without the need for flash. It's important to be sure you're equipped with the right camera and film to make the best series.

Anniversaries
Imagine how unique and valuable it would be to have a photo album devoted entirely to your wedding anniversaries. It makes no difference that all the anniversaries will not be extraspecial celebrations. Some may consist of a vacation trip, a visit to relatives, an evening on the town, or even a quiet evening at home. Whatever the form—from the first to the fiftieth—don't forget to take pictures.

Parties
Parties are important times for everyone! They help the world go 'round! People love to congregate and socialize, and what fun it is to look at the pictures! To illustrate the techniques of flash photography at parties, we used a birthday party for a seventhgrade boy, with a pie-eating contest featured.

HOUSES AND HOMES

Moving Day

It's the big "M-Day at the Tundermanns'." Pop was too busy directing the movers and keeping the kids and dogs from underfoot to take any pictures. But Uncle Louie's camera saved the day. Watch how he did it.

Renovating

Once upon a time (actually 1814) an elegant brick house was built in an attractive neighborhood. At one time in the life of the house, it was even owned by U.S. President Millard Fillmore. Then times changed. The structure deteriorated as a host of "don't-care" roomers moved in and out. However, a creative young couple envisioned an exciting restoration project and bought the house. The very first and last steps in the renovation were the use of a camera—to provide a fascinating before, during, and after series of pictures. Want to know how to document the interior of your home? We'll show you— with pictures.

IT'S MOVIES FOR ME

Ira Current has been making home movies for more than 50 years. The movies taken each year are edited down into a family-event series titled *Current Events.* Ira says they are like a gold mine to him. Many of those early movies are more interesting now than ever, depicting scenes of events, people, and places he had nearly forgotten. It's a thrilling rediscovery process. Why does Ira prefer movies to stills? It's more than the obvious desirability of lifelike motion. He feels that stories can be told much more dramatically, creating more interest and suspense, as movies capture the reactions of people to one another, or to events, much more effectively.

OTHER OCCASIONS

Sports Events

Is there a Little Leaguer in your family? Do you have a son on the football team or a daughter on the swimming team? Perhaps you yourself are a jogger or golfer? Whether you're a participant or a spectator, sports events are picture events set in a world of available light, fast films, and fast shutter speeds.

Recitals

Should you interrupt a piano recital with flash during a delicate, lovely rendition of the first movement of Beethoven's "Moonlight Sonata"? Never! But be sure to take pictures afterward, perhaps at a reception for the soloists. You might even engage the

services of a professional photographer to do a studio or location portrait of protégée and instrument to commemorate the occasion. This goes for dance recitals and other performances, too, of course.

The Solo Flight

Once there was a teenager who would rather fly than eat. He worked at the airport on weekends and vacations and took his pay in the form of flying lessons. On the day of his first solo flight his wise father was there with camera in hand, determined not to miss one moment of the event. He had even planned the pictures he would take beforehand.

Religious Milestones

Days that will never come again and that you might want to photograph include occasions of great religious

significance, such as baptism, first communion, confirmation, and bar mitzvah.

The Visitor

Suppose Uncle Paul, who lives 2000 miles away, is coming for an extremely rare visit. Or perhaps it's Grandmother, an old school chum, or even a visitor from overseas. Will your camera languish on the closet shelf? Or will you preserve this rare event in your life? Perhaps you'd like to do it with a multiple-flash setup for snappy lighting? Look at the pictures and see.

VACATIONS

Fun with a Recreational Vehicle

Let the good times roll! Recreational vehicles can help you discover a new leisure life-style. And a camera should be part of your gear for preserving the memories of those good times.

Walt Disney World

How about some family fun at Walt Disney World, with pictures to preserve memories of the rides and the sights? More important here than the obvious advice of taking pictures of your visit is to learn the value and techniques of *nighttime picture-taking.* If you put your camera away when the sun goes down, you miss myriad fantastic picture-taking opportunities—colorful lights, signs, reflections, parades—with nighttime illumination. In this section we'll tell you how to take them.

That Once-in-a-Lifetime Overseas Trip

Surely an international trip ranks as one of the great times of your life and should be documented from A to Z. Before you leave, make sure you're familiar with your camera and its capabilities. Don't confine your picture-taking only to targets of opportunity. *Planning* is the key! Come with us on a fabulous trip to Spain to see what *can* be done. We'll show you some ideas on sequences, what to take when the sun isn't shining, and why you should think of what you want to show your audience as you shoot.

AFTER THE PICTURES HAVE BEEN TAKEN

You wouldn't just cram your valuable pictures into a drawer, would you? Don't even let the drawer-file system begin! This section deals with albums, easy and decorative layout suggestions, the reasons for making enlargements, and the importance of captions and how to write them. For the more ambitious, there are ideas on decorating with pictures large and small, mounting and framing, plus other display ideas—all ways to enjoy pictures of the people you love, the things you love, or a moment in your life you want to savor.

THE LEGACY

Jennifer Gibbons is three-and-a-half years old. She has been taking countless make-believe pictures with a toy camera. But this year for Christmas she was given a real camera. "It wasn't just another toy," her father said. "I gave it to her as a kind of magical box that remembers—something she could use to record things she sees or likes. Of course she's pretty young, but I'd like to think that this magical box and the knowledge of what it can do is part of my legacy to her."

Once upon a time
A little babe was mine.
Now there is a time
This grown-up girl is mine.
Once again she's mine.

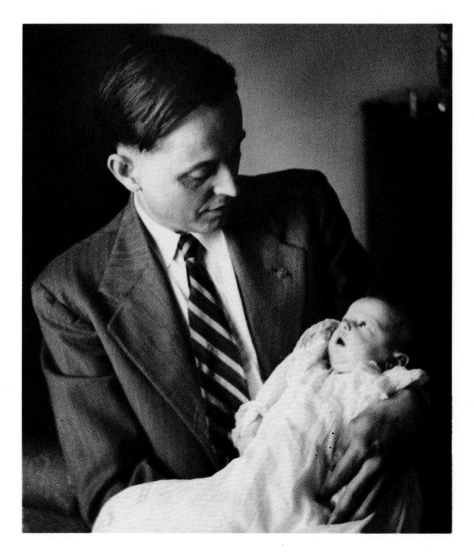

How Much Are Memories Worth?

Funny thing how the mind works!

Usually it forgets or suppresses one's failures, disappointments, or unpleasant moments. On the other hand, it delights in recalling and savoring good times, awards, achievements, pleasures, and happy moments.

After all, what really makes a good life? It's not only the good but fleeting moments, but also the countless times of recalling these moments—in other words, the *remembering*.

Memories have no intrinsic value, but are essential to our general well-being and good health.

How well do you remember *the times of your life?* If you are over forty, do you remember your graduation from grade school? Do you really remember the occasion, or do you remember pictures of the event that you have looked at now and again? We'll wager that it is the pictures which come to mind. Now if those pictures did not exist, would you remember at all? Would it be like the tree that fell in the forest when there was no one around to hear it? Was there really a sound?

2 years

3 Years

4 years

5 years

6 years

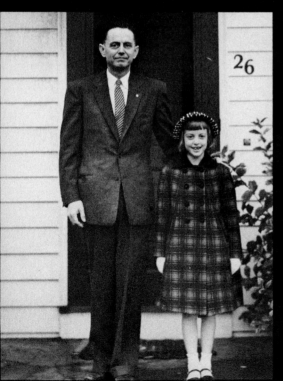

9 YEARS

10 years

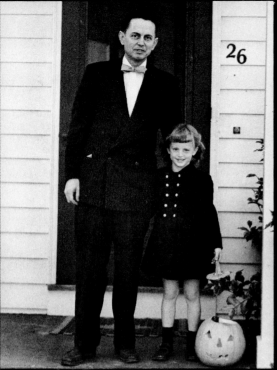

7 YEARS

8 years

11 years

12 years

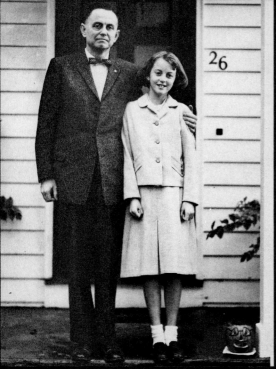

13 YEARS

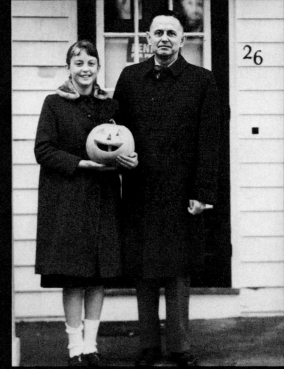

14 years

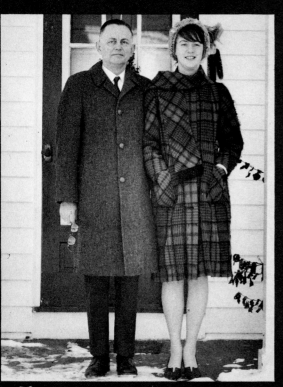

17 YEARS —

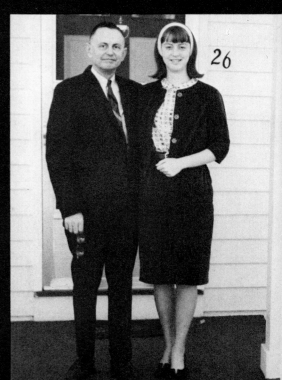

18 YEARS!!!

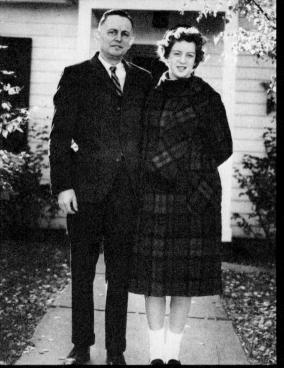

15 years

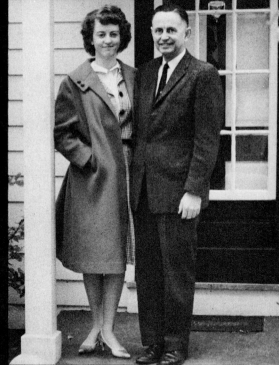

16 years

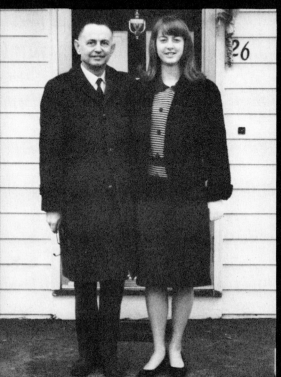

19 years

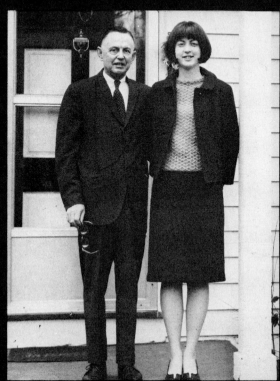

20 years

21 YEARS!

22 years

25 years

26 years

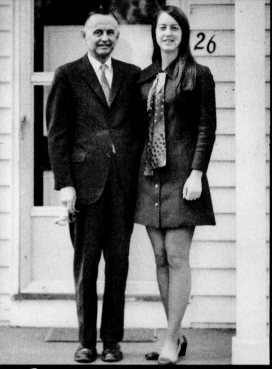

23 years

24 years

27 years

28 years ...

29 years

30 years

180

Every year on her birthday Susan's
parents take her picture in front
of their house. The sequence isn't
complete—grandchildren have
their own pictures to perpetuate
tradition.

31 years

32 years

Turn back the sands of time:
The wondering maid is mine—
The running girl is mine—
The little babe is mine—
The memories are mine.

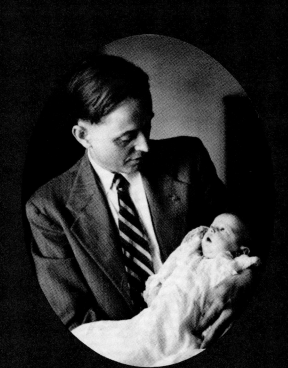

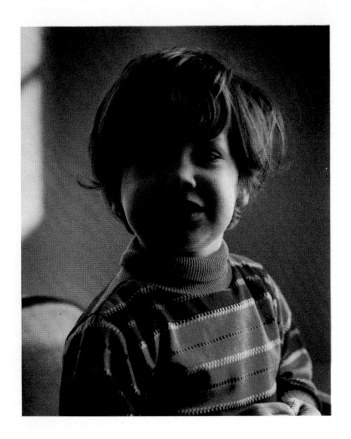

Just think: There is only one first for everything we do. Only one. We take our first steps only once; there is only one first haircut; and the first puppy or kitten is encountered only once.

Later there's the first time on roller skates, then ice skates or skis, the first day at school, the first bicycle ride, and the first day at camp, the first date, the first driving lesson.

And throughout life these firsts continue—all great occasions and exciting moments in the lives of your family that break through the haze of routine. All are a sparkle of moments that you'll never want to forget.

Have you ever said to your 15-year-old, "Do you remember the time when . . .?" Only to be told, "I don't remember that." How wonderful it would be if there were pictures of every pleasant thing that happened in our lives to keep the memories alive for our enjoyment. Life has so many wonderful moments. It's hard to list them, let alone remember them.

Pictures give us a priceless gift of storing memories but can do so only if we take them. Once the opportunity is missed, it is gone forever.

Good memories are therefore priceless!

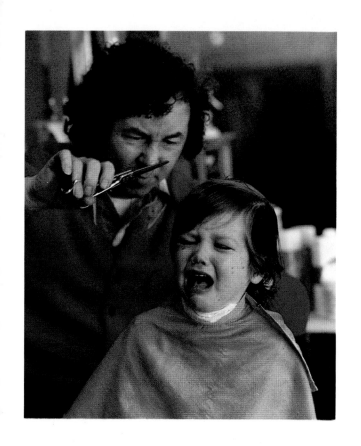

Cameras Are Memory Machines

People have a fantastic memory for pictures. Better by far than for words or numbers. This is because we think in images, not words.

Of course any mental image fades in time. Any particular impression gets crowded further and further back into your mind as thousands of new impressions enter every day. The problem becomes one of recall, doesn't it? How much of this mass of material can you summon to reimage in the forefront of your memory?

Strong or vivid impressions are the easiest to remember. You can, of course, reinforce the strength of these impressions to make recall easier. One technique you can use is rehearsal—repeating something until it is committed deeply in your memory; another is association—as in composing and memorizing a rhyme that makes something easy to recall.

But probably one of the most powerful recall-reinforcing devices is a photograph. Not a drawing, a sketch, or a painting, but a realistic color photo-graph. But don't misunderstand. A sketch is better than nothing at all! A sketch of a face is more easily remembered than that of a random design; but the closer the representation resembles the actual subject, the better it is as a memory aid.

Of course motion pictures, providing the closest images to life itself, are the very best memory aids. (See "It's Movies for Me," p. 164.)

Research has indicated that recollection of photographs you have seen before is often essentially perfect. Common experience suggests that the capacity for remembering pictures may be unlimited. This is especially intriguing when you consider that such memory is maintained without labels, words, names, or the need for rehearsal. We'll wager that you can remember some of your high-school classmates by recalling their pictures in the yearbook, even though you probably haven't picked up that volume for years.

You'll probably recall the faces of your former classmates better than their names, since memory for words isn't nearly as strong as for images. In fact, if it weren't for having the pictures available, the chances that you could recall much of anything about many of the people would be remote. We need pictures as triggers for recalling details.

This memory power photographs have—this easy access to your long-term memory—is especially amazing when you consider that photographs, such as of a person, represent three-dimensional objects. Yet the flatness of a two-dimensional picture does not prevent you from recognizing what's in it. You recreate in your mind the third dimension—the depth, the roundness, the realism—as you view the picture. This process is automatic and you don't have to learn how to do it.

So this is what the camera can do to help preserve any event in your life. Want to remember it better? It's simple—just picture it!

31

You Are the Photographer

It sounds ridiculous and obvious to say it, but you can't take pictures if you don't have a camera. But who among us has never said, "Boy, I wish I had my camera with me," when something happened that was important, interesting, unusual, beautiful, memorable, newsworthy, or otherwise worth documenting?

Most people don't forget the camera for big occasions, like a wedding. However, it's commonplace to arrive at a picnic or a campsite without it. Of course there's nothing you can do about it then.

You *must* condition yourself to think of the future in terms of *now.*

If you mark upcoming occasions on your calendar, add this reminder: "Don't forget the camera." After you've seen this note a few times, you'll probably remember it.

The day before an occasion, we always put a note on the door as a reminder of something we must take when we leave the house. Sometimes we place the object in front of the door the night before, to be sure we can't get out the door without it.

The same goes for flash . . .

and fresh batteries . . .

and *enough* film.

Photojournalism

Perhaps the best way to produce a memorable sequence of an event is to imagine that you're a staff photographer for a picture magazine or Sunday supplement. In other words, the situation calls for photojournalism. You are eyewitness to an important event that will happen only once, and you must produce a photo essay on the situation.

You must look for, find, even initiate and catch the storytelling or decisive moments with your camera. You'll have to be patient. You'll have to be persistent.

When should you push the button? When the action is good, when the expressions are interesting, and when the subject arrangement appeals to your sense of composition. Try to be selective, but when in doubt, shoot! Don't wait around trying to take the best picture of a family picnic, for example. Instead you need a series of pictures, each one of which is part of the central theme.

One of the common pitfalls of trying to say "family picnic" with your camera is that a series of pictures can be monotonous. You must constantly fight this by varying your coverage as much as possible.

Shooting Distance. Think in terms of the moviemaker's technique. Your opening picture—or at least one of them—should be a long shot, taken at a distance from the group to show the people *and* the surroundings. Later this long shot will help orient the viewers as to time, place, and participants.

Some of your pictures should be medium shots, say, from ten to fifteen feet away.

If you don't keep your camera ready for instant use, you'll miss great picture opportunities like this.

But don't forget the closeups! By close, we mean from three to four feet from a particular subject. Even consider some extreme closeups if your camera is capable of focusing closer than three feet. Remember what the great journalist Robert Capa said: "If your pictures aren't good enough, you aren't close enough."

Beyond simply varying your shooting distance, there is a lot you can do to add variety to your pictures. Use high and low angles, different focal-length lenses for a change in perspective, or shoot through or past objects in the foreground that frame the subject.

Before you do anything, first consider what *kind* of pictures you want to take.

Coverage Techniques. You're *not* going to line up the entire wedding party, the whole sophomore class, or all the members of the football team in a single row. You're not taking pictures for publication, advertising campaigns, or formal portraits, all of which admittedly benefit from photographer/subject rapport and various kinds of subject control.

But you *are* going to be concerned with *event* photography—recording *the times of your life.*

So what should your attitude be toward your subjects? What should you say? How should you act?

Well, in this day of modern high-speed lenses, shutters, and fast film, there is no *technical* need for you ever to say "Hold it" to prevent blurred results. With adjustable cameras and high-speed film, you might be taking outdoor pictures at 1/500 sec., which

would freeze most normal subject movement.

Some pocket cameras have an automatically programed shutter. In bright light conditions with high-speed film, the shutter speed can be as short as 1/500 sec. This high shutter speed will slow down somewhat under conditions that are less bright. But you don't have to know what the shutter speed will be; just have faith that it will stop most action satisfactorily. Indoors, our preference is for electronic flash of 1/1000 sec. or faster.

It's only when you are using ordinary room lighting, which is considered low-level existing light, that you must use slower shutter speeds in order to expose even high-speed film adequately. Consequently you must be more careful about trying to stop subject motion, such as jumping-jack kids at a small-fry party.

There is an even more important reason for not saying "Hold it" for this kind of picture-taking. Your objective should be natural, candid coverage.

You should document an event as it really happened—natural and unposed, not contrived, hammed up, or artificial. It should almost be as though you were invisible. You can obtain more natural-looking pictures by maintaining a low profile as you go about your shooting.

The Cheese Syndrome. So don't say "Smile," don't say "Line up," and don't tell everyone to say "Cheese." A syndrome is a group of signs, symptoms, or ideas that occur together and characterize a particular *abnormality*.

Explore each subject photographically: Don't forget close, closer, closest!

Surely you don't want to remember a graduation or a Thanksgiving as an abnormality with contrived poses and peculiar facial contortions!

If you *do* want your subjects to have a pleasant expression or a smile, evoke it—don't demand it. If you feel the need for some directions (perhaps the group is too scattered) suggest the logical action that will bring them together. But try to make it look *uncontrived.*

So your opening and only directions might be: "Don't pay any attention to me. I don't exist. Don't look at me. Pretend I'm not even here."

Then let it happen.

Of course there will always be someone stealing a look at you, or, even worse, the hams who stare constantly at the camera. Don't take their picture! Not then, anyway. You can make your subjects realize that you won't shoot if they're hamming it up. Eventually they'll forget your presence and start acting naturally.

To reiterate, there is no *technical* need for you to say "Hold it" to *freeze* the subject motion. But there may be a *compositional* need to exercise some degree of subject control. For the sake of getting a good picture, you may have to invent a pose that looks unposed, or slow the action down, or even have the subjects repeat it if it all went by so fast the first time that you didn't have a chance to click the shutter.

So, yes, there are times you'll have to assert yourself rather than snap timidly from afar and miss a good shot.

Candid pictures are not always the best kind. This was
obviously staged by an imaginative photographer. The
idea is amusing even if you don't know the subjects.

CAMERA AND FILM CARE

Driving to the beach for a swim, to a track meet or picnic, to a summer vacation down south, or through the National Parks? When you're traveling, try to protect both your film and your camera from extremely high temperatures. Even as a temporary storage place, cameras and cars don't get along very well together.

If your car is parked in the sun (even when you park it in the shade, remember that the sun's position may change before you return) with the windows closed, a camera left on the rear deck or on a seat in direct sunshine can heat up to as much as 175 F. On a really hot day and with more than an hour's storage time, the temperature can soar even higher. These conditions can ruin *any* film and possibly *even* damage the camera, some of which have plastic parts, such as springs, that will soften enough to make the camera inoperative.

You should have your camera with you. If you must leave it in the car, however, keep it out of the direct sunshine. Put it under a seat or in the trunk. Even the glove compartment doesn't get quite as hot as the car interior because it isn't subject to the "greenhouse effect" in which the glass magnifies the light and heat. A camera on the shaded floor can be as much as 60 degrees cooler than one on the seat in the sunshine. This is partly due to the shade and partly to the stratification of the heat zones in the car.

If you are taking a quantity of film on a trip, you'll surely want to consider protecting your picture investment with an insulated container, such as a thermal bag or polystyrene picnic hamper. Such a storage device will do a lot to keep your film from heating as fast as the car interior. You could include several refreezable picnic packs to keep the film desirably cool. *Be sure to keep exposed film dry in such a container.* Plastic bags should be adequate.

Realize that heat damage to film can be an insidious and a cumulative thing—a half hour of baking today adds to yesterday's half hour of mistreatment to deteriorate film quality further.

Temperature Effects on Instant Pictures

Instant pictures are quite subject to temperature extremes during development. Cold weather can cause lighter-than-normal pictures and high temperatures, darker-than-normal ones because of the related increase or decrease in the activity of the processing chemicals. The recommended temperature range during development is 60-100 F. But suppose you are walking around in the sun at an amusement park with the temperature about 95 F. Your dark-toned or black camera will soak up radiant heat and the film temperature will climb well into the danger level. So keep the camera in the shade as much as possible. Also keep the developing prints out of direct sunshine.

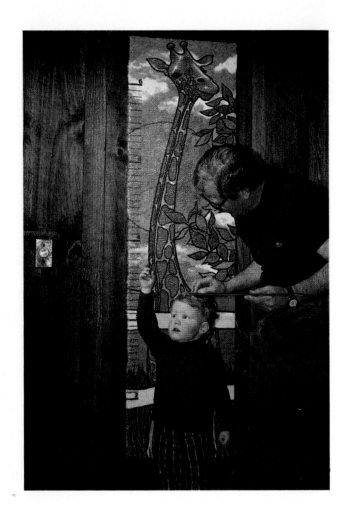 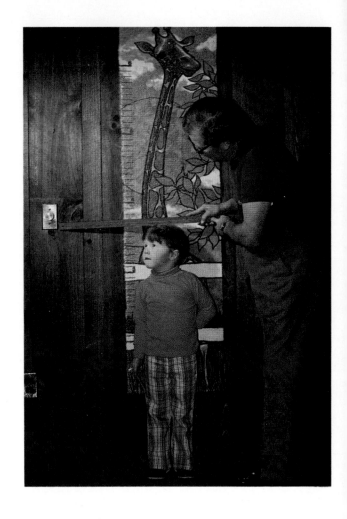

A sequence can take minutes . . . or it can span years. How much can a little boy grow in a year's time if he eats his spinach?

Album and Slide-Show Building Blocks

You'll probably agree that people take pictures for three basic reasons: (1) The original fun of taking them—the enjoyable feeling of involvement in the situation and in the creation of something worthwhile. (2) The fun of seeing the results. (3) And perhaps the most important, sharing the prints or slides with others, which seems to be a powerful motivation in our lives. Let's talk for a moment about sharing. Naturally, the better your pictures, the more you'll enjoy showing them to someone else.

Did you ever watch the average person pick up processed pictures at a photofinishing counter? He or she immediately opens the box or envelope, hastily checks each one, then looks around to see if there is someone handy—anyone—to whom the best ones can be shown. Any stranger, the clerk, or a fellow shopper will do for an audience.

We're sure this same impulse happens to you (it does to us) every time pictures are returned from the photofinisher. You can't wait to show the best ones to someone; you wouldn't be human if you didn't.

Why does this happen? And why do you want to show only the best ones? To hide the mistakes? Of course, it's all part of another motivation factor that controls human behavior, namely, *what do other people think of you?* It's the reason you comb your hair, you like compliments, you strive to excel, and you show your best pictures to others.

A behavioral psychologist might even state that you really take pictures for someone else to see and, furthermore, that you really desire to impress this audience.

But to some extent this sharing depends on the nature of the pictures, doesn't it? More pictures of children and grandchildren are foisted onto friends and strangers than any other kind. What pictures do you carry in your wallet? Not of the Grand Canyon, we bet!

It's all in your heart. If you love the subjects, you will show their pictures to others, regardless of the technical and artistic merits of the photographs.

But suppose you could view all your pictures objectively—*as if someone else had taken them.* Now let's say you *wanted* to improve them compositionally, artistically, technically, and communicatively. Let's say you wanted as your goal to take and show only "best" pictures—pictures with a *high-interest content for everyone.*

How should you do this? Show the sharp slides, the prints with the dramatic lighting, the best composed, the extreme closeups, the unusual camera angles, the clever picture ideas. These are all good ideas; however, the best way you can impress others is with storytelling sequences and interesting picture collections that aren't afflicted with picture sameness.

Let's see how to do this.

Tell a story with your CAMERA

Once upon a time there was a family vacationing in Florida . . .

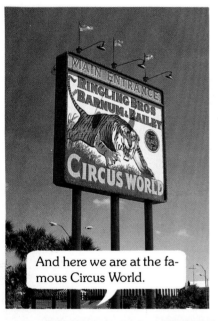

And here we are at the famous Circus World.

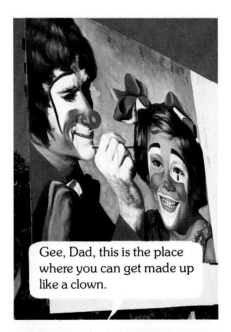

Gee, Dad, this is the place where you can get made up like a clown.

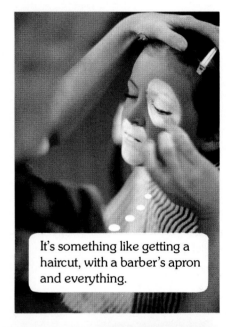

It's something like getting a haircut, with a barber's apron and everything.

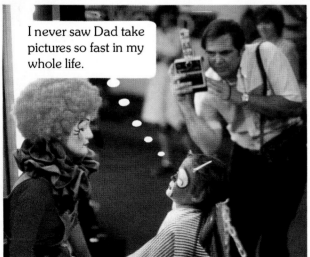

I never saw Dad take pictures so fast in my whole life.

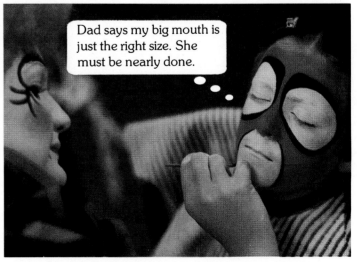

Dad says my big mouth is just the right size. She must be nearly done.

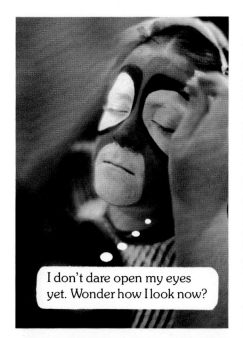

I don't dare open my eyes yet. Wonder how I look now?

Hey! It's really me! I'm actually a clown! Boy, if the kids back home could see me now!

Can you tell which one of us is the real clown?

I like his red hair and his clown suit, but I like my face better than his.

Okay, Cowboy, look over this way.

I'm no cowboy; I'm a clown.

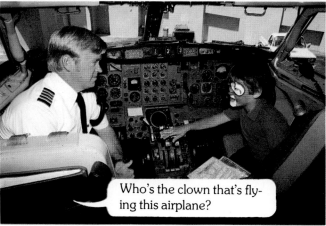

Who's the clown that's flying this airplane?

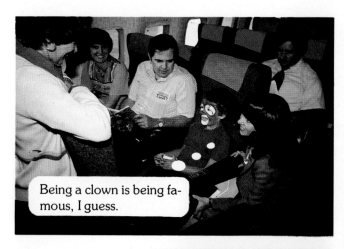

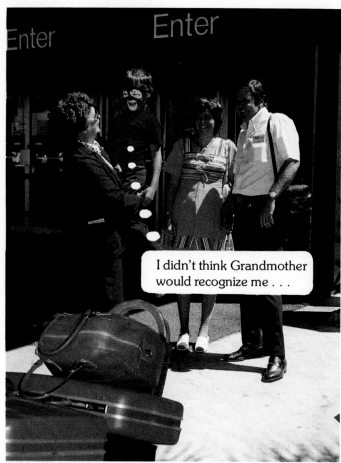

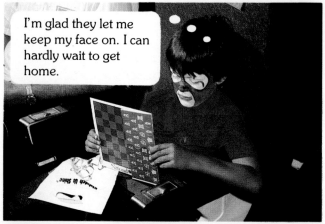

Sequences Make Sense

Single, isolated pictures have their place, such as on a calendar or a framed picture on a wall. But the real challenge is to communicate impressively the complete idea of a butterfly's emergence or the tears to smiles (or vice versa) of the first haircut.

The fun events in *your* life are documented best with a *good picture sequence.* But a lot of pictures, even of the same event, do not necessarily make a sequence. A sequence, like a story, has a beginning picture, an ending picture, and also the good times that you capture with in-between pictures.

Let's imagine that you've been asked to photograph the couple next door so that they can use the picture on their Christmas card. You can try to get one shot of them in front of the fireplace bundled up in colorful ski clothes. You might expose an entire roll of film trying. Have you produced a storytelling sequence? Not really. You couldn't even arrange the pictures into any logical sequence because there was no real action or time difference between the poses.

In this situation you were really after the *single best picture.* Maybe you tried different poses, expressions,

lighting, props, action ideas, and locations; took long shots, medium shots, and *extreme* closeups; tried lenses of different focal lengths, different camera angles, and a variety of framing ideas. But you still wanted only the best picture. You didn't produce a sequence with a beginning, middle, and end.

How, then, can you produce a meaningful sequence? It's easy if you remember that you want to *tell a story with your camera.* Now let's take that same couple and make a good picture sequence using the ski theme. A brief scenario might include:

- Looking at the map of ski country
- Packing the car
- Skis in the rack
- Friends' cars arriving at the house
- Crowd in the living room
- Friends around the fireplace ready to leave for the ski resort

You haven't left the house, but now you have a sequence that will recreate the spell and excitement of that time. A little plot planning does help. But the important thing is that you told a story; you didn't try for the one best picture. A good example of this storytelling technique is found in "The Solo Flight," p. 174. See if you agree.

There are other reasons for taking sequences. Want to tell the folks how

well your son can ski? Use an "ideal" sequence made up of the best shots (make sure the clothes in each scene are the same) from four or five sequences of his downhill runs, and you will get more of an idealized run that represents his very best.

There are many reasons for making sequences. They permit life to be relived, appreciated, or understood more fully than individual pictures. Weddings and birthdays are only two of the many experiences of life that can best be saved in this fun way.

Don't underestimate the challenge of sequence photography. If you consider yourself an expert photographer, for starters try making each shot in a storytelling sequence a pictorial masterpiece. It won't be easy. But keep in mind that the difference in achievement between a single, perhaps lucky, shot and the great sequence complete with a sound track is like the difference between checkers and three-dimensional chess!

To start down this rewarding road probably will require a change of attitude on your part. *You should regard each picture you take as one piece of a multiple-piece sequence* —one that you could eventually use to motivate an audience. This is especially true with slides.

Fun with Picture Collections

Not all subjects or situations lend themselves to sequencing. There's nothing wrong with making a picture collection of the flowers in your garden, the different birds that come to your feeder, or the amusing signs seen on a vacation trip.

Take a battlefield, a historical residence, or a pretty girl. Since you'll probably share these scenes eventually with someone else, why not regard yourself as a communicating photographer? Suddenly you'll see that your job is to provide as much information as possible about each subject, and that several shots from different points of view and camera-subject distances will provide more information than a single shot.

As a show producer, you might keep this in mind: If something is *worth* looking at, it's probably worth looking at *well*.

Let's take a second look at any of the examples above. Don't you want to check out front, side, back, details, general outline? You'll do it that way with your eyes, so why not with your camera? The same is true for a lovely garden, a single flower, a machine, or a ferryboat.

In other words, your attitude should be to exhaust the subject interpretation photographically. Shoot the long shot of the totem pole on your trip to the Pacific Northwest, but don't forget to take a full-face, dramatic closeup of each figure of the group.

If we had to boil all this advice into a single sentence, it would be this:

Think of your audience as you shoot.

Picture collections make interesting slide-show building blocks. Try flowers, amusing road signs, quaint architectural examples of the area, places you've stayed, interesting people you've met, sunsets, or, as in this case, unusual trees.

Growing Up

**JENNIFER AND HOW
SHE GREW**

Pictures and Thoughts by Bob Gibbons, Jennifer's Father

"I guess there's something miraculous about the birth of a child. It seems to me that it's one special chance, as a human being, to witness a great miracle of nature. That's why I decided to witness and photograph the birth of our first child, Jennifer. I think it's really terrific that more and more prospective fathers are being allowed into the delivery room with their cameras so that they can see and record this miracle of the beginning of new life.

"Obviously the doctor has to decide whether to permit the father into the delivery room with his camera. I suspect most doctors would vote against using flash. But that's all right, because you don't need it with today's high-speed color negative and transparency films and the new low-light-

46

level cameras with large lens apertures. As a result, I didn't bring a tripod. Even the film available at that time was sufficient for hand-held available-light pictures with my 35 mm camera and the high level of illumination available in the delivery room. I just hand-held the camera for all my pictures. Before things really started getting busy in the delivery room, I turned on my camera meter and took a light reading of the doctor's face. This gave me my general exposure setting. With my camera all set, I was free to think only about recording the event as it happened.

"'You have a wonderful little girl,' the doctor said. What made the occasion doubly meaningful was that Jennifer was born on my birthday."

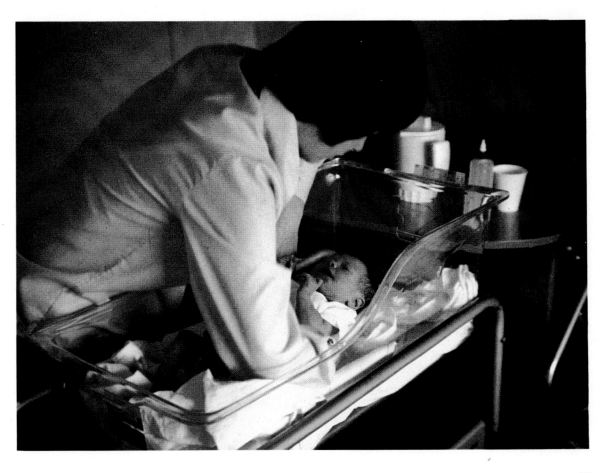

"It's Jennifer's christening day. The dress she is wearing was borrowed from my wife's sister. Her child had been christened in it three months earlier, so it was a sentimental gesture.

"You may be interested in the special photographic technique I used for this picture. I have a rubber lens hood onto which I fastened a piece of $2'' \times 2''$ slide glass smeared around the edges with Vaseline petroleum jelly. The center was clear. This homemade lens attachment just kind of mushed up the edges of the picture and placed the attention on her face, which is what I wanted. I think the effect looks very pleasing.

"This is my mother holding Jennifer. What I tried to do at Jennifer's christening was to take a lot of individual pictures of people holding her. These pictures have become very special to us and will increase in importance over the years for remembering some of those people shown with Jennifer who aren't with us now. Jennifer never really knew them, but already she's met them in the pictures.

"It's Jennifer's first picnic! She's three months old and can't quite sit up by herself. All those hands are reaching in to prop her up. She would have loved to sit up like her cousin Katie, but if we had let go she would have fallen right on her face.

"We picked out a little picnic spot underneath a tree so the children would be in the shade. I exposed for their faces using my widest lens aperture and a compatible high shutter speed. This combination was intentional so that *everything in the background* would go out of focus and keep attention on their faces, where it belonged.

"It's funny how kids go through various stages where they do cute things and you say, 'Oh, I'd like to remember this always! Tomorrow I'll take a picture of it.' The problem is that when tomorrow comes, you forget your good intentions, or the children change their habits and go on to something else; so you don't get to capture those precious moments.

"This time we were lucky. Jennifer had just discovered her feet and found that her big toe was a great substitute for sucking her thumb. Late one afternoon we took her out on the porch where there was plenty of light, I got down on her level and took a whole series of that amusing habit.
"I'm glad I did, because shortly after that she quit it forever.

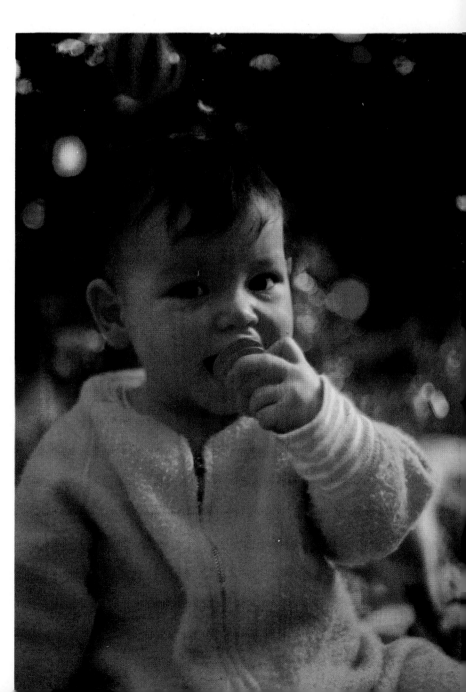

"This was Jennifer's first Christmas. At nine months she couldn't realize much of what Christmas was about, but she got the idea that it was a fun day. She still needed a little help sitting up on her new horse walker. It turned out to be one of her favorite toys later.

"My parents have a custom of giving their grandchildren stockings full of presents. I took this stocking picture to send to Mom to show her what a great time Jennifer had discovering the treasures inside.

"While she was immobile on her new rocking horse, it was a good opportunity for me to pop on a 105 mm lens for a head-and-shoulders closeup of her chewing on some plastic poppet-beads she got for Christmas. She was at the age where she had to try biting everything. It turned out to be a new tooth.

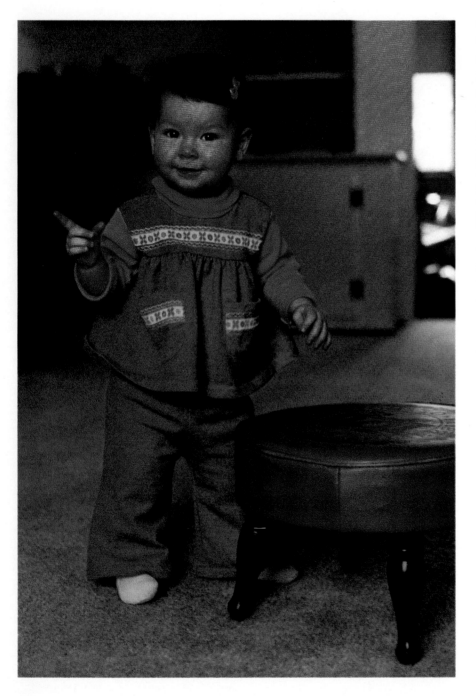

"This is Jennifer taking her first steps. When she was about ten months old, I decided to take a picture of her in a new jumper outfit. I put a small hassock in the middle of the room where, from my shooting angle, the background would be relatively free of distractions. 'Stand up, Jennifer,' I told her, and she pulled herself up on the hassock. I was just about to take a picture of her standing there when she tottered toward me. I got the picture just before she fell. She crawled back, hauled herself up again, and repeated the attempt at walking three times before she finally gave up. You guessed it, I got three pictures of her very first attempts at walking.

"You know, those were her first steps and those pictures are really important to us. Of course she's running all over the place now!

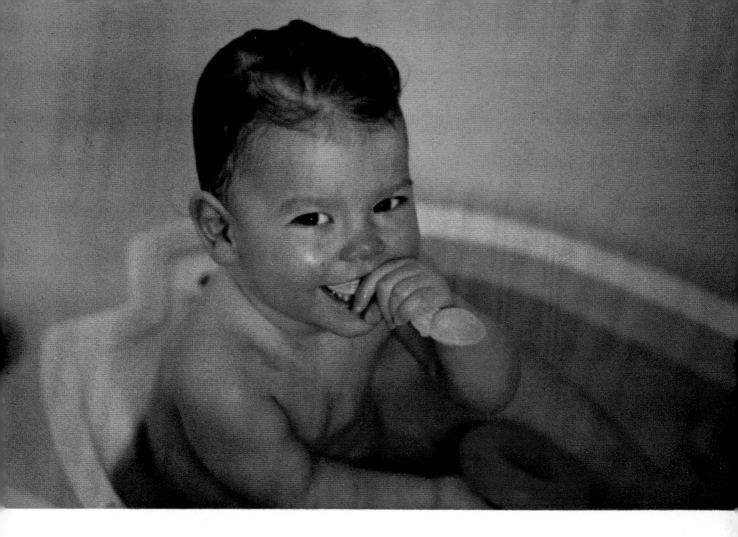

"At 11 months, Jennifer loved her bath. There was enough available light, so I shot a picture of her looking right at the camera and smiling.

"I think scenes like this are natural picture-taking situations. A camera should be used with children so often that it becomes part of their world. It shouldn't be something that is dragged out only on special occasions, like a birthday, Christmas, or Easter. If you take pictures only on those occasions, they tend to be contrived rather than natural pictures. You

see, at those special events you don't catch the kids in their day-to-day activities. The ordinary things they do in the process of growing up—taking a bath, being fed, etc.—are some of the most important activities of those first years. Because they happen so early, they are the most difficult memories to recall later. It's those daily routine events which shape children into who they eventually will become, not the Christmases and Easters. That's why it's important to try to capture many of the day-to-day activities.

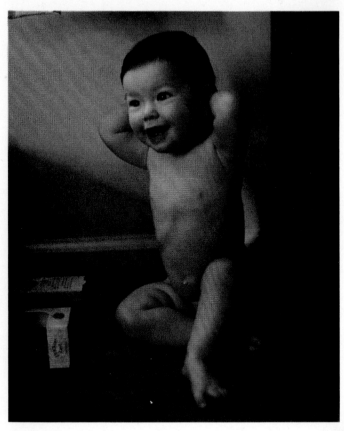

"We call this Jennifer's 'Playmate' shot. She had just completed her bath and was trying to escape the toweling. She was crawling away at a hundred miles an hour, stopped suddenly, sat up, and assumed this funny pose. I'm just glad I had my camera ready.

"I feel sorry for parents who don't have a picture of their child's first birthday, because it *is* a once-in-a-lifetime occasion. Look at Jennifer on her first birthday with frosting smeared all over her face. I don't know why, but she refused to wear a party hat.

"Since Jennifer and I were both born on the same date, we usually share the limelight each year.

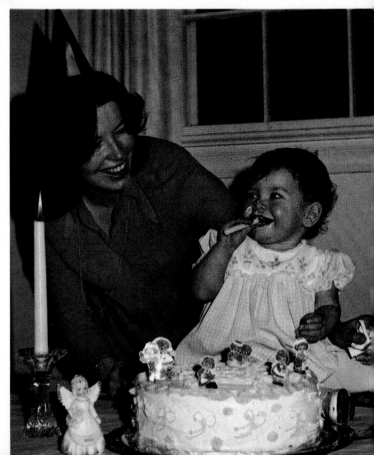

"Look what a difference one month can make in Jennifer's appearance. Here, visiting Grandma and Grandpa, she's 13 months old.

"Look at the lighting for these pictures. See how I like to use backlighting. This is because the backlight filters through the trees and gives people a beautiful aura. This is most likely to happen in late afternoon when the sun is low in the sky. I try for unobstructed backgrounds and natural expressions.

"Instead of posing my subjects, I'd rather let them get interested in something and then shoot at an opportune moment.

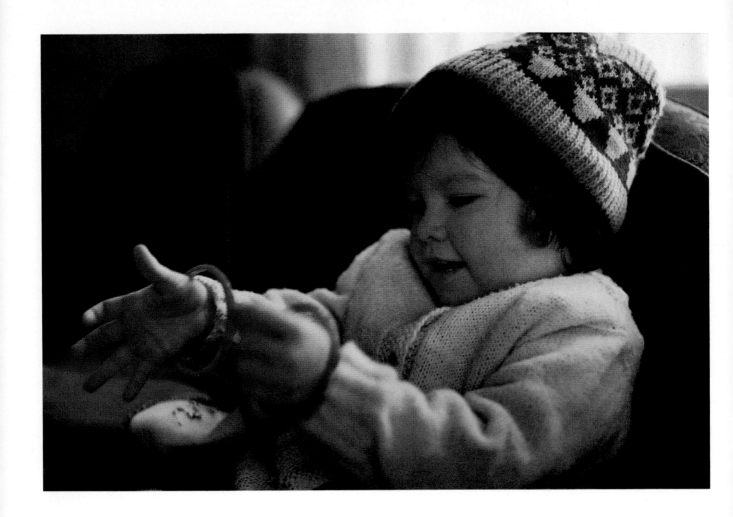

"It's her second Christmas, and Jennifer is a year and nine months old. She's trying on a bracelet she received for St. Nicholas' Day. She is sitting on a couch in the living room, and I'm shooting available-light pictures with just the illumination through the window. These are candid pictures of Jennifer being herself.

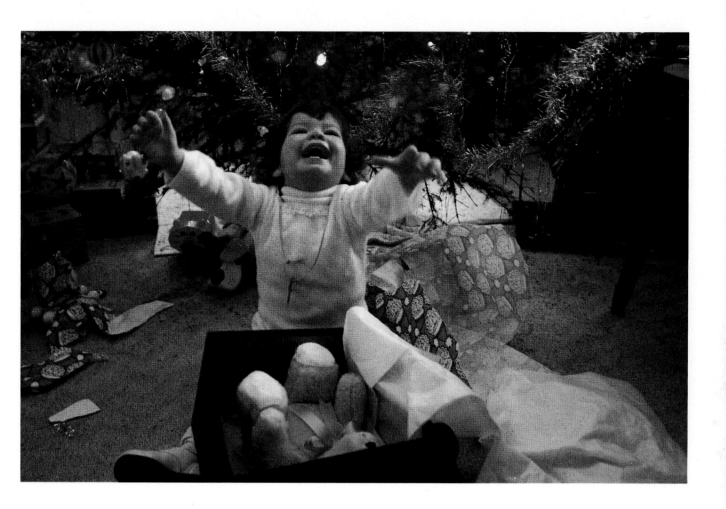

"When children open presents, they get so absorbed in what they're doing that they lower their faces and eyes and start ripping open the packages. That's okay, but I usually like to see the face of my subject in my pictures. Especially the face of a child, because the expression really adds to the story of the occasion.

"Here's how I took this picture. Jennifer was busy opening a gift of a teddy bear. I was focused on her and ready to shoot. My wife stood behind me and said, 'Here, Jennifer, catch!' and prepared to toss her the next present. Jennifer's eyes lighted up, a big smile came over her face, her arms opened up, and with the other present already opened in front of her, I shot. The priceless picture I obtained just shouts 'happiness.' Don't you agree?

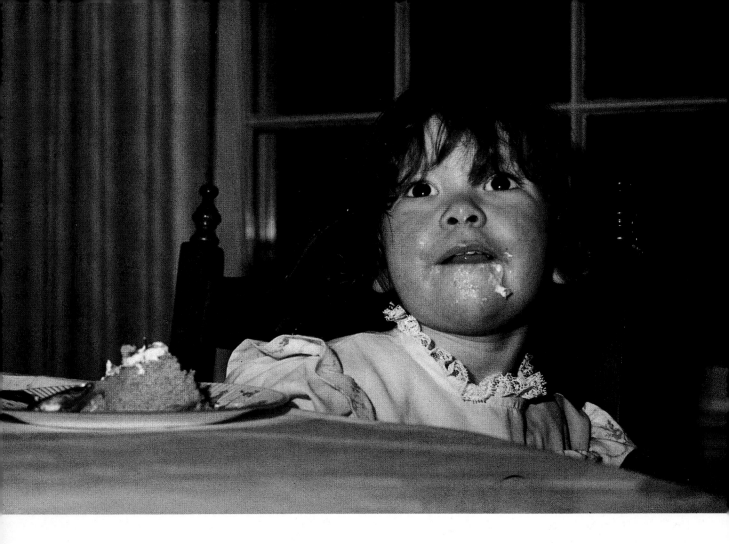

"Birthday No. 2. Wind her up and watch her grow!

"Jennifer takes her new brother, Timmy, for a ride in the stroller.

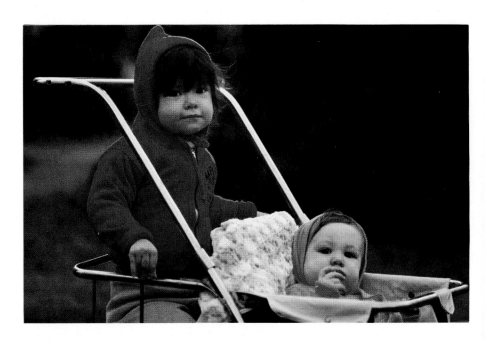

"One day I was washing the car and Jennifer was 'helping' me by playing with the hose. It was almost evening, and I noticed what a terrific effect the soft, low sunlight had on her hair. I couldn't resist getting my camera and taking a couple of pictures of her.

"Several times a year I have an especially good picture enlarged to 5″ × 7″. This picture is one we gave to our parents and friends. It was our spring picture of Jennifer that year.

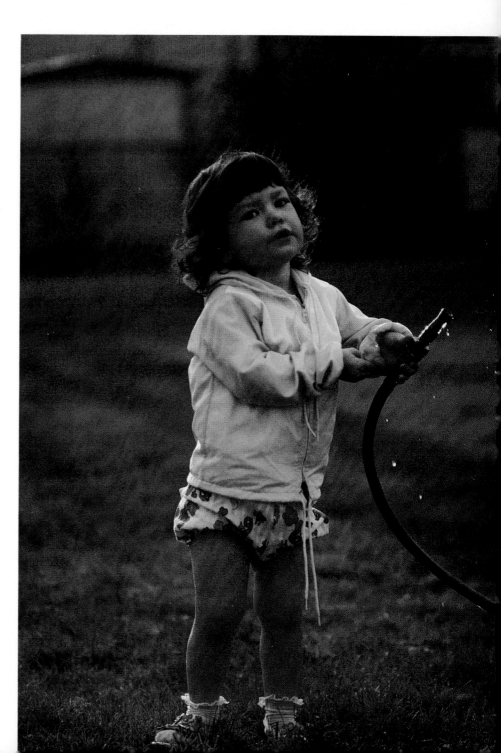

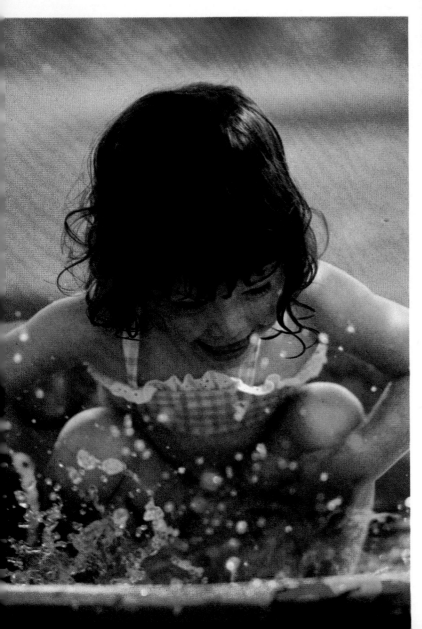

"Sometimes I think that childhood consists of two things: spontaneity and movement. Kids seem as if they're always either in motion or reacting to their world. So if you want to take sensitive, revealing, delightful pictures of children, you should try to see things through their eyes. You ought to get down to their level to take your pictures. Use a medium-long lens. I often use my 105 mm lens because it seems to make small things as large as they appear to children.

"Perhaps the most important thing in shooting pictures of children is to have your camera loaded and available, because you never know when kids are going to do something unusual and interesting.

"You should shoot with available light as often as possible. In this way the

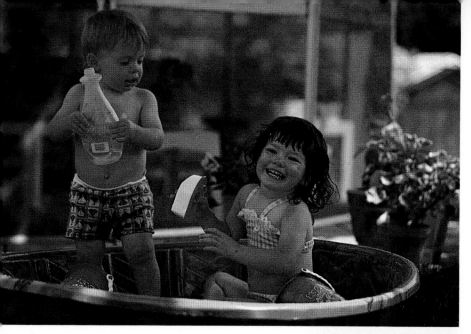

child is not intimidated or inhibited by lights. A child like Jennifer can just be herself. And now with high-speed color films available and a camera with a fast lens, you can take available-light pictures more often.

"I think it's also a good idea to shoot pictures of kids on their bad days. I've got pictures of kids with colds, crying, with bandages, and with their hair messed up beyond belief.

"Sometimes my wife disagrees with this theory. She thinks the kids should usually look like scrubbed angels. However, I think that kids are a lot like diamonds. They have so many different facets to reflect themselves that I think it's important to photograph as many of the facets of childhood as possible.

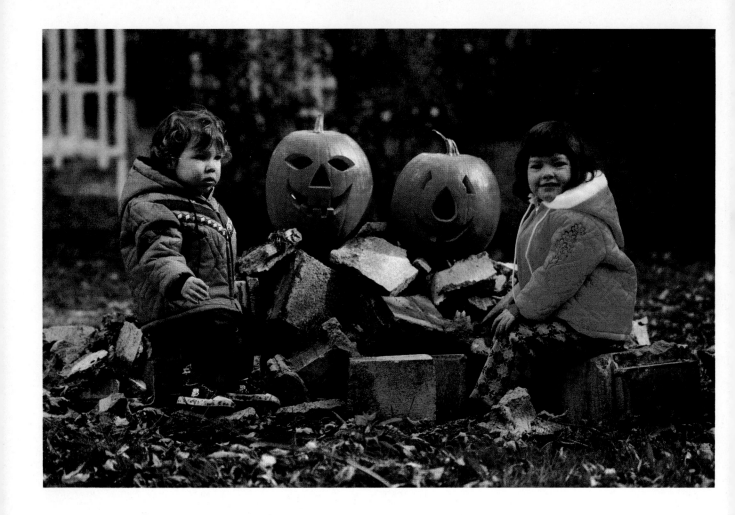

"Two kids, two pumpkins, but only one picture? Of course not—this is only one in a sequence going from the pumpkin purchase to the carving to a candlelight display.

"Three-and-a-half years old—and *so* grown up! Jennifer found a box of hair rollers and wanted to know what they were used for. Then she wanted them in her hair. After they were in, she came running to show me how pretty she was.

"You know, with every day that passes I realize that neither Jennifer nor any of us is ever going to be this young again. I keep telling myself I'll always remember the cute things she does, but I realize I won't. I mean to write or even tape record the cute things she says, but somehow I don't. I'm grateful that we have these pictures, because they're our visual memories of a little girl—our little girl—growing up."

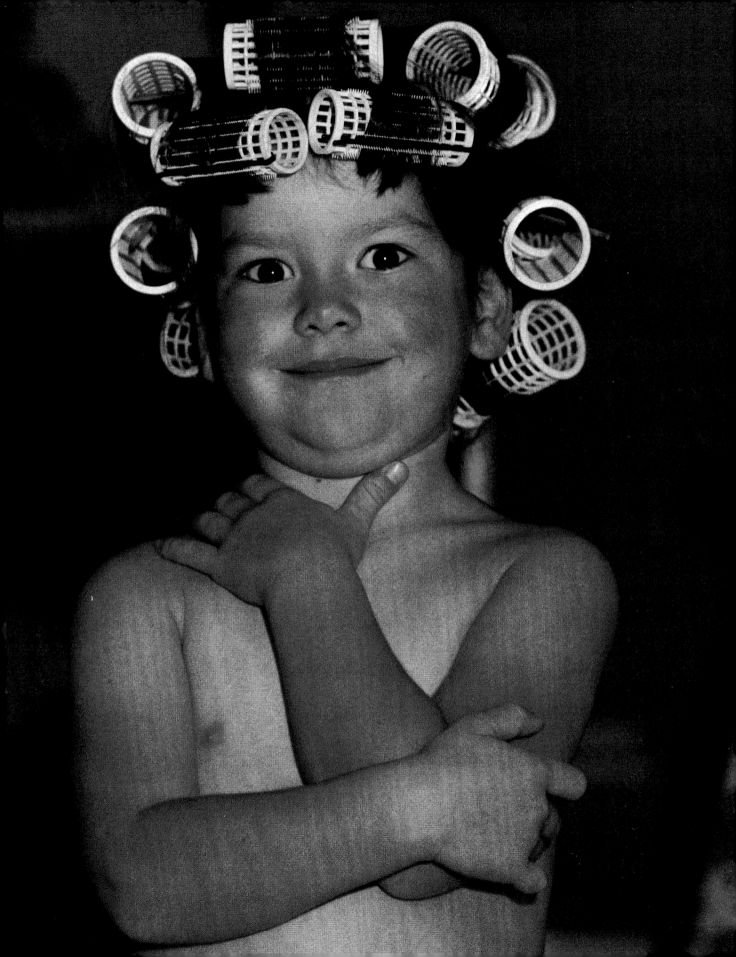

A FIRST-GRADER'S DAY
Pictures and Words by A. David Charlton, Jeannie's Father

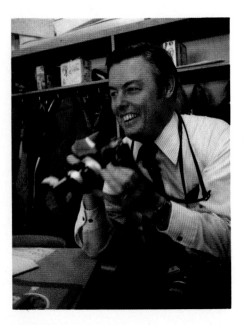

"After I had made several exposures, the children were used to my presence and practically ignored me the rest of the day. This provided me numerous picture-taking opportunities for natural, available-light pictures.

"Taped to my lens is the CC20 magenta filter that I used to counteract the effects of the greenish balance of the flourescent lighting in the schoolroom."

"The apple of my eye is, of course, my only daughter, Jeannie, who is now a first-grader. Like any proud papa, I've been taking pictures of her since she first arrived—the usual occasions: birthday, vacation, Christmas, and other special events. As a matter of fact, Jeannie turned me into a real camera enthusiast. She is the reason I lug around a 35 mm camera with interchangeable lenses. The lenses range from a 28 mm wide-angle to 50 mm normal, 105 mm medium-long focus, and 135 mm telephoto. Someday I'll probably trade some of them in on a couple of versatile zoom lenses.

"Most of the pictures I have taken were of special family events. They were taken as minisequences, but without any real planning. The other day it occurred to me that maybe I was missing the best photographic boat. I

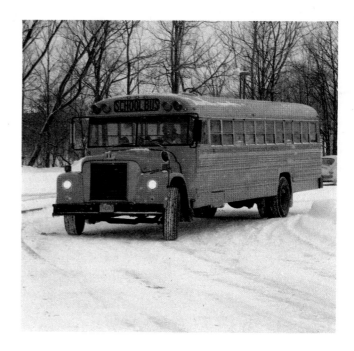

decided to shoot a typical day in Jeannie's life, from wake-up to bed-time, and turn the daily routine into *special-event photography.* Furthermore, I decided to select a different event and make an album each year. What fun it will be years from now to look through the collections! I'm only sorry I didn't think of it sooner.

Planning Makes Perfect
"I determined that a terrific subject for the first album would be a typical school day for Jeannie. First I had to obtain permissions. I stopped at school to see if it was okay for me to spend a day with the first graders. I stressed that I'd try for minimal disruption of their daily routine and would not use any distracting flash. The teacher, the principal, and the district school superintendent liked the idea. Even the school bus driver didn't mind. I had their support for a

possible slide show of the class and perhaps a showing at a P.T.A. meeting. (I reminded myself to be sure to include some pictures of the teachers, who were very helpful in suggesting picture possibilities.)

"Considering my promise not to distract the children and the teachers with flash, it didn't take much thought to conclude that the school day's photography could best be handled by shooting with bright available light. So let's chat a little about available light.

Available Light
"What is it? It's simply the light as you find it—excluding sunlight. Some people call it existing light. For the school interiors it was a combination of the diffused overhead fluorescent fixtures plus the bluish light of the sky (not direct sunshine) pouring in from the outer wall of large windows.

"If you want prints and use color negative film, picture-taking under these circumstances couldn't be easier, especially with high-speed negative films. Just rely on your built-in exposure meter or automatic exposure control, focus, aim, and shoot. Negative films have a greater tolerance to minor exposure errors than do transparency films. Further, you don't need to use color-compensating filters, because any color imbalance can be corrected by the photofinisher when the prints are made.

"I should mention at this point, however, that I prefer slides to prints. Projected slides are big and the colors are rich. I think slides—especially in a dissolve show accompanied by music—are exciting. Sure we have albums of prints, but these were made from slides whenever I thought a picture was worth a print. (Incidentally, prints made from slides are better than

65

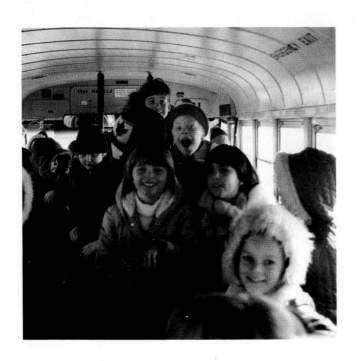 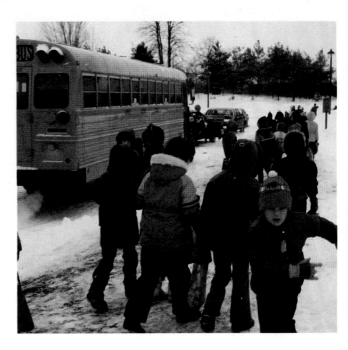

ever. If you haven't had any made recently, you'll be pleasantly surprised.)

"Admittedly it takes accurate exposure to come up with an excellent slide. There simply isn't the great latitude of color negatives. Furthermore the color balance has to look just right for transparencies. This is especially true for people pictures because flesh tones are a photographically sensitive subject. A wide variance in color balance and even density can be tolerated with a nonsensitive subject, such as an empty room interior, but a human face is a different matter. A face should be rendered properly or else the value of the picture may be diminished. A wall of a room can sometimes be tolerated off color in a greenish direction, but a face shouldn't be! Remember that you don't have the chance to correct the color, as you do in print-making. Consequently I find it difficult to tolerate pictures that are out of color balance, too light, or too dark. But this is a challenging and rewarding aspect of available-light photography. Getting consistently good results is possible even under unusual shooting conditions. Let me tell you what's involved.

Available Means Variable

"Consider the variables in available-light shooting, whether it's in a school, home, office, public building, or wherever. First, there are several varieties of fluorescent tubes, each requiring different color-correction filters for optimum slide results. This is because fluorescent tubes, although they appear white to the eye, are deficient in red emission, so slides taken with only this illumination will be objectionably greenish. Nobody can predict accurately the filter combination that will give you perfect balance. But with daylight film in your camera you'd probably end up with something close to my preference of a CC30 magenta filter *plus* a CC20 blue filter for most fluorescent situations. But this suggestion also assumes there are no windows admitting bluish daylight. (If *direct* sunlight is coming in the windows there's too much *lighting contrast* to cope with. Don't shoot then; wait until some other time of day when it doesn't shine in.)

"Actually, the filters will depend on the *proportion* of the various light sources. Which means that if you take a closeup of a child standing next to a window and looking outdoors, you shouldn't need any color-compensating filter when using a daylight-balanced film. But take this same child over by the coatrack on the

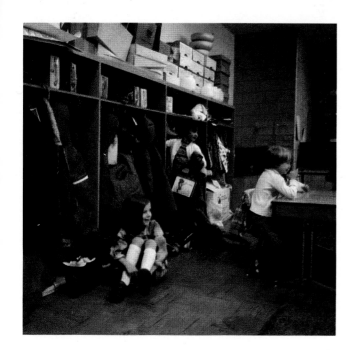

opposite side of the room, and you'd need substantial magenta filtration to counteract the increased *proportion* of fluorescent illumination.

"As I toured the school I made a note of the illumination in each room, since there was a wide variance. All the schoolrooms involved had high, inaccessible, overhead fluorescent fixtures with mysterious tubes hidden behind a diffusing screen. Nobody could tell me what type of tubes they were, and I didn't have the slightest clue as to their color-temperature characteristics. In addition to the ceiling lights, the homeroom and library each had one wall of large picture windows providing bright northern light, while the artroom in the corner of the building had two walls of huge windows with a northwestern exposure which completely overpowered the ceiling fixtures. My best guess was to use no

filter in the artroom and a CC20 magenta filter in the other rooms.

Exposure Information
"Schoolrooms, with their abundance of ceiling fixtures and large expanse of windows, can be what I call exposure-meter traps. Camera meters survey and integrate subject reflectances in the process of exposure determination. They do this with a central image area and 'think' they're doing this for a normal-toned subject. But really, exposure meters don't 'think' and there is a tendency for them to underexpose light-toned subjects and overexpose dark-toned ones. In addition, direct light sources such as floor and table lamps or sizable overhead ceiling fixtures will, if included in the field of view, influence meters unduly. The meter, seeing a ceiling full of fluorescent tubes, tells itself: 'My gosh, this is a bright scene.

I'd better stop down the lens so as not to overexpose.' But you're really interested in obtaining the correct exposure for the comparatively darker people in the lower portion of the scene. If you let the meter have its way such a scene will be appreciably underexposed.

"In addition, there are more bright reflective objects in a schoolroom scene than you might realize. For example, if you're shooting toward windows watch out for reflections from backlighted objects, such as varnished desk tops, polished floors, or, even worse, a portion of the window itself. Yes, you can include such objects in your people pictures, but be sure to adjust your exposure for them. For adjustable cameras, try the estimated normal exposure, but also bracket with another shot that is one stop over the normal exposure. Some

automatic cameras can be 'fooled' into doing this by changing the ASA speed. For example, set the meter at ASA 200 instead of 400 to achieve a one-stop exposure increase. *You must think for your meter like this for every shot you take if you're going to obtain enough consistently good exposures from which to choose.*

"Remember, I had decided to use a CC20 magenta filter for an average correction of the two mixes of light sources in the homeroom and the library. Because of the higher percentage of daylight in the artroom, my evaluation there was to use no filter. A slight word of caution when using filters with a single-lens reflex camera: All filters absorb some light and the amount is called the filter factor. For example, a CC20 magenta filter has a factor of about 1.5, which means that the lens should be opened ½ stop to compensate for this loss of light. However, some camera meters are not sensitive to all colors. This means that, while the film needs the extra exposure, the meter isn't going to let it have it, and the picture will be underexposed by the amount of the filter factor.

"You can check this possibility quite easily. Look through your viewfinder at any normal scene and watch the exposure-meter needle. Now, still concentrating on the needle, hold the filter up in front of the lens. If the filter has a factor of 2, for example, the meter needle should move from, say, $f/11$ down to $f/8$. If this happens, you'll know that your camera will *automatically* compensate for that filter factor. If the needle doesn't move when you add the filter, you'll have to compensate by using your manual override exposure control, by changing your predetermined exposure brackets, or by adjusting the ASA setting.

"Now that the technical matters have been decided, is that all there is to consider? No, for now comes the *most important* part of all.

Picture Coverage
"Look at it this way: the purpose of learning to use a typewriter is to communicate better; the purpose of learning to drive a car is to get places faster and easier; and the purpose of learning to use available-light techniques in photography is to provide another tool for obtaining interesting and meaningful pictures.

"So what do we want to *say* with our cameras?"

"Remember, this self-assignment was to document a typical day in the life of my first-grade daughter. The

chronological sequences were: waking up, teeth-brushing, dressing, breakfast, school bus, coatroom, and a progression of school-day activities through lunch. Then afternoon classes, home again, playtime, evening, and bedtime. In other words, I planned a collection of the memorable moments of the day.

"One tendency to be avoided, it seemed to me, was taking an overabundance of tightly cropped closeups of Jeannie's face. It would be easy to get carried away like this because I like informal closeup portraits and they often result in great pictures in which interesting facial expressions are paramount. Frankly the occasion wasn't meant to be a day-long portrait session. It was important to show her interaction with friends and teachers —to show her not just being, but learning and doing; not just combed and

shining for a picture, but with clothes slightly wrinkled and hair askew as she is much of the time.

"For a major sequence like this it is very important to have the coverage as varied as possible to keep it interesting. If you plan a similar session with your youngsters, my advice would be to shoot from different parts of the room to vary the coverage of the subject. This may also vary the lighting. Stand on a chair, sit on a stool, or lie down on the floor to provide variety in your camera angles.

"Use different focal-length lenses to vary the perspective. Normal and long lenses are excellent for closeups of faces. I'm sure you'll be using a wide-angle lens for a majority of shots. For a 35 mm camera, a 28 mm lens will be ideal since you will need the wide angle of view and the extreme depth of field it'll provide.

"One thing is definite, especially in kindergarten and the first and second grades: the children will quickly come to ignore you. They'll just keep on being their natural selves and give you simply marvelous opportunities for unique and delightful available-light pictures.

"You'll find, if you undertake a project like this, that most of your best pictures, especially closeups, will be taken from child's-eye level. You'll really have to stoop to conquer, or else you'll be photographing only tops of heads.

"As you sit there on a child-sized chair, elbows on a table in front of you for steady camera support, your eye glued to the viewfinder watching your little target, an important decision is *when to push the button.* When her hair is out of her eyes, when the light

on her face makes her look beautiful, when she has a peak expression, the moment of interaction between her and another child—all of these times are wonderful picture opportunities, but you'll need an instant trigger finger to capture them. And by all means take more pictures than you think you'll need, because kids have a habit of moving just at the last moment and producing blurred images. You'd better shoot a lot and let the law of averages take care of you.

"Also be alert for minisequences within your larger chronological framework. Some may even be planned in advance with the teacher. For example, let's say the teacher gives an audiovisual library assignment to four children. They march off to the library, set up a record player, put on earphones, turn the book pages as the record/picture story pro-

gresses, and then write a brief report on what they've seen and heard. Each step can be photographed.

"Or, as another photosequence, a tyke is struggling with an arithmetic problem. On the face appears a quizzical expression of searching for the answer on the ceiling followed by counting on the fingers. 'Oops! Two hands are needed for this one.' And, finally, the triumphant writing down of the answer.

"Targets of opportunity—be alert for them! They're almost impossible to restage as well as the original happening.

"Be honest now, and admit it—isn't it comforting to have all technical matters of camera operation and lighting behind you so that you can concentrate on getting really good pictures?

Available-Light Pictures Around the House

"How should I take the pictures of Jeannie at home to complete the sequence of a day in the life of our first-grader? Conveniently with flash? No, for several reasons. First of all, on-camera flash with its sharp directional shadows, high contrast, and falloff effects wouldn't provide the same pleasing, natural lighting I enjoyed using in the school. And as in the classroom situations, I would be dealing with near and far subjects in the same picture. Flash on the camera would over-light the foregrounds and under-expose the backgrounds. So to have the lighting for the home shots consistent with the school shooting, something other than flash lighting had to provide the answer. Most homes are simply not illuminated for convenient available-light picture-taking, even

70

with the fastest film. Sure you can take flashless pictures of a person *near* a sizable window in the daytime, and in the evening you can take snapshots of someone *near* a floor or table lamp. (Incidentally, in both instances the pictures will be better if the subject is relatively close to and facing the source of illumination.)

"But people don't really do most of their living right next to a window or a table lamp, do they? No, they're out in the central room area—out where it's much darker and harder to take pictures of them *unless you do something to boost the level of illumination.* Furthermore, home interiors are most conveniently taken with a wide-angle lens. I used a 28 mm lens for all these pictures of Jeannie at home. Generally speaking, wide-angle lenses have a smaller maximum aperture than normal lenses, so there is an addi-

tional need to give a good boost to the overall illumination.

"But that's easy. Two No. 2 flood lamps with inexpensive reflectors or two reflector photolamps (RFL-2) will do it. My general recipe is to use the highest-speed tungsten-balanced slide film and two 500-watt flood lamps, one of which is bounced off a white ceiling to increase the general level of illumination. No color-compensating filters are needed if the ceiling is white or off-white because the color temperature of the photofloods is matched to the color sensitivity of the film. Just don't try this with a colored ceiling.

"In this case, the slight amount of daylight from the windows during the afternoon shooting session was ignored because of the overwhelming proportion of the bright artificial light. If you

have tungsten-balanced slide film in your camera, remember that windows permitting large quantities of bluish daylight to enter are your color-balance enemy. The bluish light will be especially objectionable for flesh tones. I know I don't want my daughter to have a sky-blue face in some of the pictures! So if you have this balance situation, consider which one of these actions might best solve it:

1. Lower the window shades or draw the drapes.
2. Change locations to eliminate the window-light influence, particularly bounce glare from glossy walls, ceilings, or polished floors.
3. Postpone your shooting until evening.
4. Try to overpower the daylight by using direct instead of

bounce floodlight illumination.

5. Use a yellow color-compensating filter on the camera lens. Try a CC40 yellow filter as a start.

"I use two photofloods, but you might use only one—or possibly three. The basic idea is to boost the ambient (existing) light up to convenient working levels. Arrange the lighting and judge the result with your exposure meter. My personal preference is to produce enough general illumination to shoot at not less than 1/30 sec. at $f/4$; at 1/60 sec. is even better. Lower illumination levels would either force you into slower shutter speeds (at the increased risk of recording camera or subject movement without a tripod) or wider lens apertures (with the disadvantage of shallower depth of field). The main purpose of boosting the general level of illumination is to

eliminate the need for a tripod and to give yourself quick freedom of choice for a good camera position. In a word, mobility.

"But you must bounce the light *discriminately.* You must watch and consider the effect on your subject and the distribution of the light over the entire area included in your picture. So in addition to getting the ambient level up to picture-taking convenience, you must also see to it that broad diffused light has the right direction and distribution.

"The term 'bounce lighting' usually refers to bouncing the light off the ceiling. But this often results in dark eye sockets for the subject. The remedy? If there is a white or nearly white side wall, use it as the bounce target for one of your two lights. Even the white door of a refrigerator or a white tablecloth or bed sheet would serve

this purpose. Direct a large expanse of diffused illumination *sideways* into the subject's face rather than from directly above. Also, you may want to experiment with the bare-bulb technique. Just remove the reflector for a combination of direct and bounce illumination.

"A few words of caution about bounce lighting. Most home ceilings are white and that's fine. But many walls are painted or papered and whatever color (non-white) is used *will influence your pictures far more than your eyes tell you it will.* The reason is that some of the light directed at the ceiling is also reflected from the colored walls onto the subject. This color contamination is correctable with color-compensating filters. You may have to experiment to find out which filters would be best for your situation.

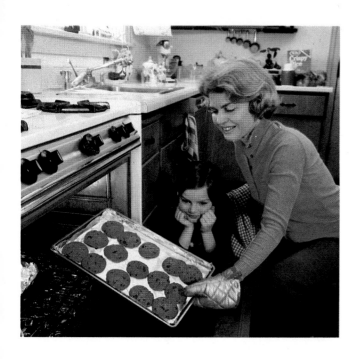

"As I said, I like to use two photoflood lights. One is clamped to a lightweight adjustable-height stand and bounced directly off a white ceiling to flood the shooting area with general illumination. The other can be held by someone. From your shooting position, where you can best evaluate the effect of different lighting combinations on your subject, ask your assistant to try different positions and angles for that second light. (Be sure this person is operating with a long extension cord.) Observe the lighting effects on your subject *objectively,* not *emotionally!*

"What to look for? If you're not careful, one tendency in bouncing a light off the ceiling is to overlight the background wall in proportion to the amount of light reflected onto the frontal planes of the subject's face *where it should be.* In fact you may have not only created an inartistic

lighting effect by overlighting the background, you probably also created a meter-fooling situation where you'd end up by underexposing the subject. The smaller the room, the more this is noticeable. To avoid this situation, ask your helper to stand about halfway between you and the subject and to one side. Now while you *carefully* watch the effect (glue your eye to the camera viewfinder if you find this helps to concentrate on the lighting distribution) ask your assistant to *slowly* tip the floor reflector forward from where it was aimed at the ceiling. Watch for *just the beginning* of the direct spill light to illuminate your subject's face. It's a tricky, delicate maneuver. Freeze the lamp position right there. This will raise the brightness of the face to where it should be, just a little higher than the background wall. You'll be using a bit of directional sidelighting plus diffused

bounce fill. It won't look anything like on-camera flash lighting and so will be beautiful. Now elicit a good expression from your subject, and shoot!

"Many photographers feel that the availability of higher-speed films and/or faster lenses could eliminate the need for supplementary bounce lighting for available-light pictures around the home. But this isn't the complete answer because the *direction* and *distribution* of the existing light are often not as good as they should be for picture-taking. Windows and artificial lighting fixtures will always be proportionately too bright, and higher-speed film won't change that. What you need is a higher overall level of illumination to lighten shadow areas. You need to lessen the lighting contrast, and this is what supplementary bounce light can do for you. Direct flash on the camera

"Even when using a high-speed film, available-light picture-taking at home is more convenient if you boost the level of existing room illumination with one or two floodlights."

may be very convenient, but it will give you the highlight contrast and falloff that reduce the desirable naturalism which flashless lighting provides. Bounce flash from the camera isn't the answer either, because you usually can't direct it for the most artistic effect. And besides, you can't *observe* the lighting effect *before* you shoot.

"Let's examine one final consideration. There's a large difference in the *amount* of available light—much more in schoolrooms than at home, for example. This can have a direct influence on your relationship with your subjects. At school, candid shooting was very possible with very little subject control. But at home, where you are fighting to beat the depth-of-field and subject-movement

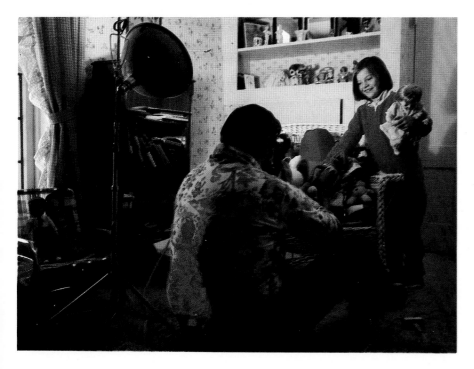

problems, it's better to exercise more control over the situation and the pose. The challenge is to invent natural, interesting picture ideas and then pose your subject so that the result doesn't look posed. It's not easy to do, because it'll take imagination and skillful direction on your part. But surely it's worth the effort.

"So don't unthinkingly accept available light as you find it. It may benefit by some alterations. Remember: Enough available light in the right places isn't really all that available!"

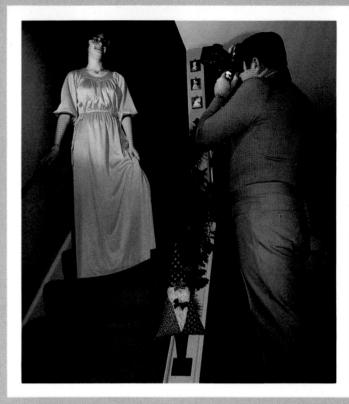

Mom shoots Dad shooting me.

THE PROM

By Carolann Stehling

"There are more than two authors of this book—I wrote some!" (Carolann speaking.) "I was asked to tell you exactly how I ended up with a terrific picture sequence of my senior prom. Of course I'm glad to do it because, well, just think of all the thousands and thousands of high schools that have proms, snow balls, J-hops, senior dances, and the like every year. Then multiply those by the hundreds of kids that go to each one of these dances. There must be literally millions of teenagers who would like to have a good photo record of this great time of their life. Besides, all my family are amateur photo enthusiasts, complete with several cameras and flash accessories.

"The big idea is that everybody—me, my date, my family, and the other kids at the dance—has to get into the

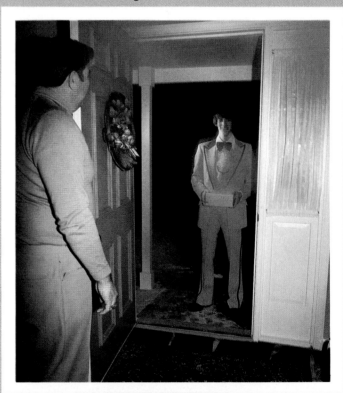

I shoot Dad greeting my date.

76

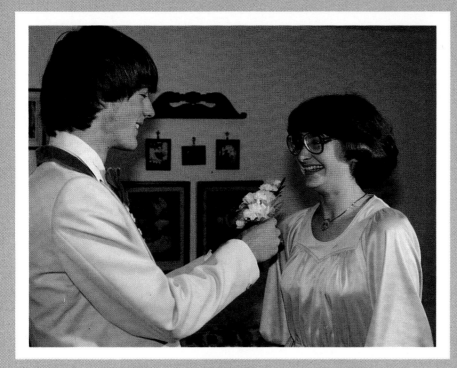

My first corsage! Dad takes a closeup.

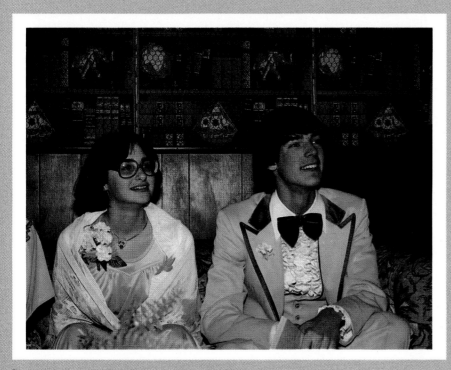

Dad gives us a last-minute course in Prom photography.

act—taking pictures, that is. But of course this just won't happen automatically. Someone must make it happen. That is, someone must be the director of photography. In this case I was it, because I wanted the pictures and knew that I wanted a start-to-finish series of the prom. After all, it was my first prom, my first formal dress, even my first date with Steve, and you bet I wanted to save those moments in pictures.

"You can't be too timid about asking people to help. Dad always calls me his M.D.S., for Marine Drill Sergeant, but that's all right; few people mind holding an extra flash or even taking a picture for you.

"I guess I can show and tell you best if you look at the pictures and then read how each was taken. Please keep in mind that these weren't *all* the pictures we took. The people from Kodak said they couldn't fill up this whole book

77

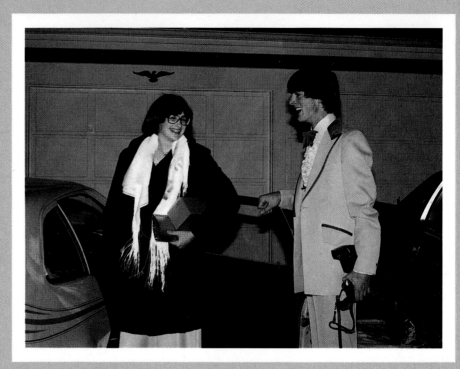

Here's where Dad had to guess at the focus.

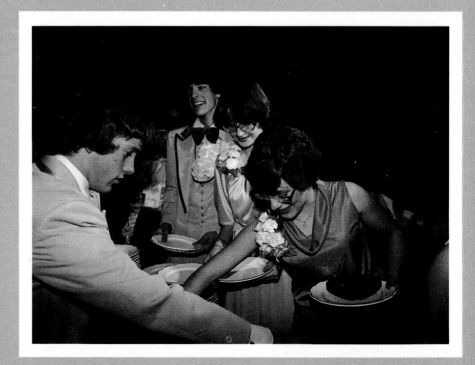

with my prom; so I picked out the one I liked best from each situation. It was hard to do, but here they are.

"Dad took the closeup all right, but of all the pictures of me coming down the stairs in my first formal I liked this flash shot Mom took. It shows the entire length of my dress. She used a wide-angle lens because in the cramped quarters of our entrance hall she never could have included everything with the normal lens.

"This doesn't look like a tricky shot, but it was! It's a good thing we're a photographic family where almost anything goes to get the picture. The flash was on the camera, but do you see the light at the left side of Steve's face? We put a blue flood lamp in the porch light and then used a slow enough shutter speed (1/30 sec.) so that it would record as a sidelight. He

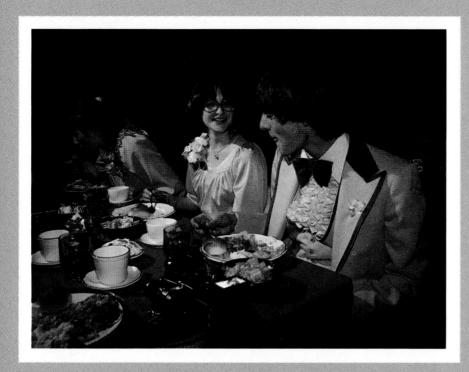

Friends used our camera to put us in the picture.

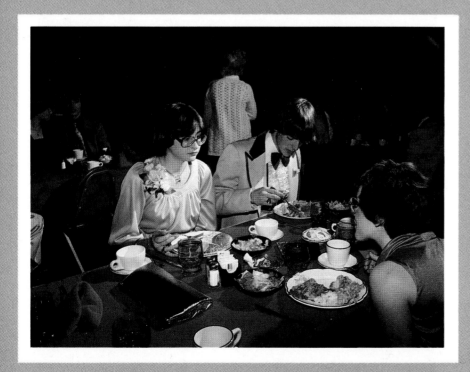

would have looked too dark if the camera flash had been the only illumination.

"I might as well point out a minor goof. That blue halo above Steve's shoulder was caused by moisture condensation on the lens that we didn't notice and didn't wipe off. We had been taking pictures outdoors just before this, where the temperature was below freezing, and the room moisture fogged up the front lens surface. Well, even a photographic family makes mistakes sometimes, but I'm sure glad to have this picture anyway. I just tell Steve his halo is showing!

"Dad knew it would be dark outdoors and he wouldn't be able to focus accurately. So before going out he preset the distance scale and the lens aperture for a ten-foot flash shot. He just stood about that far from us and, wow, it came out great!

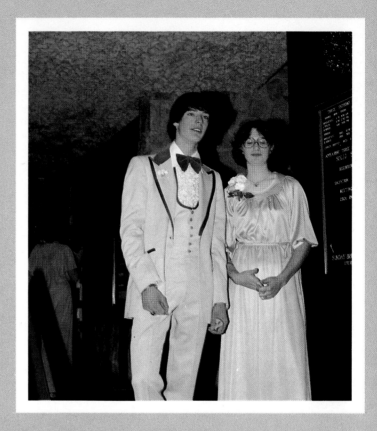

"When we left for the dance, Dad loaned us his camera with an electronic flash and made sure we had an extra roll of film. The trick here, if you want to call it that is that we had our friends take pictures with *our* camera. We made sure it was set right and gave them strict instructions on what to take and how to take it. Of course they made some errors in composition, like aiming the camera too high or too low, but we're glad to have the record anyway.

"My favorite picture of this long camera series is where we were dancing in front of the band. One of our braver friends stood up on a chair to get this one and the exposure caught a neat sidelighting effect. Really, the picture-taking made the prom a lot more fun. Our friends were even calling us the 'photo couple.'

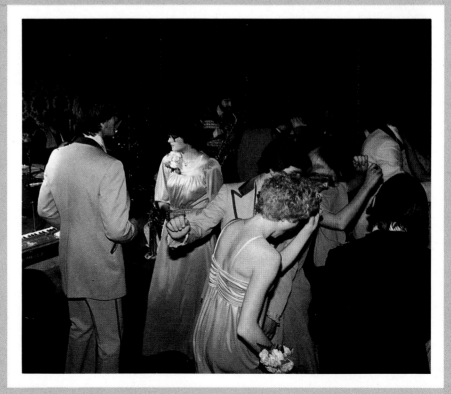

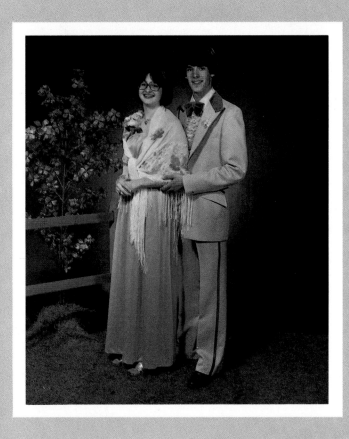

"One of the local professional studios was taking portraits in the room right next to the dining and dancing area. Portable background, props—the works—and Steve and I wanted a really nice picture of ourselves. Imagine my embarrassment when neither of us had the few extra dollars it took for the picture! But the studio people said 'No problem,' and Dad came through for the pictures and even ordered some extra ones.

"There was one last flash picture we took on the front porch when my date brought me home and said goodnight. We set the camera on the edge of a window flowerbox and aimed it at the front door. The camera had a self-timer that gave us about ten seconds to dash back to the doorway before the flash went off automatically. The picture came out fine—but it's the only one I'm not going to show you!"

ALL ABOUT ME

Pictures by Steven Shuler

Calling all teenagers! Sure you're "now" people today, but do you really think you have a supply of endless tomorrows? You probably have a suspicion that someday you'll be "then" people, like the rest of the world—people with yesterdays and memories that will be fun to recall.

However, we give you credit. You're very aware that you're going through a time in your lives when your values may be under duress, you're changing your mind about things, and you're coming to new realizations of yourselves.

Why not use a camera to document your progression through this time of your life? For instance, there surely are things you'd like to photograph that are important to you—things you like—photographs that would show important parts of your teenage lives. In other words, a kind of socially conscious photojournalistic use of the camera in order to record your own progression through your teenage years.

So if someone handed you a camera and said, "Go and photograph your life," where would you start? By making a list of the things you like, the places you like to go, and those who are special to you.

Our teenage neighbor, Carolann, dashed off this list in seconds.

"Hi, I'm Carolann Stehling and I live here in Victor, New York, together with my parents, grandmother, a brother and a sister, and my guitar."

82

"Grandma just loves this picture of me and my guitar by the fireplace. My friend Steve took it with flash. The quality is nice, but *I* don't like the picture! Know why? It doesn't *stress* anything. The picture has no meaning or feeling."

"Steve and I talked over how we thought the guitar picture should be retaken. I wanted the emphasis on my guitar. It speaks for me, it expresses my feelings, and it's important to me. So Steve used a wide-angle lens from a low viewpoint. He wouldn't let me look at the camera; said that a semi-silhouette of my serious face would help tell the story of the guitar. Of course Grandma doesn't like this picture as well as the other one, but I think it's more *me*."

"I like:

 skiing
 woodworking
 ice skating
 eating
 meeting people
 dancing
 cars
 music
 my house and neighborhood."

Every item on the list is a potential picture. If dancing turns you on, have a friend take pictures of you at a discothèque.

Why don't you expand this simple list of likes and dislikes to a *few* paragraphs of *feelings?* Like these, which Carolann also wrote:

• "Motorcyclists have their own style. I feel unique while I'm riding my bike because the way I handle it is a form of expressing myself. It's a style no one else can copy.

• "Music is very important to me. I can reach out to people with my music. While playing my guitar, I can express everything I feel.

"Here's what Steve and I tried to say with the camera: 'Sometimes I really wish I were two people—one would help keep me out of the trouble the other gets into!' Steve used his wide-angle lens again and had me rest my chin on a mirror while standing next to a large window. He said he had trouble keeping both of me sharp, but I'm not sure if he was kidding."

"My eyes are windows on the world now, but my camera is my window on the world always. A person's mind can see only *images* of the past, but a camera can turn those soon-forgotten images into pictures to remember always."

- "Sometimes I feel like a bird—just flying. A time when I have no ties to anyone or anything. A feeling of complete freedom, which is important when I have myself tied to the ground.

- "As adolescents we are trying to find our own way. We're trying to choose between our childhood fantasies and the reality of the adult world. But while we're in between, we find ourselves in sunshine and dreams.

- "At times I hate being a teenager. Too many things come upon us too quickly and we never have time to enjoy the things we should. Everything we do during our teenage years has a great influence on our future. But this is what makes our lives more memorable—all this hectic activity."

You recognize this process of change as an evolution that's going on within you. The important thing is that it would be revealing, helpful, interesting, and amusing for you to look back in future years to what was important to you as a teenager. You know that what seems important will be different at various periods of your life.

"We teenagers are sometimes torn between emotions such as insecurity and responsibility. Having the power to divide ourselves into two could help solve at least half our problems! I hope.

"Of course this is a double exposure. Steve put the camera on a tripod. He took one picture of me facing the camera, had me move over and turn around, then made the second exposure. I have to admit it was an experiment, and this is the best out of four tries."

85

"Steve said, 'You know, Carolann, if dividing yourself didn't work, maybe you could just make yourself fade away. I could fade you away with a now-you're-here and now-you're not double exposure. Want to try it?' And I said yes. Here's what I'll write about this picture if I look ghosty enough: 'There comes a time in everyone's life—telling a joke that isn't funny, or being called on to answer a question when you haven't been listening to the discussion—when fading away could solve some of the embarrassment that results.'"

What do you think about documenting this time of your life? You really don't need to know a lot about photography to do this.

Do it with any camera.

GRADUATION

"Graduation," one dictionary says, "is the act of receiving a diploma from a school." But it can be more than a moment to parents with a camera. It's a whole day of great sequential picture-taking possibilities.

Come on, we'll show you some of them!

Lighting? Your options are open on this subject. The easiest way to light such scenes is with on-camera direct flash. An improvement would be to bounce the flash off a white ceiling to prevent overlighting (and overexposing) the gown in the foreground. This would also spread the light to minimize the possibility of vignetting if you use a wide-angle lens. The most elaborate technique would be to use on-camera flash to trigger off-camera auxiliary units aimed across the subject from the sides to provide roundness and better rendition of textured surfaces.

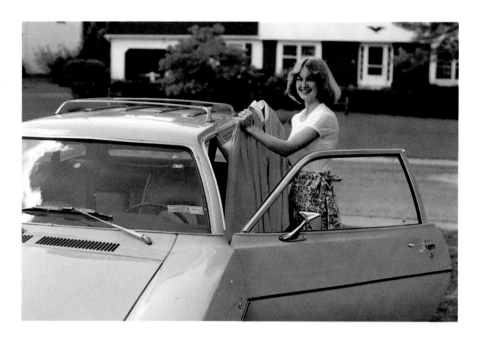

10 A.M. Here comes Aileen back from the rehearsal with her graduation gown. It's worth a long shot as she gets out of the family car. Focus, compose, shoot—easy!

10:02 A.M. Move in for a closeup. Fortunately the sun is under a cloud. There's no problem with harsh highlights, shadows, and squinty expressions. "Aileen, tip your head a little to your right—toward the car—that's right—makes a better pose—got it."

10:30 A.M. The ironing board is set up in the kitchen. She has to be careful not to scorch that rented gown. The quarters are cramped in this small room, especially since I want to include most of the gown. A 28 mm wide-angle lens for the 35 mm camera should be about right.

12:15 P.M. Time only for a snack-tray lunch on this busy day and an easy on-camera flash shot. Just be sure when you are taking flash pictures like this, especially in low-light interiors with fair-complexioned subjects, that the flash is used about four inches higher than the lens in order to avoid red reflections from the pupils of the eyes. A flashcube extender should solve this problem as should a flipflash or electronic flash that is mounted slightly off the lens axis, as most of them are.

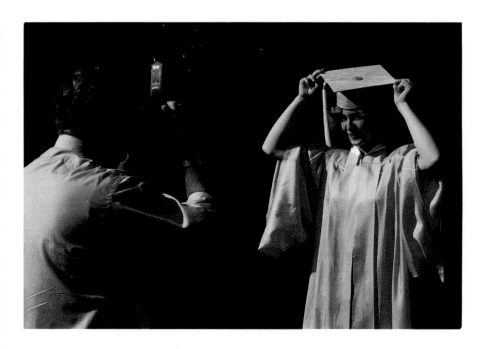

3 P.M. It's Father's turn to photograph the graduate—but wait, not like that, not with Aileen facing that harsh, brilliant sunshine. If you snap it now, it'll look like . . .

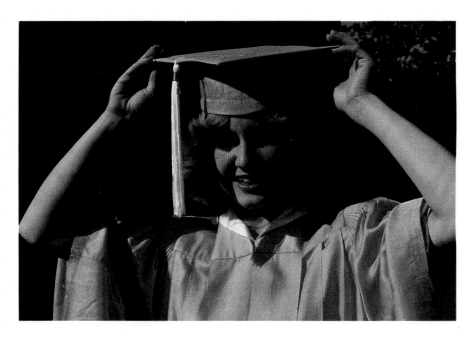

this! It would be much better if he had turned her away from the sun and exposed for the shadows. Wait, do you see that willow tree over there with its overhanging branches?

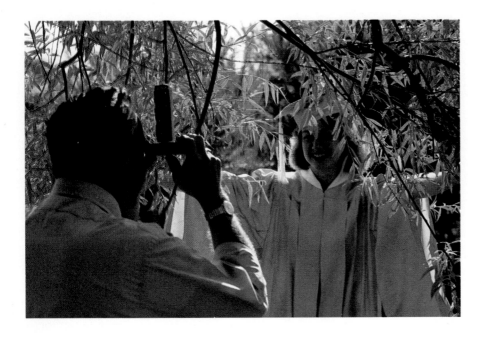

3:05 P.M. Well, this will be an improvement. You can easily see it in the viewfinder.

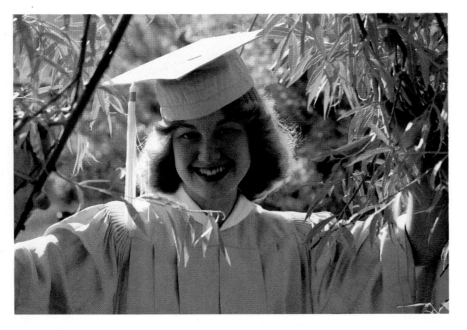

3:06 P.M. Yes, it was surely better to do it this way with the backlighted branches providing a lovely frame for the face. This is the picture all the relatives are going to want a print of. It may be difficult, especially when there's a high degree of emotional involvement in a picture-taking session like this, to concentrate on pose, lighting, closeness, composition, and technical matters such as exposing for the shadows. But your pictures will be better if you can. That's for sure.

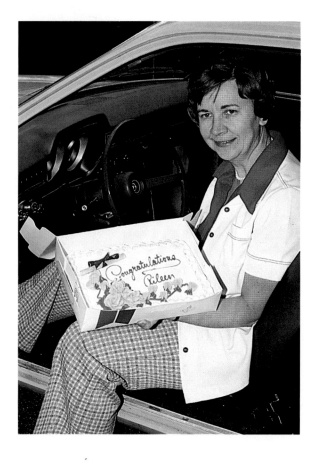

4 P.M. Mom arrives home with a special dinner cake. This calls for fill-in flash to lighten the car interior. It's a little hard to make out the cake decorations from this medium-shot distance, so . . .

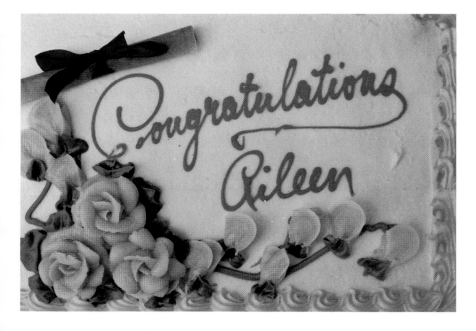

a closeup is surely in order. As long as the closeup attachment is still on the camera, let's also include . . .

the graduation invitation and tickets, using the mortarboard tassel as part of the still-life composition . . .

and for an extreme closeup of Aileen's class ring. Note these picture-taking tips. First, her hand is resting on the round lens case to steady it and to provide a round, graceful position for the fingers. This is much better than if they were flat. Second, a white piece of paper is placed next to her hand as a minireflector. Nearly all glossy metal objects can be photographed better if they reflect a white-surfaced cardboard put just outside camera range.

7 P.M. It's shower and get-ready time. You've caught her peeking around the shower curtain? Good picture idea. Use bounce flash off the ceiling for a soft, even illumination? Not when there's a yellow ceiling, or your result will look yellowish—like this. And where are the catchlights in the eyes? Not there with bounce.

7:01 P.M. Better switch to direct flash illumination. Use one on the camera to put good catchlights in the eyes and another identical unit (a slave light) off to the right to add a peppy modeling effect.

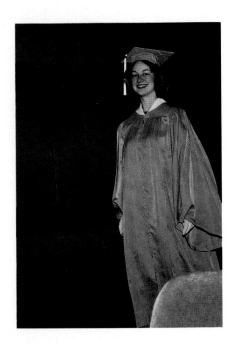

8:15 P.M. Graduation time! The flash picture of the graduate coming down the aisle is the hardest picture in the entire graduation series to execute properly, but planning will pave the way. Arrive a little early to be sure you'll get an aisle seat. Take those few moments to make sure you're ready with camera loaded, flash in place, and the spot selected where your subject will be when you shoot (very important).

Flash can be tricky, especially if you have a flash unit that doesn't automatically monitor the light reflected from the subject and adjust the exposure accordingly. Although the camera-to-subject distance is very important for proper flash exposure, the simple secret is to be familiar with your own camera and its flash capabilities.

Furthermore, your camera must be focused for the exact camera-to-subject distance in order for the picture to be in sharp focus.

Now here comes the graduate walking down the aisle. Closer—closer—you can't "follow-focus," and you have but one chance to shoot. What should you do?

Well, you should have preset your camera for about ten feet. Practice keeping a few of the preceding graduates in your viewfinder. Pan the camera with the subject, keeping a little space ahead so that the subject will be walking into the scene. Now you should be ready.

You have just this one fleeting chance. Don't lose it.

Want some good advice? There you are sitting down, taking a fairly close-up picture of a standing person from a low camera angle. The flash is appreciably closer to the subject's hands and waist than the face. The print will be considerably lighter at the bottom than the top, making the face look a bit dark. This can be corrected in a custom-made enlargement by dodging. However, you can also do a lot in taking the picture to even out this unfortunate lighting if your flash unit has a swivel head, is detachable, or operates on an extension cord, and if you tilt it up slightly. You can also bounce the light off a white card held by an assistant at a 45-degree angle to the subject. This provides better results through diffused lighting. You'll need to compensate for about a two-stop loss of illumination (if your automatic flash doesn't do this for you) but you should have plenty of light left over to invest in this worthwhile fashion.

96

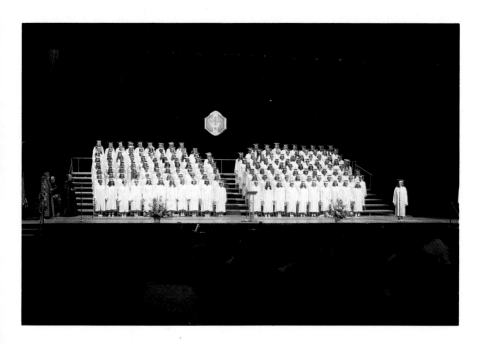

8:30 P.M. Tried to make an available-light picture of the graduating class on the auditorium stage. There was enough light all right, but it was such a long shot that individuals couldn't be easily identified. From the audience, it was impossible for any parent to get a good picture of that proud moment —the receiving of the diploma.

9:10 P.M. So the answer was in *restaging.* After the ceremony was over we fought our way through the excited crowd and went backstage. We had to hurry before the gowns were turned in. Sister Bonaventure was kind enough to reenact the presentation to Aileen. Notice that the two subjects were posed so that Aileen with her light-toned gown was in front of the *dark* background, and Sister Bonaventure in her black habit was in front of the *light* background. This provided excellent subject/background separation. Just imagine how it would have looked had their positions been reversed.

10:25 P.M. We're back home, and it's gift-giving time. Also time for more flash pictures with some hammed-up poses for fun.

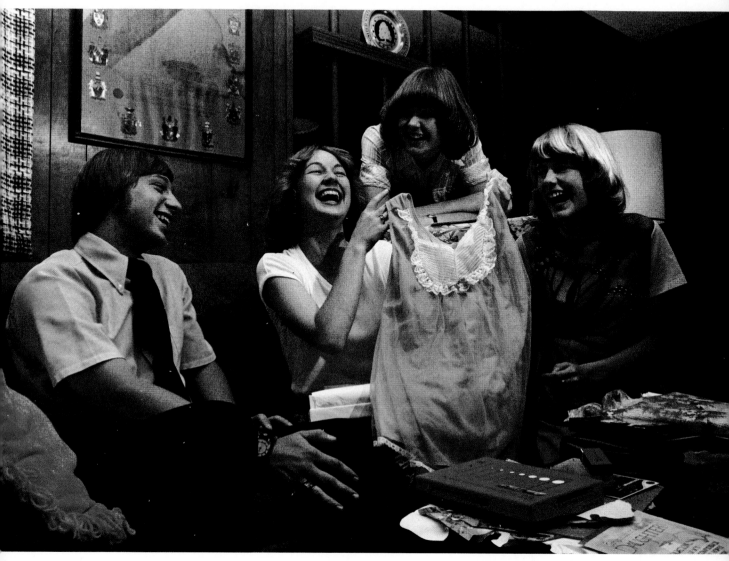

10:30 P.M. If everything is just right, you might take an unposed treasure like this. You could never *plan* this fantastically funny moment of embarrassment over opening the gift and holding up the nightie in front of the startled boyfriend and Aileen's sisters pealing out gales of laughter. You couldn't *believably* recreate this same scene with the same action and expressions.

You have to be ready with your camera and shoot at the decisive moment —and, admittedly, be a little lucky.

Holidays

HALLOWEEN

"Ghoulies and Ghosties and Long-leggety Beasties and Things That Go Bump in the Night . . ."

Once a year "let's pretend" takes over, and little bodies can become anything they dare to. Witches, goblins, white-sheeted ghosts, scarecrows, and comic characters all come to life. It's "trick-or-treat night," when we all respond to repeated rings of the doorbell to be confronted with these diminutive monsters and their bags of loot, demanding even more.

But what's in it for you?

Would you settle for memorable fun?

What's the best way to make it the *most* fun and *really* memorable? You know, sometimes when it comes to picturing *the times of your life* you have to be unselfish and think of the other guy. It's the "more-rewarding-to-give-than-to-receive" philosophy. Here's what happened to us.

Just before last Halloween, we were out buying the usual candy for the trick-or-treat crowd when *the idea* struck. Why not take an *instant* picture of those lovable mini-demons and give it to them as their special treat—not forgetting the edible goodies, of course.

So when the doorbell began its clamor, we were ready. Pictures? Oh boy! Wide-eyed wonderment shone from beneath the masks. And the parents who drove the tiniest goblins from door to door were profuse in their gratitude for the instant prints.

You know, we always thought that picture-taking was an essentially selfish thing. You took pictures primarily for yourself to see and to treasure. Others could glimpse, of course, but that was it.

But we gave all the groups of Halloweeners an instant picture, which was carried off while it was still developing. How did the goblins and ghosts and monsters feel about their instant souvenir pictures? It was the best treat in their bag!

And how did we feel about it?

Well, we haven't seen a single instant print from the evening's shooting, but we're sure they were the best pictures we have ever taken!

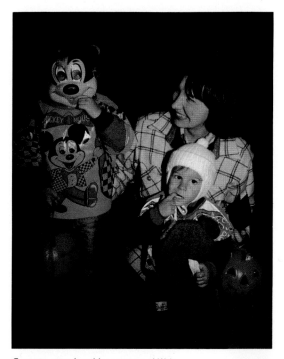

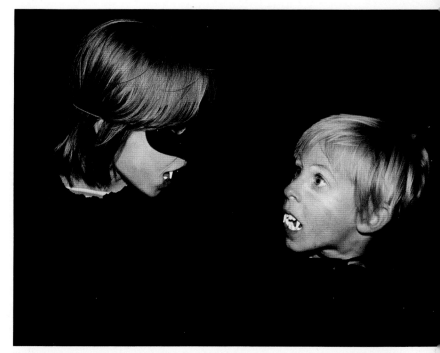

Costume reproduced by courtesy of Walt
Disney Productions, © 1980 Walt Disney
Productions.

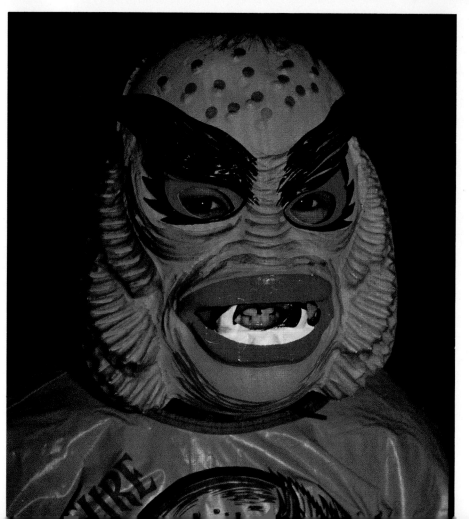

How the 35 mm Halloween Pictures Were Taken

No question about it, this photography is accomplished best with a wide-angle lens, if you have a choice. A 28 mm lens for a 35 mm camera is about right. Consider that your degree of subject control is minimal, that the costumed little folks are usually in a small group, and that you want medium-closeup shots. All this demands a fairly large depth of field in quarters that are often cramped, making you shoot at fairly close distances. Sure, a normal or even a moderately long lens would be preferable for those dramatic, tightly framed facial closeups. (You *must* show Dracula's

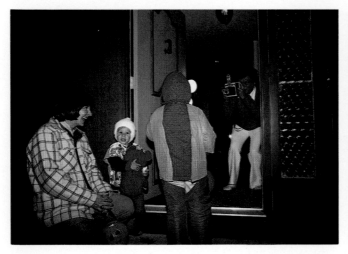 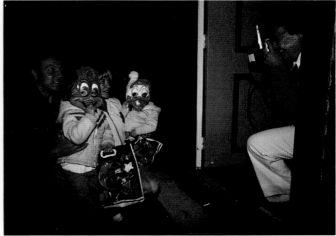

fangs!) But who's got time to change lenses at a fleeting moment like this? (And someone looking over my shoulder just shouted, "Hooray for zoom lenses!")

The situation calls for on-camera flash illumination and a few words of advice.

First, if you have any control over the group arrangement at all, put the tyke in the white ghost costume farthest from the camera and the dark-costumed figures closer. This will help the lighting distribution.

Second, don't make the common mistake of using a wide-angle lens and normal-beam flash or you'll get vignetting (normally illuminated central areas and dark corners) in your pictures. Some flash units have a wide-angle beam spreader, which is one answer to this. Another solution would be to bounce the flash off a 45-degree-angled white cardboard. You'll lose about two stops with this technique, but this is tolerable with closeups, and the card will do wonders in making the flash illumination more even.

If you were fussy about the lighting in your pictures, you might want a natural, warm-appearing room behind the home owner in the doorway. Since flash normally overpowers normal room lighting, how would you solve this problem? One method would be to place two No. 2 photofloods in cross locations where the camera from outdoors wouldn't record them. Their function would be to light the indoors in a warm, natural way as though the house lights were on. But a combination of the really bright floods would be needed, plus a fairly slow (1/30 sec.) shutter speed, to balance the exposure with the relatively intense flash illumination.

A high shutter speed, say 1/125 sec., would not allow the *relatively* weak floods to record sufficiently. And, since the duration of the flash is extremely brief, there would really be no need to use as high a shutter speed as proper synchronization permits.

In other words, it would be the job of the floods to keep the house interior looking like a normal room and not like a dark cave.

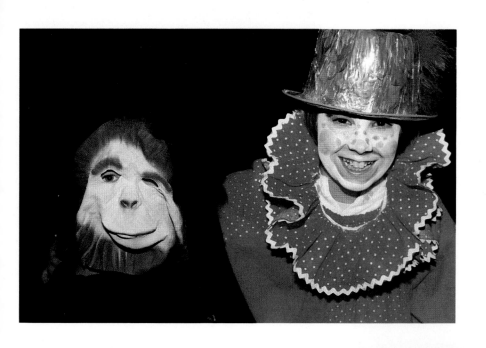

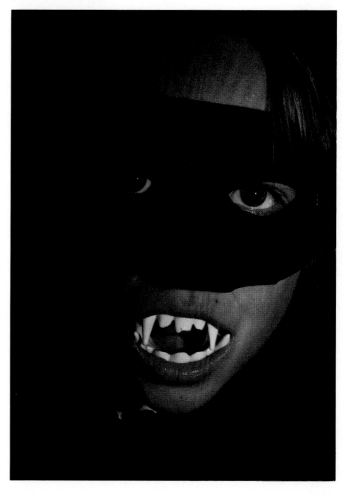

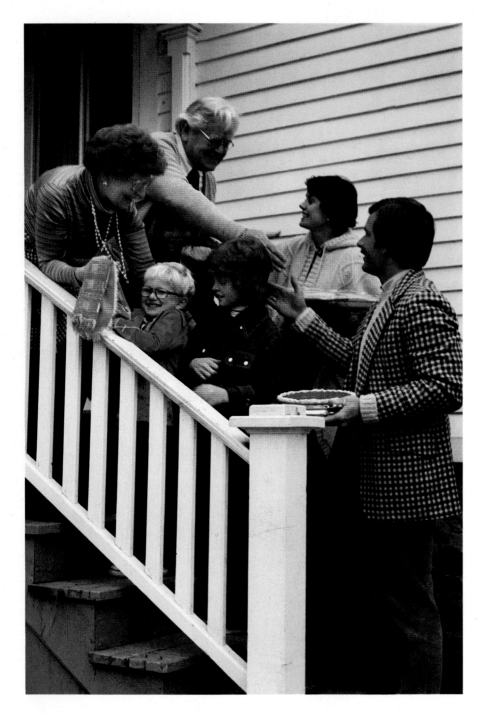

Renewing warm family relationships.

THANKSGIVING
*Pictures by Norm Kerr and
John Menihan*

Holding the new baby.

Thanksgiving Is:
Renewing warm family relationships.
Holding the new baby.
Whispering with a cousin you haven't seen for a year.
Exploring Grandma's attic and "dressing up."
Working up an appetite to polish off a big turkey.
Getting a kiss in the kitchen.
Trying the new game.
Carving the turkey at a bountiful table.
Seeing those wonderful, happy faces.
Relaxing when it's over.

In summary, Thanksgiving is being thankful for all the good things we have and remembering them with pictures.

Whispering with a cousin you haven't seen for a year.

Exploring Grandma's attic and "dressing up."

Working up an appetite to
polish off a big turkey.

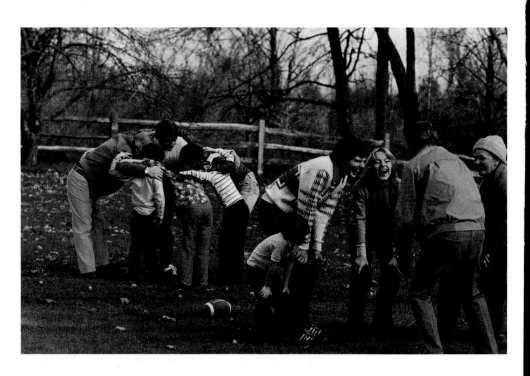

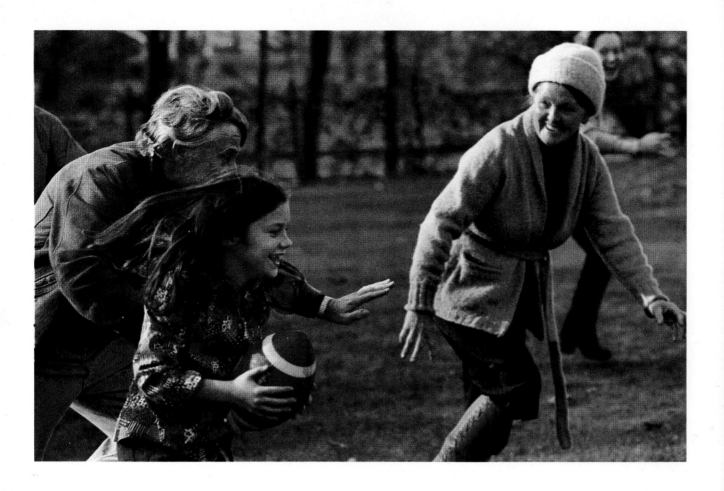

Because it is so important to take good pictures on an annual occasion like this, we want to take just a moment to tell you how to do it.

Shooting in Daylight

Outdoors it's a snap. With a hazy-bright fall day, just keep shooting when the action is right. Use a high shutter speed to stop any fast action. The barn and the attic had large windows to permit easy available-light exposures. The game was played on a screened-in porch, which is practically outside. Photographically it added up to using ASA 400 film and fast lenses.

If you're lucky enough to have a bright, sunny day, an ASA 200 or ASA 64 speed film might be adequate.

Getting a kiss in the kitchen.

Shooting Indoors

But the interior pictures are a different matter. Notice that light mirrored by the window. It was behind the camera and *supposedly* where the camera wouldn't record it. Accidents such as this sometimes happen when you're taking pictures where there's a lot of commotion and you're trying to concentrate on the foreground action. We didn't see it in the viewfinder, but oops! There it is in the print.

Why not take advantage of our mistake and learn how the indoor pictures were taken?

Yes, this is available-light photography. But the *level* of available light in the house, even during daylight hours, was so low that it really needed supplementing by three strong flood lamps. If you find you need more light than an ordinary 500-watt flood lamp will provide, you might consider using a quartz-iodine lamp. Small size, high intensity, and relatively low amperage are advantages of this type of lamp. But be careful, it has an extremely high operating temperature. A well-equipped camera shop can probably tell you more about it.

Trying the new game.

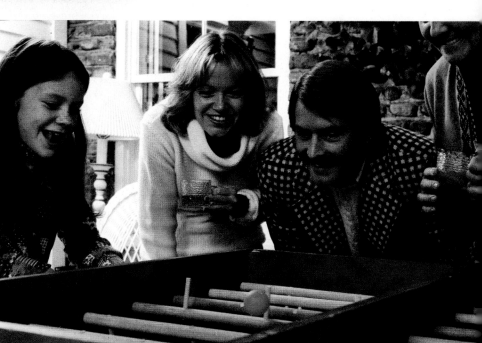

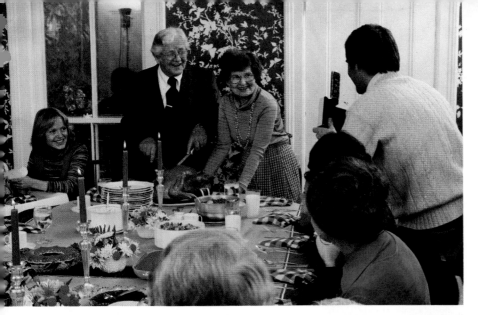

Remembering all these good things with pictures.

In almost any normal room situation the existing (ambient) light is so low that you'd have to shoot in the neighborhood of 1/5 sec. at $f/2$, even with the fastest film available. That certainly wouldn't work with a room full of active merrymakers. Wide apertures provide shallow depth of field. For indoor pictures showing subjects all at the same distance from the camera, a large aperture will provide adequate sharpness; however, if the subjects are at various distances, image sharpness will suffer. If anyone tells you they can take good living-room scenes with only the existing normal light, most likely it's a single subject seated next to a bright table lamp or standing next to a window and looking outdoors. Most certainly it's not of several people distributed at varying distances throughout the room.

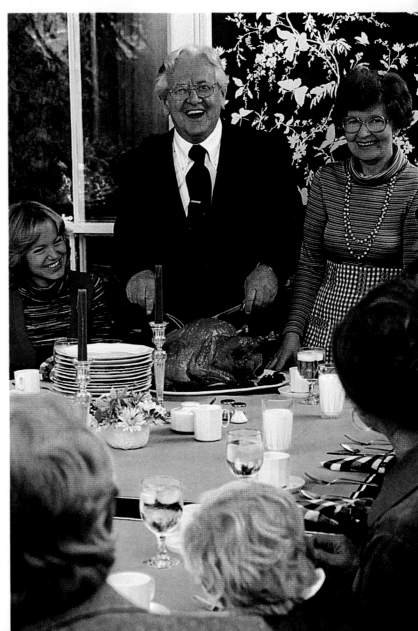

Carving the turkey at a bountiful table.

Seeing those wonderful, happy faces.

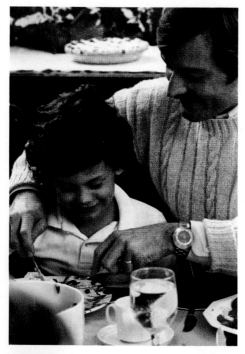

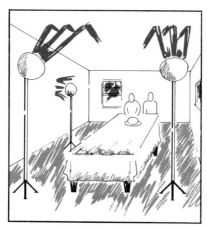

Using Floodlights

The three floodlights were strategically placed in the corners of the room where the camera wouldn't record them (we thought) and directed toward the white walls and ceiling.

These lights bring the general level of illumination up to where you can shoot at about 1/30 sec. No tripod is necessary if you're careful to squeeze off the exposures without jabbing the shutter release.

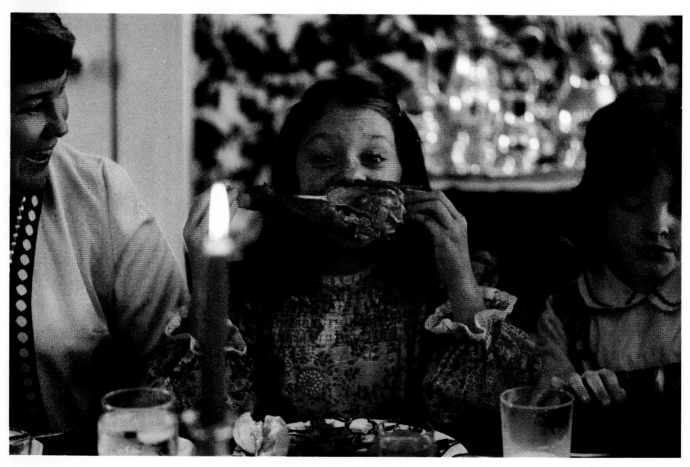

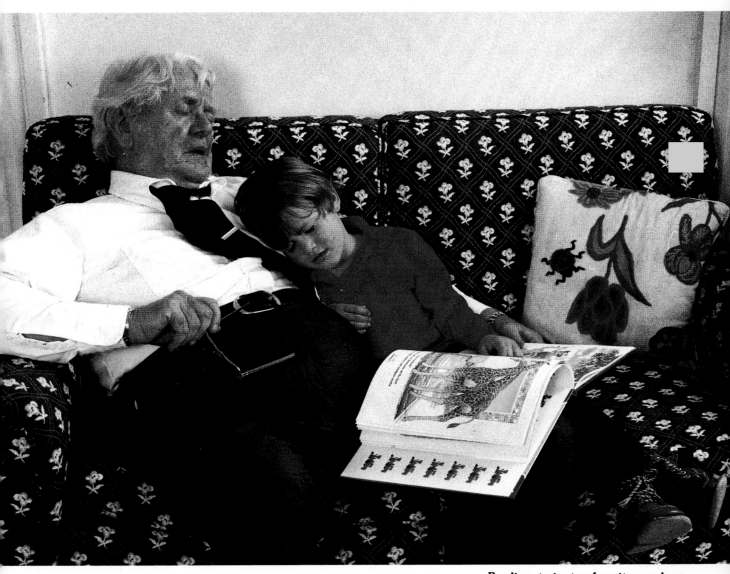

Reading stories to a favorite grandson.

You notice we said the floodlights were bounced from the *walls and ceiling.* Look at the lighting diagram. Two lights were directed toward the ceiling. The third light was aimed more at the white side wall. In bounce-light photography you don't want only ceiling light from directly above your subjects. The reason is that you'll create unwanted eye shadows. Some directional sidelighting from a wall helps this situation. Providing bounce lighting from all around is really a great way to shoot. It allows the photographer almost complete freedom of movement without the worry of overlighting any foreground people, as would have been the case with flash on the camera. Also, if you are careful about arranging the bounce illumination so that it is distributed relatively evenly around the room, the exposure will be virtually the same for any subject at any distance. You can also put a wide-angle lens on the camera without worrying about flash falloff at the corners of the pictures. Then you only have to watch for focus and the best expressions and actions before you push the shutter release.

You don't need any filter for color negative films, even with flood lamps balanced for tungsten illumination, because satisfactory color correction can be made when the negatives are printed.

111

CHRISTMAS

Christmas is not a day; it's a season. To give you an idea of just a few of the picture possibilities, we followed Tom and Chris Burns and their three children through the holidays with a camera.

The tree. It really started on a frosty mid-December morning. The kids were bundled in their snowsuits. Tom was armed with a trim saw. The family was at a tree farm and had to decide which special one of the hundreds of trees they would cut, lug out, and pack on top of the car. And we were there to record the occasion with our cameras. It made us wish also for a tape recorder to preserve the shouts and laughter and the words, "Mother, my toes are freezing!"

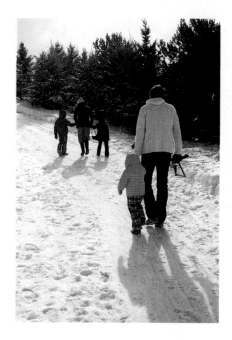

The most noteworthy comment of the morning came from a family that was just arriving as the Burnses were leaving with their tree. The wife said: "Oh, I'm so sorry we didn't bring our camera. What a good idea for pictures."

And she was so right.

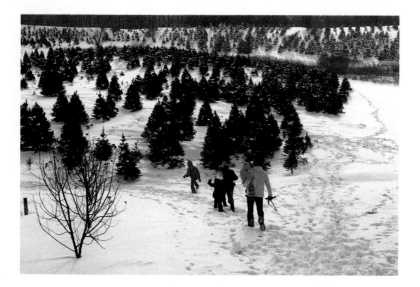

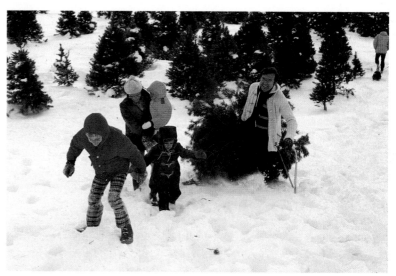

Santa Claus. It's so real for little kids. They look forward to the moment of meeting Santa Claus in the store or shopping mall. They've been rehearsing their speech for endless days. The big moment is at hand. They're actually sitting on Santa Claus's lap. "Yes, I've been good . . . and here's what I want for Christmas . . ." Shy faces, apprehensive faces, happy faces. *Camera ready?* Tom held the slave electronic flash as though he were the Statue of Liberty while I hastily made a few shots of expression variations of each of the Burns kids while the huge waiting lineup of other parents' children wished we'd hurry up. Do you know why little Kevin is crying? He's mad at Santa for not *immediately* handing over his Christmas gift request. "I want my walkie-talkie *now*!" *Camera ready?*

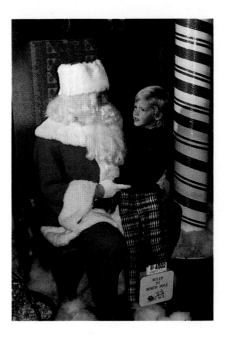

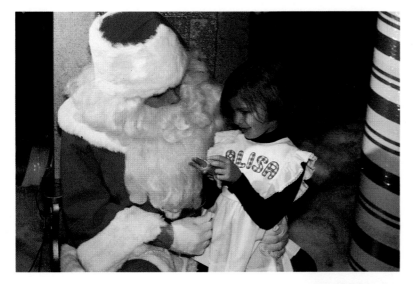

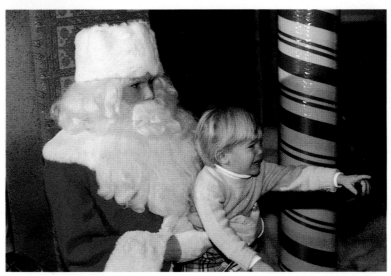

The Christmas-package moment.
Let me tell you how these pictures were taken.

Monica and I arrived at the Burnses' at 6:45 A.M. Christmas morning, ready for picture-taking. It is the custom in this family for Santa to bring the presents sometime Christmas Eve when everyone is asleep. Then when the children wake up *early* the next morning, there are all the wondrous packages under the tree. Mystery! Magic! Wide eyes! Camera!

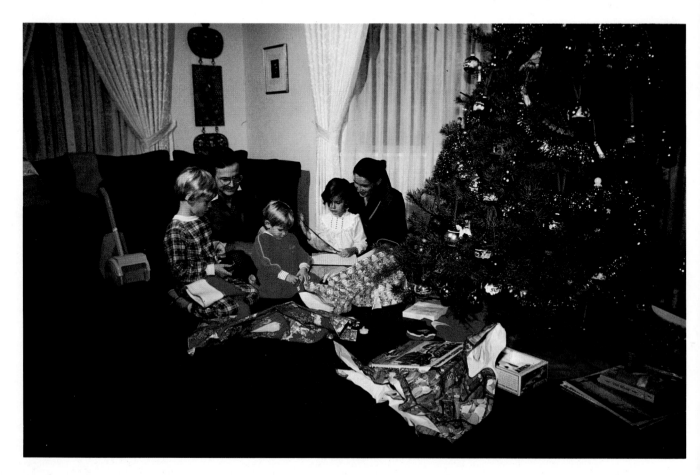

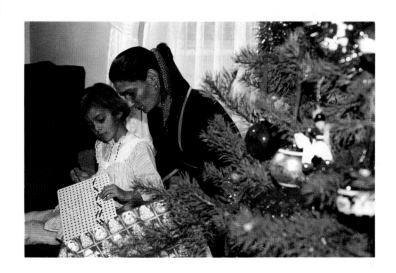

So we were ready (as you could be with your own family) when the pajama-clad tykes peeked over the stair railing to see the miracle. You may want to use flash as a convenience, but we set up three reflector photolamps on lightweight aluminum stands. Two were aimed to bounce off the white ceiling and one was tipped down to give a little directional flexibility to the lighting. Our lighting setup covered the entire living room, so that the exposure was the same for any activity near the tree. With the camera hand-held, and using exposures of 1/60 sec., the "available" light made it possible for us to capture instantly any sudden, great expression as a package was opened.

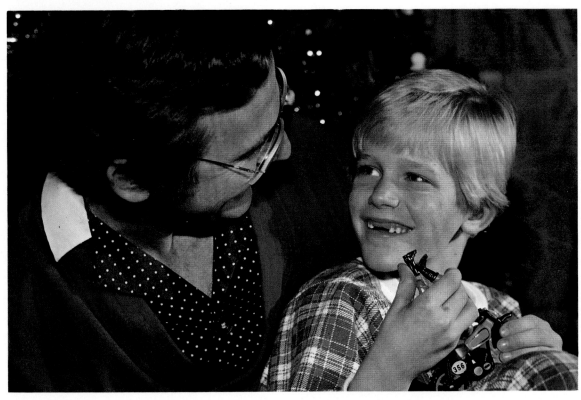

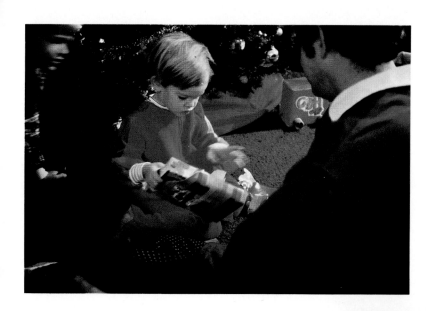

Sure we missed some shots because of last-moment moves or because we were so excited ourselves that we couldn't hold the cameras steady. But the use of extra film is nothing at a moment like this. Get the action! Get the expression! Keep shooting! You *can't* restage these moments effectively. Think of how much they are going to be worth to you *years from now.*

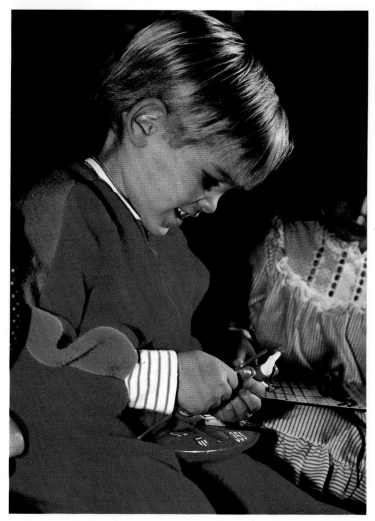

Closeups—at Christmas

How close is close? Santa Claus was about five feet away. The Christmas packages on pages 120 and 121 were about three feet from the camera. The child's hands holding the ornament were about two feet. The illuminated ornaments were taken at from 8 inches to 12 inches away. Many 35 mm cameras will focus that close without supplementary attachments. Of course there has always been a variety of inexpensive slip-on close-up lens attachments that will take care of most extra-close situations. And now there is a new generation of zoom lenses that have macrofocusing capabilities.

There's a wonderful world of diminutive subjects to explore via close-up photography. Christmastime has its share of them.

One important focusing tip for the use of single-lens reflex 35 mm camera for super closeups: For the final focusing adjustment, to ensure critical sharpness, don't turn the focusing ring: Focus by slowly *leaning* forward or backward while watching the relative image sharpness in the viewfinder.

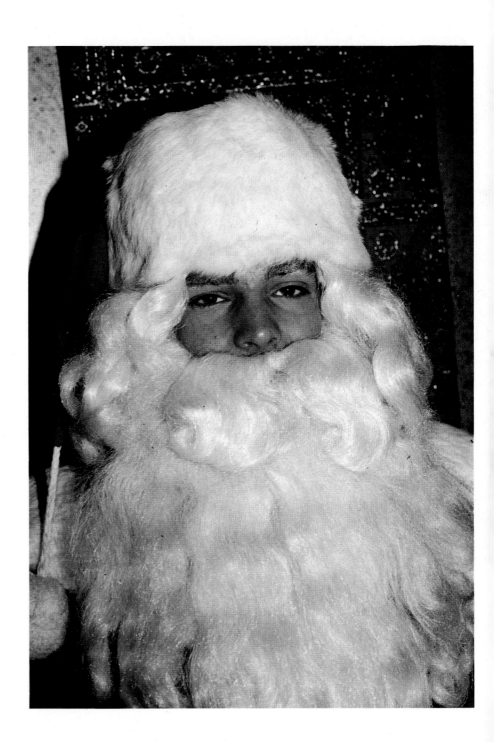

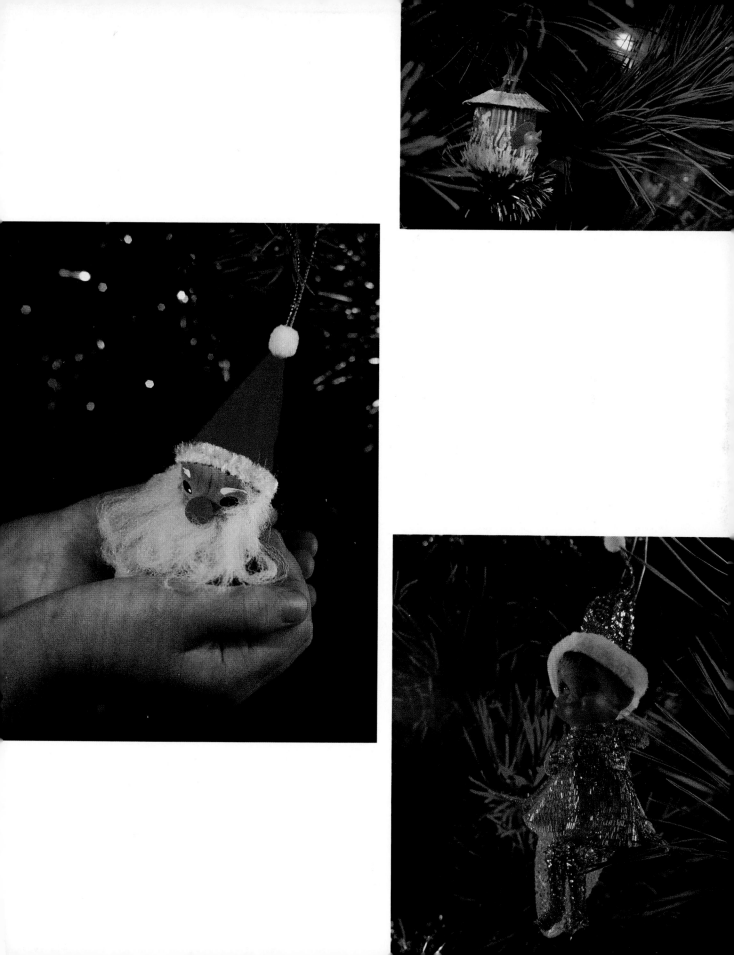

These clever packages belong to the Tom Burns family children whom you met on the previous pages: Chris, the oldest; Ali, the daughter; and Kevin, the little guy. Surely each package was worth a careful portrait treatment before little hands tore it apart. Want to know what was inside?

The robot was really a record player for all the children to share.

For Ali, the bird concealed a game. A toy vacuum cleaner was dressed as an "Ali-Cat."

120

Chris didn't recognize Long John Silver, the pirate, as his wished-for bowling bag.

Kevin wanted only a walkie-talkie. He was dismayed when Santa at the shopping mall didn't hand it to him right then and there. But surprise! It was under the tree disguised as a train.

Photographic Christmas cards.
We'd be remiss if we didn't tell you
how we feel about *photographic*
Christmas cards. They're personal, at-
tractive, welcome, unique, and usu-
ally remembered longer than a com-
mercially printed card. "They're the
only ones we keep," many friends
tell us.

The easiest way to have a picture
turned into photographic greeting
cards is to take the negative or slide to
a photo dealer or photofinisher. You
may decide on any of several
standard greetings with or without
your own handwritten or printed sig-
nature. There is something available
to fit every taste.

About the picture—don't select it,
take it! Don't hunt through a batch of
last summer's vacation shots or other
inappropriate family hobby activities.
Think up a *Christmas* idea (or at least
a holiday-season idea) and then make
a photograph especially for your card.
Don't let everybody just stare unimag-
inatively at the camera. Have them
do something interesting. Get into the
picture yourself. Use a self-timer with
the camera on a tripod, or have a
friend take the picture for you.

**Every year friends,
neighbors, and relatives
look forward to receiving a
Christmas card from the
George Butt family. That's
because the picture on it is
always taken with care and
creativity. Each year it
brings seasons greetings in
a well-lighted, colorful, dif-
ferent way. The family
seems to be enjoying a holi-
day moment that makes you
wish you could join them.**

**George uses three reflector
floods bounced off a white
ceiling. One is usually
tipped forward slightly to
lend direction and form to
the lighting. The camera is
on a tripod and loaded with
color negative film. A help-
ful neighbor makes the ex-
posure after first acting as a
temporary stand-in to allow
George to make a compo-
sitional check through the
viewfinder.**

122

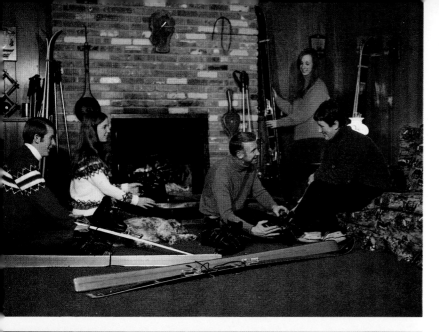

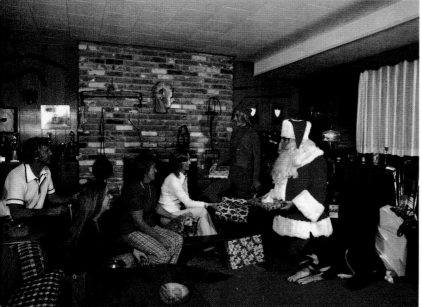

Ideas are a dime a dozen. Which of these appeal to you?

- Hanging a wreath on the door
- Gift-wrapping packages
- Cooking a turkey
- Picking out a Christmas tree
- Decorating a Christmas tree
- The family in front of the fireplace
- Snow scenes with the family
- A package-laden family at Grandma's front door
- The kids building a snowman with Santa décor
- The family singing Christmas carols
- The family in church with a stained-glass window background
- Fun with a Santa Claus suit
- The family on and around a snowmobile

Make a paste-up card by combining cutouts from photographs with cutouts from other sources. Add some red ribbon and write your message. Have this original card copied and cards printed by a photo dealer or photofinisher.

NOTE: Many of these pictures could be posed and taken at another time of year.

Finally, get an early start with this project. October isn't too soon. In fact, most photo dealers stop accepting orders for holiday photo-greeting cards at least three or four weeks before the holiday.

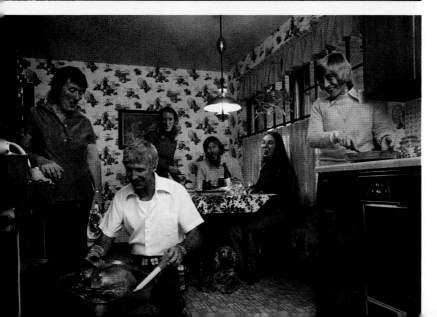

Family Events

THE ENGAGEMENT

What comes to your mind when someone says "engagement picture"? Is it the tightly cropped closeup of a girl's face such as you see in the society section of the newspaper? It's easy to take acceptable pictures like this. Just move close and make sure your subject isn't standing in harsh, contrasty, direct sunlight. A shaded area with a simple, uncluttered background is best.

However, for the priceless memory collection of a family member or friend you'll probably want to make a picture series that depicts this time of promise—that symbolizes the tenderness, joy, and love of these precious moments.

Here's how one photographer created the series that follows:

"Two of my close friends had just become engaged. They asked me if I would take some special pictures to commemorate the occasion—something a little out of the ordinary. I suggested that some lovely pictures could be taken on an outing in the woods.

"We selected a beautiful autumn day. The leaves on the maple trees had turned a striking yellow-brown hue. For their walk in the woods, I helped them select informal clothes of harmonious and muted earth-tone colors. We found an open grassy meadow that rose gently toward a background of colorful hardwood and evergreen trees. This was the setting—nature's studio!

"For this situation, closeups were not appropriate. It was very desirable to include a disproportionate area of the surroundings so as not to lose the symbolism of the moment. You might think of the couple as the compositional center of interest in a landscape. I wanted a paintinglike quality to the scene with some foreground, middle distance (where my friends were), and the forest background.

"First my eye was intrigued by the golden translucency of the leaves on a low-hanging branch of a maple tree. A carpet of fallen leaves was backed by still-green weeds and, farther back, the darker forest. Notice how I placed my friends so that he didn't block the soft, directional sidelighting on her face. A big toothy grin, or the two of them staring into the camera lens, would have spoiled everything.

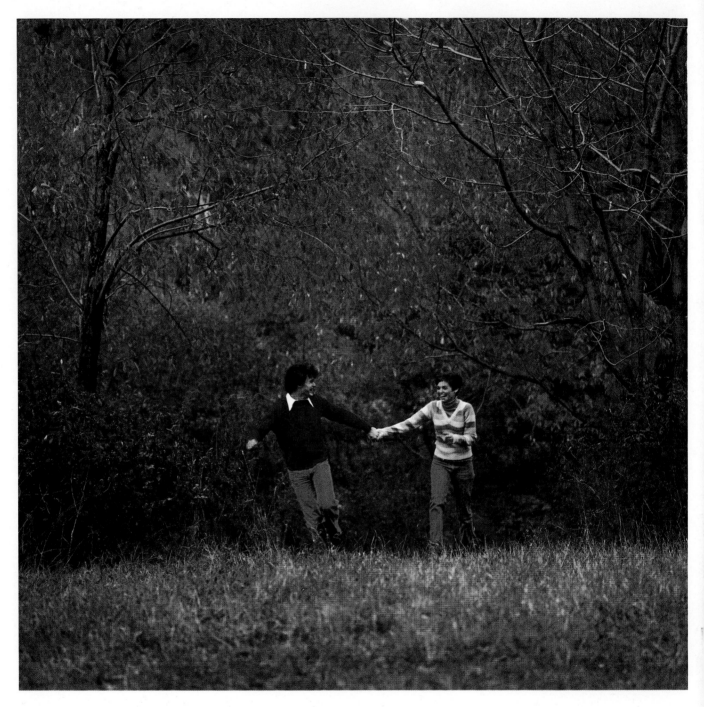

"Next I suggested that they run out of the woods hand-in-hand for another effect. I took the pictures as they reached the gap in the underbrush. The action was repeated about six times and I used a shutter speed of 1/250 sec. to freeze the movement.

The picture shown here had the best arm, leg, and body positions. Although it's a photograph they wanted to keep it doesn't just say, 'We're going to love each other forever,' does it?

126

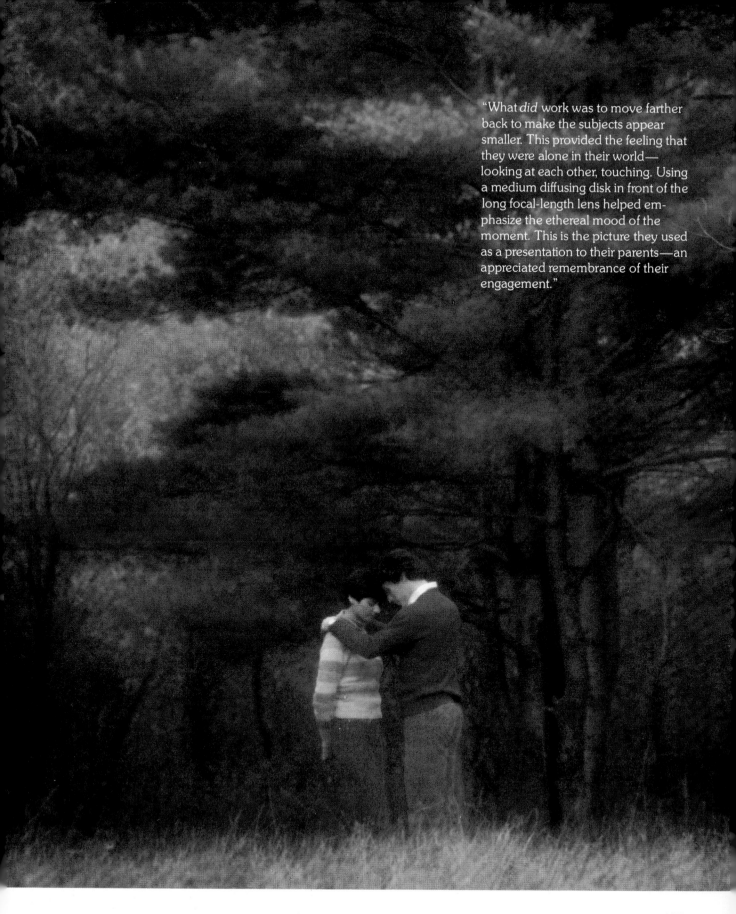

"What *did* work was to move farther back to make the subjects appear smaller. This provided the feeling that they were alone in their world—looking at each other, touching. Using a medium diffusing disk in front of the long focal-length lens helped emphasize the ethereal mood of the moment. This is the picture they used as a presentation to their parents—an appreciated remembrance of their engagement."

WEDDINGS—LARGE AND SMALL

Pictures by Don Maggio

Of all the times of one's life worth picturing, a wedding wins hands down as the situation most likely to be well documented. Most brides would probably say there could never be too many pictures. So don't miss any important moments if you're doing the candid coverage.

This rather complete list is typical of a studio specializing in weddings. Use it as a planning guide. Go over it with the bride to see what she wants. Don't be surprised if she wants everything!

Formal portraits. A series of poses to be taken at a studio or other suitable place. Bride and bridegroom with rings, candlelight, stained glass, parents, sunsets, special effects, woods (outdoor scenes), champagne glasses.

Pre-ceremony.
- Bride dressing at home or chapel
- Bride with maid-of-honor
- Bride with flowers
- Bride with veil
- Bride with garter
- Bride with wedding gifts
- Bride near window, silhouette
- Full-length portrait of bride
- Bride with attendants, flower girl
- Bride with parents
 Pinning flowers on mother
 Father holding bride's hand
 Father and mother in background
- Family at home of bride
- Portraits of parents
- Bride leaving house with father

- Invitation, with flowers (NOTE: Send copy of invitation to studio)
- Outdoor scenes with bride
- Bridegroom and best man
- Bridegroom and clergy
- Bridegroom and parents
- Bridegroom and ushers, ringbearer
- Bridegroom and rings
- Portrait of bridegroom
- Bride arriving at chapel
- Exterior of chapel
- Signing of marriage license

Ceremony.
- Processional—guests, ushers, ring-bearer, flower girl, bridesmaids, parents, grandparents, bride and father
- Ceremony sequence—closeup and overall views, multiple images
- Kiss
- Recessional—bride and bridegroom
- Posed pictures of ceremony with clergy

Group photographs.
- Bride, full length
- Bride and bridegroom, full length
- Bride and bridesmaids
- Bridegroom with ushers
- Bride and bridegroom with parents
- Bride and bridegroom with grandparents
- Bride and bridegroom with bridal party
- Bride and bridegroom with other relatives
- Bride and bridegroom with special friends
- Bride and bridegroom with clergy

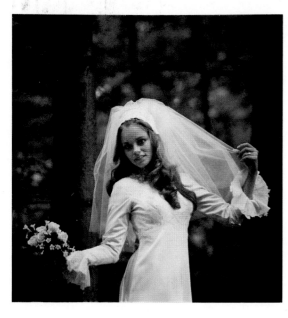

Notice that the picture was taken in the shade, not in direct sunlight. The pose is the photographer's idea, not the bride's.

Most 35mm cameras have a provision for making intentional double exposures. But these must be planned carefully, to be successful.

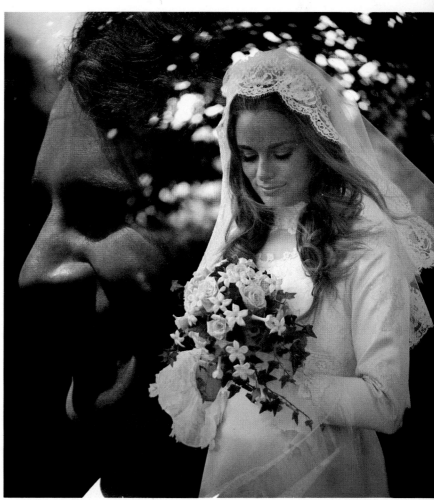

A low camera angle—actually at table level—was needed for a look underneath that wide-brimmed hat. The out-of-focus foreground? Probably better that way to concentrate attention on the face.

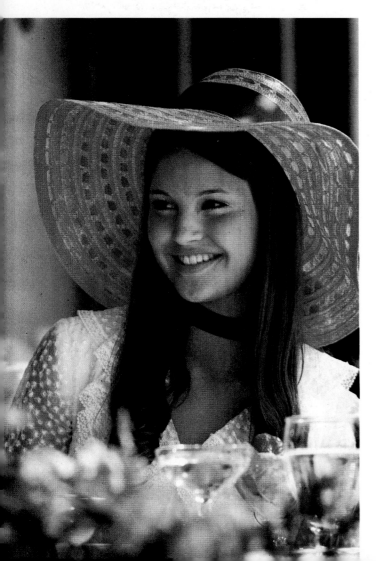

Corny, but nonetheless worth a smile in the years to come. Note that this picture was not on the idea list. Be inventive!

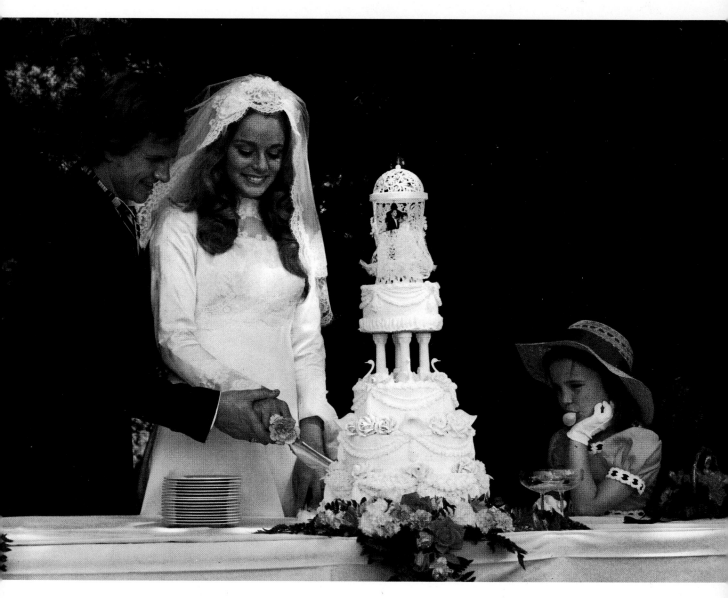

Do you think that the flower girl blowing a bubble just happened to appear when the cake was being cut? Not at all! It was the doing of an imaginative photographer.

Reception.
- Bride and bridegroom arriving (back of car)
- Greeting friends
- Grand entrance
- Sitting down to dinner
- Toasts by best man and others
- Prayer over dinner
- Cake and flowers
- Cutting cake
- Sharing first piece of cake
- Guests signing guest book; flowers, gifts, tables, decorations
- Main table and/or parents' tables
- Table photographs
- Bride and bridegroom opening gifts
- Dancing—new couple's first dance; bride with father, bride with father-in-law, bridegroom with mother, bridegroom with mother-in-law; parents, guests dancing with bride and bridegroom in foreground
- Photograph of band

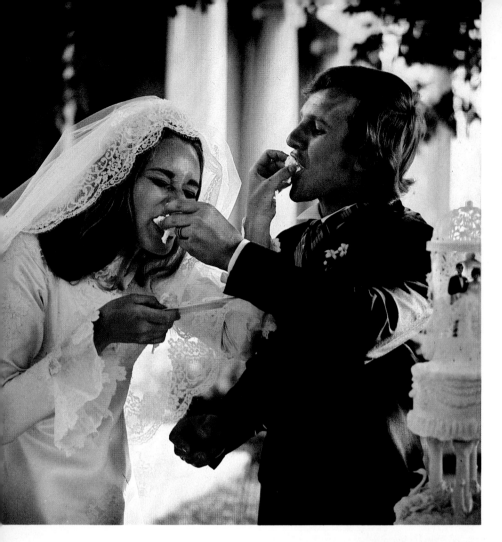

It looks like an easy shot to take, but you have to watch myriad compositional details to make it a good picture—such as staging the action in the shade, and not letting the hands obscure too much of the faces.

At a wedding reception ▶ the bride and bridegroom won't go off by themselves and automatically strike a pose like the one on the opposite page. You, as director of the picture-taking, have to suggest and control the various situations.

- Traditional folk dances
- Candids of guests and of couple
- Bride throwing bouquet
- Bridegroom taking garter off bride
- Bridegroom throwing garter
- Bride and bridegroom with friends
- Leaving reception

Be constantly alert for priceless candid opportunities like this. The out-of-focus people in the background are unimportant; the subject's action and expression are what really count.

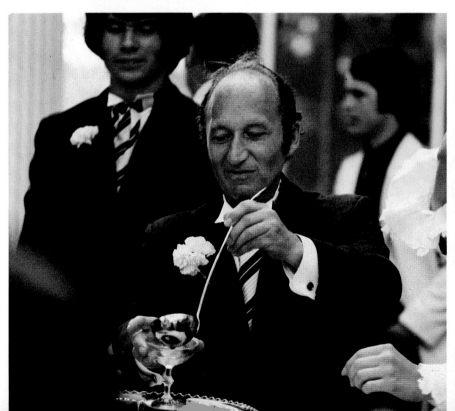

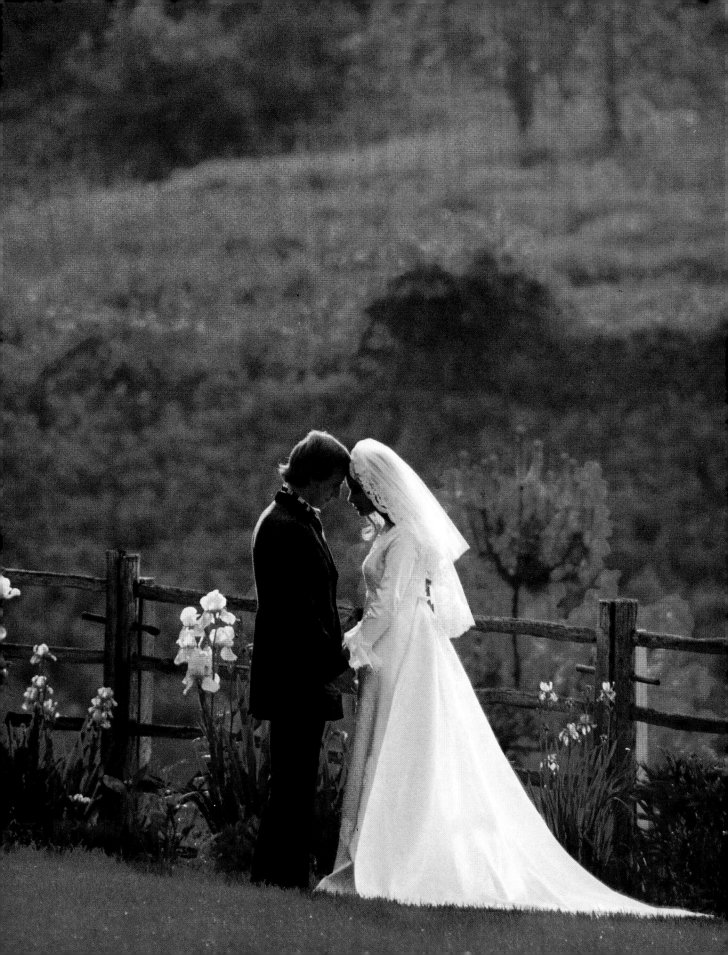

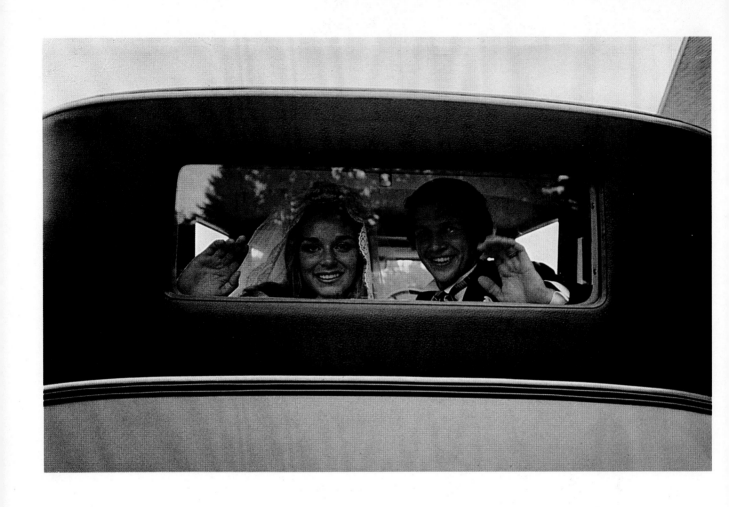

Car interiors are dimly lighted places, photographically speaking. Flash in this instance would have resulted in an objectionable reflection from the glass. The answer: *control.* Ask the couple to put their faces right up against the window where the light is while you take their picture.

134

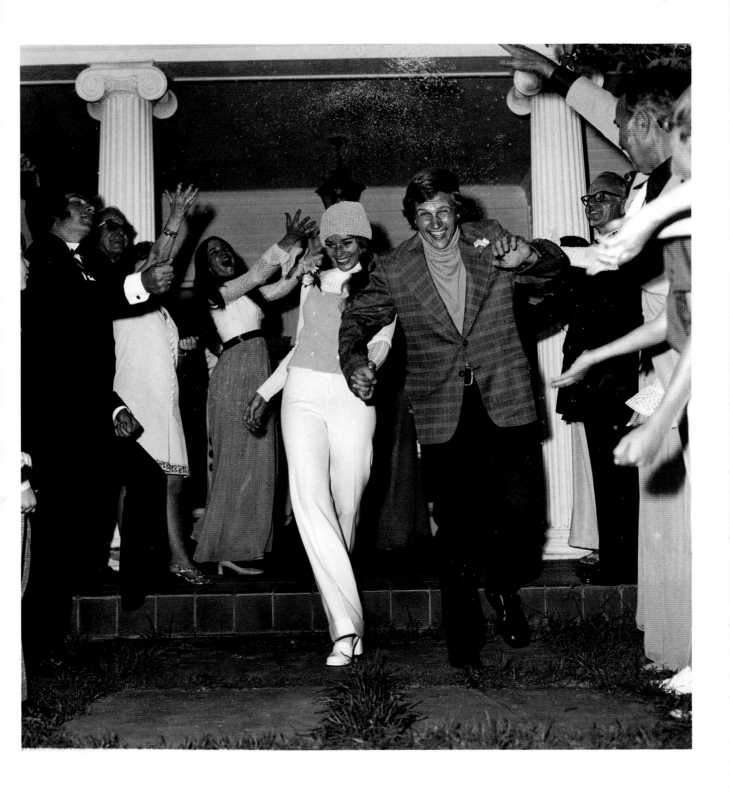

Electronic flash is the answer to stopping the action here. To provide a successful picture, the couple was asked to walk directly toward the photographer and the crowd was asked to stay back.

ANNIVERSARIES

Know what I wish? That right from the start pictures had been taken on every anniversary of my wedding day and, furthermore, that I had reserved a special snapshot album just for those pictures. Each year's little batch of pictures wouldn't have taken up more than a couple of facing pages. Captions giving dates and places, and anniversary cards would have been some of the most important inclusions.

Now put yourself into the wish. Wouldn't you agree that the more varied the anniversary situation, the more interesting the album should become? You might begin on your first anniversary with some flash pictures (taken by a neighbor) in your first apartment. The second year might be an anniversary party with some of your friends. On the next anniversary, perhaps you would be including a new member of the family. Another anniversary date might find you on a vacation trip, perhaps waltzing on the starlit terrace of a nightclub in Nairobi. It might even be a twenty-fifth anniversary dinner given by your children or friends.

Don't forget that these memorable moments are triple-star picture-taking days. What a wonderful project to spread over a lifetime!

Wouldn't you treasure an album like that? Then start now! Even if you've missed some years, it's not too late to start such an album. Insert anything you already have and take it from there.

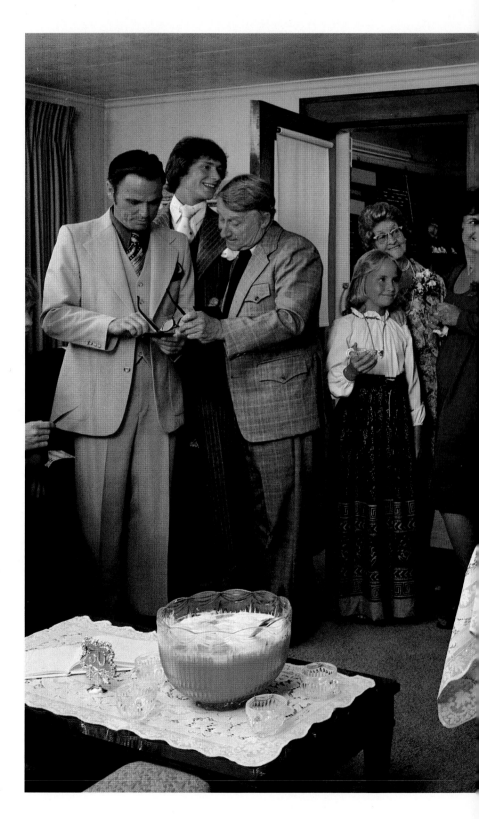

136

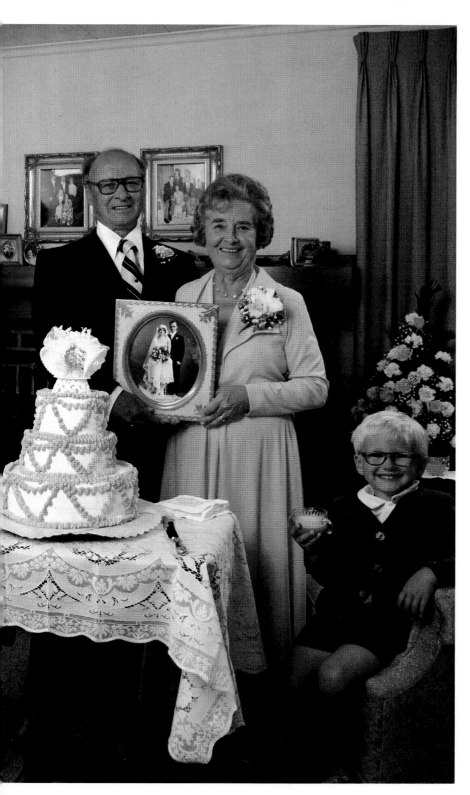

PARTIES

Parties make the world go 'round! Birthday, housewarming, anniversary, bon voyage, costume, holiday, homecoming, class reunion, Halloween, office, cocktail, engagement, graduation, shower, surprise, skating, victory celebration—people love to congregate and socialize. What fun it is afterward to look at the pictures taken on these occasions!

Almost invariably these pictures are taken with an on-camera flash. If amusing candid expressions or hammed-up poses are enough, great. You can stop reading right here.

But how discriminating a picture-taker are you? Do you really like those overexposed, washed-out foregrounds and those dark, underexposed backgrounds?

To illustrate the techniques of party flash and to show some of the errors you can make and how to avoid them, we have used a seventh-grade boy's birthday party that included a pie-eating contest! Just keep in mind that most parties represent similar photographic situations, and so the following advice applies to most of them.

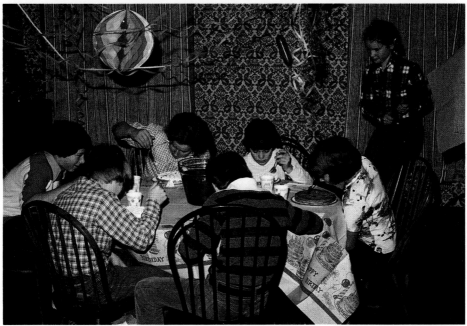

The start of the pie-eating contest was delayed slightly by taking
two versions of flash lighting: bounce above and direct flash
below. Notice the interesting differences. Each technique has its
advantages. The bounce flash has the preferable lighting—softer,
more even, without harsh shadows. However, the direct-flash
picture has more saturated colors and better depth of field (by two
stops), and the overall color rendition was not tinged with the buff
tones of the wallpaper. Which do you prefer?

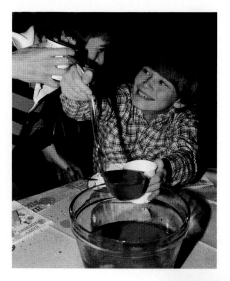

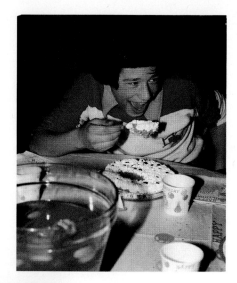

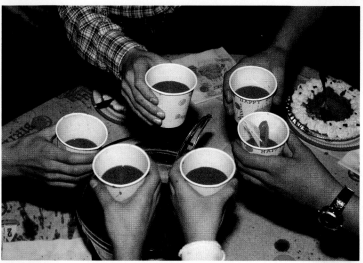

For the best party pictures you need to shoot candidly, with a degree of directed action. Sometimes you'll see an interesting or amusing interaction between people, which will happen so quickly that it's over before you have a chance to take it. Try to restage it so that the results appear unposed. Don't say "Hold it," but be ready to snap the peak moment when it happens.

Flash Techniques

At the heart of the situation is that single point source of illumination, the flash, mounted so conveniently on top of the camera. Unfortunately the nature of its output is governed by a law of physics that, simply stated, means that the intensity of the illumination diminishes much faster than you think it does as the camera-to-subject distance increases. For example, a person eight feet from you will receive only a quarter as much light from a flash as a person four feet away (instead of half as much, as you might expect). There is no way that two people can be at these distances and both be properly exposed. NO WAY! If the exposure is correct for the person near you, the one farther away will be intolerably dark; or if the farther person is exposed properly, the nearer one will be intolerably light.

You can't change that law, but there are several practical things that you, as a photographer, can do to help alleviate the situation and improve your on-camera flash pictures.

Take the case of the two subjects at four and at eight feet from the camera.

You have several alternatives:

1. Stand on a chair and shoot downward. Even if the subjects haven't moved, you have slightly equalized their relative distances from you, and every little bit helps. This gambit is especially useful for a dining-room-table shot or a roomful of people at a cocktail party, where it will also help to separate heads in the crowd.

2. Tell them to close the gap, even to stand side by side, so you have only one exposure-distance situation to deal with. It's a good answer to party groups to reduce your subject-field depth if feasible. But for the sake of naturalness avoid a police lineup arrangement. Just try to reduce the extremes of subject distances.

3. Ask one of the subjects to move out of the picture area and adjust the exposure for the exact distance of the remaining one. Then, if you wish, take a second picture of the other person, adjusting the exposure for the other distance. Of course the ideal solution would be for you to move, and then shoot from a camera position that would include only the person you want in the picture.

Let's sum up the advice thus far. You can help control a lighting/depth situation by
 a. Exercising a degree of subject control
 b. Selecting the best camera position

Closeups. It's also important to realize clearly that lighting falloff is more noticeable when you're *close to people*. Let's say that you're taking a picture of just one person. First of all, watch out especially for light-toned objects between you and your target subject—paper cups, an expanse of white tablecloth, a white wedding cake, or another guest who just happens to be at the edge of your picture area. All such objects will catch and reflect the light and become objectionably distracting, washed-out blobs of white on the print. Either move the object or the person or change the angle from which you're shooting so that you don't see the distractions in your viewfinder. Don't

Strive for variety in your party picture coverage—and don't forget the closeups.
(*Note to parents thinking of staging a pie-eating contest as part of a birthday party, reunion, scout meeting, or whatever:* Be sure to hold it in a rugless room!)

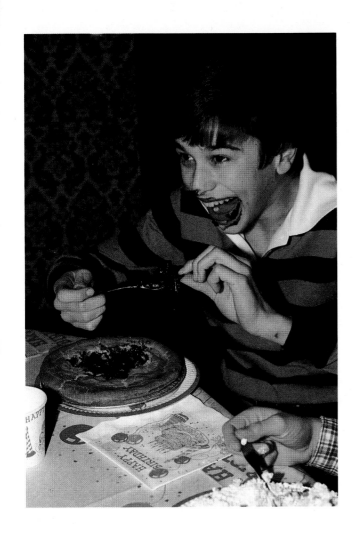

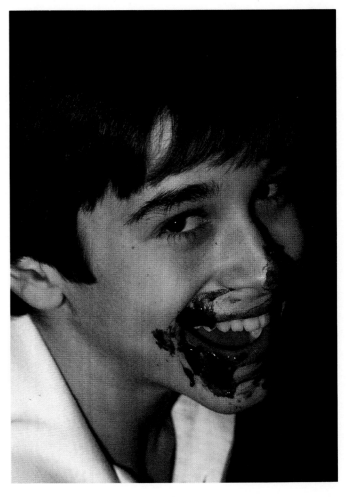

frame the target subject between two closer foreground people.

Now let's move in for a real closeup of someone. Watch out for anything that might affect the lighting distribution, such as an arm extended toward the camera. Actually, with flash on the camera, you'll get far better closeups of people from a lighting standpoint *if you move back and use a medium-telephoto lens.* Then even an extended arm won't matter.

Choice of clothing. There is still another degree of flash control at your disposal, and this concerns clothing. It may sound obvious, but light-toned clothing reflects more light back to the camera than does dark clothing. But you can cleverly utilize this principle to even out the reflected differences of groups of people. Put the girl in the white dress farther away than the girl in the dark blue dress. If you have a boy with a light tan shirt right in front of you, put a dark-colored sweater on him.

If you can control the selection of clothing that your subjects will wear, do so. Medium-toned colors will assure better results. Avoid pastel shades that are lighter than the subject's facial tones, as well as the darkest colors, such as navy, black, and cocoa brown. Solid colors are better than detailed patterns, polka dots, and stripes, which are likely to draw attention away from the subject's face.

Reflections. If you can see yourself in a reflecting surface behind your subjects, move so as to avoid being seen in the picture and also to avoid flash reflections that can obliterate a portion of the picture. Be on the alert for any background surface behind your subjects that can cause undesirable flash reflections, for example, mirrors, glass, ceramic tile, metal, and even wood paneling with a high luster. Changing the camera angle and/or subject angle so that you are shooting at about a 45-degree angle to the reflective surface will usually eliminate both reflected images and flare from the flash. In the case of windows in the background, pulling the drapes or shades will help.

Walls. A further word about walls, because they are a big part of your print-tone control. If (and admittedly it's a big "if") you can control the subject-background distance, good. If this distance is about ten feet, the average room wall will give the picture some desirable background tone and color. With the subjects standing right next to the wall, however, the flash will create a harsh, contrasty shadow, while a subject-to-wall distance of 15 feet or more will result in a very dark or black background, even if it's a white wall, because the wall will be so grossly underexposed.

Variety. Finally, for a good collection of party pictures, try for variety: take single subjects, take groups of all sizes, shoot low, shoot high, and try to include interesting expressions and decisive moments. To vary the perspective, use different focal-length lenses if you have them. Take more pictures than you think you'll need. They may not all turn out as you hope, and so you'll want a larger selection from which to choose.

There are other flash tricks in the versatile photographer's gadget bag, such as off-camera flash, bounce flash, and multiple flash, but these techniques are discussed elsewhere in this book.

The winner of the pie-
eating contest! The
prize? Another pie!

Houses and Homes

"Be it ever so humble . . ." a home should come in for its rightful share of pictures. Adding a dormer? An attached greenhouse? Moving to a different apartment? Redecorating? Renovating? Building a new house? Wouldn't you like to have a collection of before, during, and after pictures of the project—a record of your change of life-style?

We've documented two of these "moving experiences" to give you some ideas for photo coverage.

M-DAY

Off with the Old . . .

Sometimes, like when you move into a new house, you can't always take the pictures to record one of the memorable *times of your life.* You are usually too busy! But the important thing is to be sure that pictures will be taken, and that's easy to do. Ask a neighbor, Uncle Louie, or a friend. After all, you're not seeking formal portraits. The magic phrase is "Candid coverage."

Uncle Louie took some long shots that included most of the house and the moving van to establish the situation.

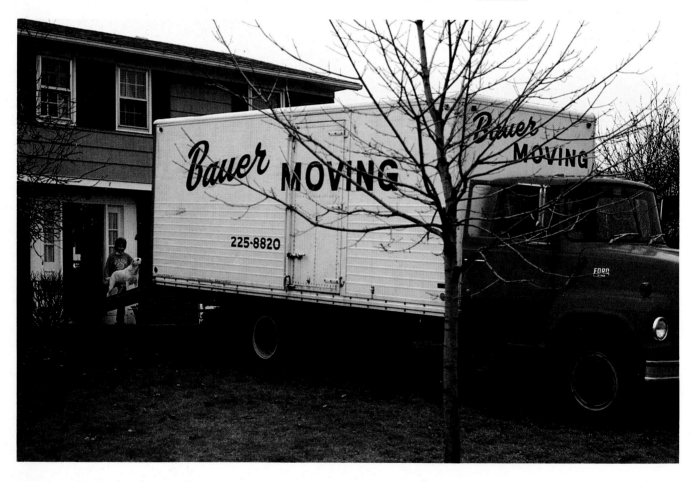

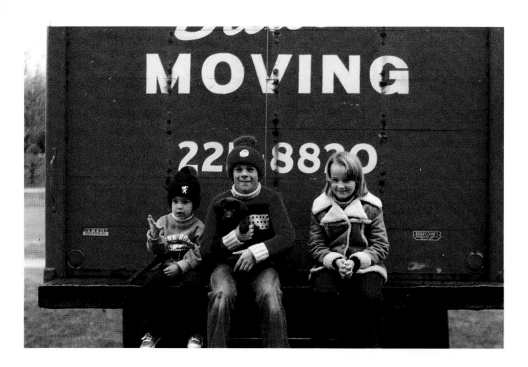

He also included closeups of the family. The word "Moving" was included intentionally to serve as a title.

Since his only responsibility was to be the recording photographer, he had time to invent and control several good picture ideas, such as Eric carrying a load of boxes up the ramp.

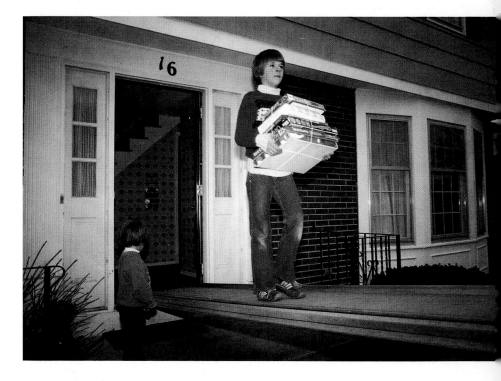

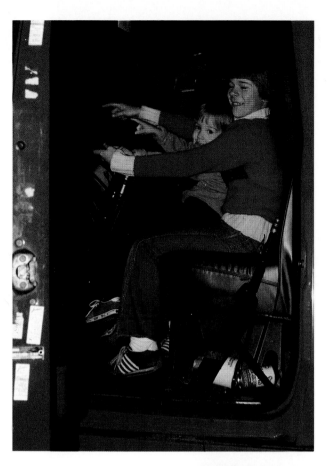

Even though this picture was taken outside, flash on the camera was used to put enough illumination into the dim truck cab.

Uncle Louie used bounce flash with a wide-angle lens to take Mom and Scott checking the boxes. He used bounce so as to avoid illumination falloff with the wide-angle lens and to produce even lighting in the room.

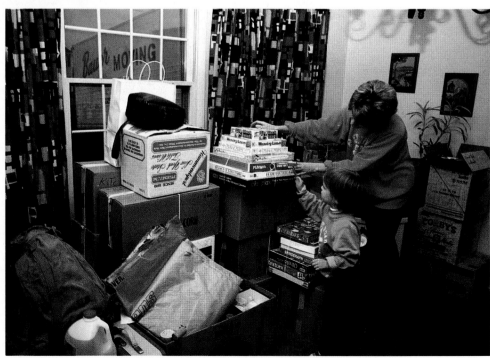

Here's that useful wide-
angle lens again, intention-
ally positioned at a low
camera angle to fill up the
wide expanse of gray sky
with the colorful truck.

"Ideas, ideas, ideas! That's what's
needed to pep up a picture se-
quence," Louie exclaimed. "I saw the
dolls and asked Karen to gather up an
armful for a colorful and interesting
shot."

So while Pop was busy directing the movers and keeping the kids and dogs from getting underfoot, and Mom was unpacking and putting things in order, who took these "M-Day at the Tundermanns" pictures? Uncle Louie, that's who!

Now Uncle wasn't a pro, but he did have a lot of good picture sense.

Thanks, Uncle Louie.

. . . on with the New

▶

"Hey," called Eric, "do you want to see my new room? It's my very own that I don't have to share with my brother." Now doesn't that situation really shout for a picture?

The move started out on a drab, drizzly afternoon. By the time everyone arrived at the new house it was dusk.

And then it got darker. But wasn't it great that the flash was available when it was needed? "Good thing I checked to make sure I had fresh batteries," declared Uncle Louie.

The dolls made it safely!

The last picture on the roll. It was night, but it was an easy thing to group the family around the new house numbers and take this final we-made-it closeup.

151

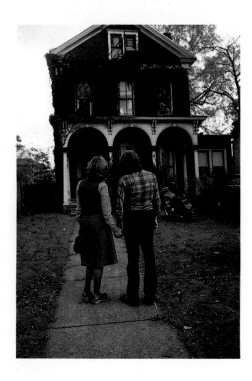

Built in 1814, this once-elegant residence was run down and needed complete renovation. Could it be saved? Time, money, imagination, hard work, and a little photographic assistance were required.

THE RENOVATION

Once upon a time (actually, 1814) an elegant brick house was built in an elegant neighborhood. And in it for more than a hundred years there lived a succession of happy families. At one time a wealthy man owned it and added a complete front wing, doubling its size. He installed three marble fireplaces, elegant egg-and-dart plaster ceiling decorations, and new parquet floors. There was a staff of servants, and a large safe beneath the front stairs.

But times changed. The plumbing rusted. The roof leaked. A landlord bought it as an investment. False ceilings of plasterboard were installed to conserve heat, and a host of "don't-care" roomers moved in and out.

Finally this once-grand old house went on the auction block and was sold for a song . . .

. . . to a creative young couple who could envision it as an exciting restoration project. Just think what fun it would be to end up with a fascinating series of before-and-after slides that could be projected in realistically large images for their friends.

The very first step in the project was the camera—and therein lies the essence of this chapter.

What is the best way to document a house interior, room by room, which in this case was done to provide the before-and-after series of pictures?

Don't Use Flash

Customarily flash is used on the camera by ninety-nine percent of picture-takers. However, the light falloff from a single on-camera flash is undesirable in architectural photography: Near objects will be overexposed if far ones are correctly exposed, and far objects will be underexposed if near ones are correctly exposed. Furthermore, on-camera flash is formless lighting: It flattens everything, and you won't have any interesting shadows, textures, or form to the subjects. There are better ways to tackle interior architectural pictures.

Multiple flash may be a partial answer for experts, but exposure calculation is tricky and it's almost impossible to pre-evaluate the exact lighting effects of the almost-instantaneous flash illumination.

Further, with single-lens reflex cameras (as most 35 mm cameras are today) you can't see bad reflections at the critical moment of actual exposure because the viewfinder image is blocked. Everyone knows that you shouldn't take flash pictures directly into a mirror. But are you *absolutely*

They're the auction winners! It's theirs! Actually, not too many people wanted the old wreck of a house that looked like a bottomless money pit. So with the price little more than a song, the renovation begins.

The attic leaked like a sieve during rainstorms, so first the roof was replaced. Insulation was followed by new wiring, new plumbing, and a new heating system.

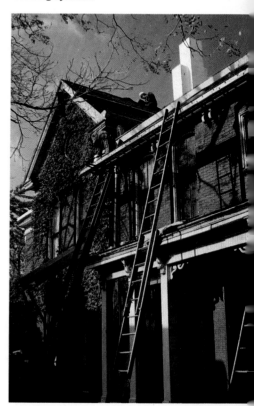

sure you haven't picked up some undesirable reflections from a varnished door or glossy wood paneling? No, you can't be sure; so don't use flash on the camera if you can help it.

Available Light
What about shooting room interiors with available light—with just daylight coming in through the windows? (There are some available-light diehards who won't shoot anything any other way, and we especially want them to read this *very* carefully!) Available light is fine *if* you don't include *any part* of the window in your picture area. The reason is that there is a *tremendous* range of brightness between the window and the room walls next to it. You could never encompass these two extremes with color film even if you split the difference in exposure. Expose for the walls and fur-

nishings and let the windows burn up, you say? Well, if you believe that, probably either you've never tried it or you don't know a good photograph when you *see* it, because the burned-up window effect will be intolerable. You won't be able to see any window detail at all—sash, curtains, leaded panes—and usually the window light flares past its outlines into the wall area and spoils the shot. This scattering effect from the light's bouncing off silver grains in the film emulsion and striking neighboring grains is called irradiation.
It isn't just a matter of getting the exposure right. Chances are that if the lighting *distribution* isn't the way you normally find it you'll have to do something about it.

Picture-Taking Techniques
That something may seem a little

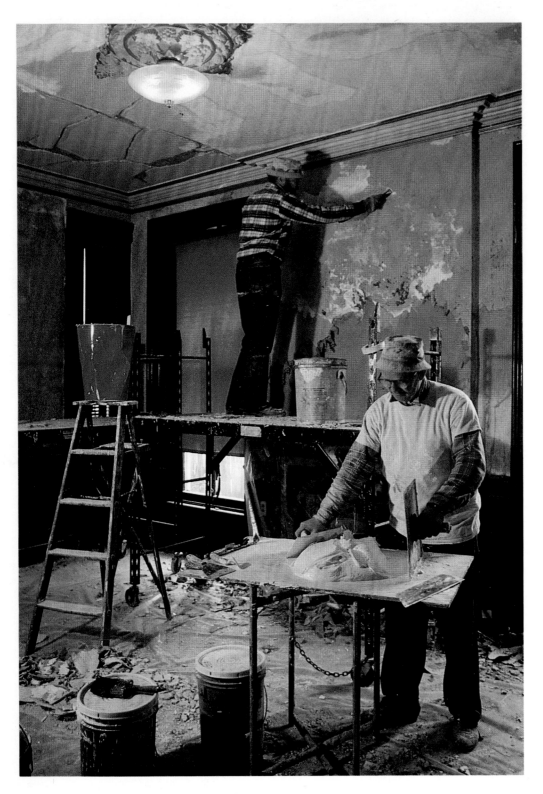

With the basics completed, the fun part began—restoring the interior creatively. Part of the design-refurbishing process was to photograph each room as it looked *before* renovation, with its false plasterboard ceilings and garish color schemes. Beautiful but ruined rococo plasterwork is being restored here.

See that battered floodlight reflector? It's one of a pair housing 500-watt blue flood lamps used to direct light back into shadow areas and, in general, to equalize the strong bluish daylight coming from the windows. A CC40 yellow filter was used over the camera lens to help the general color balance of the slides because blue flood lamps aren't quite as blue as the daylight for which daylight color film is balanced.

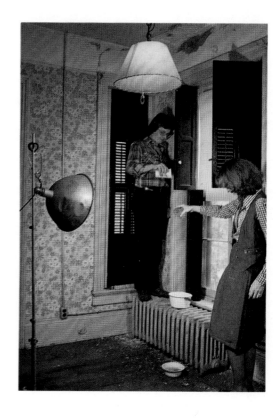

strange to snapshooters or to available-light enthusiasts, but here's the way to do it correctly: Roll up your sleeves (you're going to have to work a little harder than you thought) and roll back a decade or two in your mind, because we think you should take these architectural interiors with a combination of daylight and good old-fashioned *blue floodlights!*

List what you'll need.
- A versatile camera—one on which you can set the shutter speeds and lens aperture, and which has a tripod socket and a shutter release that can be actuated with a cable release. The lens does not have to be fast because you should be working at medium to small apertures. It will help if you can change lenses. We'll talk more about wide-angle photography in a moment.

- A sturdy tripod.
- A cable release 8-12 inches long.
- Daylight color film.
- Two clamp-on reflectors outfitted with blue flood lamps, such as No. 2B (EBW) photofloods. The reflectors can be the very inexpensive clamp-on trouble lights or chaser lights found in most electrical supply stores.
- Enough heavy-duty extension cords (two 50-footers should do it) so that you can run each light from a separate circuit outlet and thus reduce the possibility of blowing a fuse.
- Two lightweight collapsible aluminum stands (available from most camera stores) on which to clamp your lights. If you don't have these stands, clamp the lights to an open door, wall hook, ceiling fixture, closet bar, chair back—or bring two friends who'll make like

the Statue of Liberty.
- A CC40B (blue) color-compensating filter. Blue flood lamps, used alone, are not as blue as blue flash, electronic flash, or daylight; so they'll need some help from your CC40B filter. Use it over the lens for all such pictures (with either color reversal or color negative film) or your shots will have a yellowish hue. If you do shoot without it, correctable duplicate transparencies or paper prints can be made, but with extra time and expense.

Now you must determine (1) what to shoot, (2) what angle to shoot it from, (3) how to improve or rearrange the elements within the scene to make it more colorful or interesting, (4) where to place your lights, and (5) how to determine your exposure. Let's discuss these individually.

155

Someone once thought Christmas red and green colors would be charming for the entrance hallway and stairs. And a black newel post?

1. What to shoot. Don't dismiss this question lightly with an "Of course every room in the house, because that's what my insurance agent (decorator? architect? heating contractor? spouse?) wants." Every room has its features—its best viewing position, its most interesting architectural details, or a creative decor. Perhaps you'd like to plan, take, and show your house interior shots as you might a tour. It will give your house slide show a structure as you lead your audience down this hall—"See that door on your right? Well, inside is our charming library . . ."

If you want a slide show that moves (and all good slide shows should) why not intersperse a few extreme closeups of fingers pointing at a floor plan so that your audience can orient themselves better as to where you're leading them. "You see, according to the blueprint, we're now here in the foyer, which really looks like this . . ."

We mentioned closeups. All houses —old, new, large, small, brick, frame, or log—have dozens of possibilities for closeup pictures. Antique doorbells, pillar details, interesting hardware, stenciled walls, intricate plasterwork, construction details, and so on, should be photographed.

Note that we said "should", not "could." Closeup pictures are interesting per se, since your audience wouldn't notice details if you didn't think to picture them thus. But, more than this, they will provide a meaningful *variety* to a "This is the living room; this is the dining room; this is the kitchen" long-shot recital. Closeups will spice up your show.

2. What angle to shoot from. Here we're thinking mostly of wide-angle photography. The professional photographers who do the gorgeous illustrations for the homemaking magazines use large and fantastically

versatile view cameras. These cameras have rising and falling, swinging and tilting lens boards, plus swinging and tilting backs. The main purpose of this fantastic versatility is to get everything sharply in focus and, despite camera angle, to keep the back plane of the camera (with the sheet of film) *exactly vertical.* If the camera back is inclined *ever* so slightly, toward a doorway, for example, the sides of that doorway will converge in the picture like a carpenter's nightmare.

So take a tip from the pros and try to keep the camera back exactly vertical to prevent divergence or convergence of parallel lines. This is especially important with wide-angle lenses; and the shorter the focal length, the more advisable it becomes. You'll find that you'll be continually adjusting the height of your tripod so as not to fall into this trap of perspective distortion.

156

At last—an entranceway color scheme that doesn't overwhelm you as you come in. Notice the lighting fixture changes, the absence of the radiator, and the natural finish of the stair railing. In addition, two doorways have been removed.

157

Clutter, clutter everywhere, but perse-
verence has won. The *before* pictures,
together with room dimensions and
innovative decorating ideas, made it
possible to order furnishings long before
the refurbishing was completed.

The turn-of-the-century black marble
fireplace set the décor theme of the den,
where a mixture of antique and modern
seem to fit. Of course it was the photog-
rapher who placed the geraniums in the
left foreground as part of the *after*
picture.

3. How to rearrange the elements to make the scene more colorful or interesting.

Almost any room can be arranged to improve picture composition. The secret is to consider *every* reasonable possibility; for example, whether to shift the furniture, fill the bookcase, put an art object on the mantel, add a vase of flowers, light a fire in the fireplace, or rearrange the magazines on the coffee table. And this is just the beginning. Next straighten the towels, and the pictures on the wall, adjust the drapes, pick up any forgotten toys, close the cupboards, and tidy the clutter. Now add the people and pets, but do it logically and naturally: Dad in the workshop, Mom in the kitchen, the dog looking out the window, Junior in his room doing homework, Sister wearing earphones and listening to music. *Seldom should you have anyone looking at the camera!* They aren't having their portraits taken—

you're too far away for that—but are only incidental figures to the room scene, adding interest or color. Remember, this time it's the *room interior* that is important. You don't have to include a person in every room; just spread them around within the sequence to add variety to the picture coverage.

Here's an important principle of composition for improving architectural interiors: *Try to have every area of the picture "working" for you.* Watch for those uninteresting empty spaces and ask yourself what you can do to improve them. For example, a common mistake would be to include a large expanse of empty floor in the foreground. Don't do it. Instead, add a colorful throw rug if it's appropriate. Set up a card table with a chess game

or a jigsaw puzzle in progress as a space-filler foreground object.

You might select a camera viewpoint in which the principal room is framed through an arched doorway, or one in which a flower arrangement helps to fill that expanse of emptiness.

Ideally this is wide-angle photography. You should be working in the middle aperture range (and at fairly slow shutter speeds) where you'll have a tremendous depth of field; so you should have no trouble in rendering both a nearby foreground object and the farthest wall in sharp focus. In fact, it may help engender interesting room-arrangement ideas if you think of your wide-angle lens not only as being able to include a wide subject area but also as providing an aid to sharp focusing of foreground objects.

When the plaster was removed from this wall, a brick fireplace was found underneath. A print of this scene was sent immediately to the design consultant for advice on whether to keep it or cover it again.

"By all means keep it! Even if it isn't functional, it's a tremendous design adjunct," the consultant replied. Compare the floors in the two scenes. It's the same floor, only refinished in the second picture.

Upstairs, in what must have been a bedroom, was this classic white marble fireplace. A small flood lamp was put into the standard floor lamp, which then became part of the scene. The red wastebasket was placed on the mantel to add a spot of needed color.

This room became an upstairs office-den. All the *before* pictures were taken with a 28 mm wide-angle lens and all the *after* pictures with a 21 mm extra-wide-angle lens. The wider view seemed more appropriate for the *after* shots, in which there were simply more interesting subject areas to look at.

4. Where to place your lights.

First remember that the function of your blue floodlights is to help equalize the tremendous brightness range of the windows versus the room interiors. Just turn on both floods and the problem will be half solved. Use them *above* the camera height, so that pictures and table lamps won't have strange shadows over them. Keep strong illumination off the objects nearest the camera. Don't burn up (overilluminate) a light-toned foreground chair, for example. Check to be sure that the walls are lit evenly, because this is the way you think of rooms as being illuminated. It would be wrong to place the flood lamps at either side of the camera and aim

them straight ahead to try to provide an even flood of illumination because it just won't happen that way. The walls nearest you would be unnaturally bright with this lighting setup. Instead use them for crosslighting, in which the flood at your left illuminates the wall at your right and the flood at the right side of the camera lights up the wall to the left.

A good lighting trick when the next room is included in the scene is to use one light high and above the camera as a general foreground light and to hide the second light around the corner in the far room to provide a similar level of light there.

Watch out for windows that are too

bright. Even with two floods you can never compete with brilliant direct sunlight streaming through a window and splashing onto a rug or wall. Eliminate that window from your scene, draw the drapes or the shade, or, better yet, take the picture at a different time of day when the sun has moved away from that side of the house or is under a cloud.

Yes, turn on the shaded floor lamps and table lamps and include them as a part of your arrangement. Pay no attention to the cries of armchair photographers who might object that you are now mixing light sources in your pictures. It's just that they haven't tried it and don't appreciate the unusually

A downstairs parlor contained the third marble fireplace in the house. All these pictures were taken with blue floodlights for fill-in and with the camera on a tripod. The exposure averaged 1/5 sec. at *f*/11 with ASA 400 slide film.

And it became this lovely parlor with glass-topped tables and oriental rugs. The manikin on the mantel? His name is Oscar. Sometimes he sits in a chair reading a newspaper, sometimes he slides down the banister.

beautiful golden glow that a tungsten table lamp can provide to a scene that is lighted overall with bluish floodlights as well as being recorded on bluish-balanced, daylight-type color film. The ordinary tungsten household bulb in a shade should register with just about the right amount of desirable yellowishness, so turn them on and don't worry about theoretical imbalances.

By the way, if you used the flash in the normal way, an illuminated tungsten lamp and its shade would never record—and you'd miss this intriguing two-tone lighting effect.

5. How to determine your exposure. Easy. Just go by your camera's exposure meter and shoot. Remember to set your camera at a small lens aperture in order to get everything as sharp as possible. This means that your shutter speeds will be slow, in the 1/2 sec. to 1/8 sec. range, depending on the speed of the film you are using. When you've gone to this much trouble to take an excellent picture, you might want to *bracket* the exposure for your slides. So take three—the estimated normal, one stop lower, and one stop higher. One of the exposures will be better than the other two. Even the most experienced professionals cannot determine beforehand which one it will be. They bracket their exposures as a matter of course.

Were the before-and-after pictures worth all the time and effort in the taking? Well, in the case shown here the slides provided entertainment for an open house at the completion of the project, and prints were used for progress reports to distant friends and relatives. A very practical application came, too, in supplying the contractor with a complete set of *before* prints. He pinned them to a bulletin board in his office, identified each room, and labeled the walls North, South, East, and West. This way he had a ready, accurate reference whenever the owners called to discuss modifications, and potential costly errors were avoided.

Here's a pictorial idea for photographing rooms with a separating arch or doorway. Hide your blue floods in the farther room. Now have a friend lean against the entrance to provide an interesting foreground silhouette.

Yes, the same lighting technique of hiding one of the floodlights in the far room is also appropriate for this *after* picture. The fantastic depth of field results from stopping down the extra-wide-angle lens to *f*/11.

The photographic trick here, with regard to this bay window, was to pull down the shades until they just cut out the bright sky area. Note that they are pulled down to different levels to add compositional interest.

With shades gone, the lighting balance between the outside and the inside was solved by adding more blue floodlighting to the interior. Remember, especially when using wide-angle lenses, to keep the camera absolutely vertical to avoid convergence of the vertical lines of the subject.

Old family movies are a gold mine for Ira. "I not only enjoy reminiscing while I'm editing," he says, "I also like the creative aspect of arranging the scenes into interesting sequences."

It's Movies for Me

Meet Ira and Ellen Current, who are without doubt two of the world's most enthusiastic amateur moviemakers. Ira started making movies only six years after amateur moviemaking equipment came on the market. Now, more than fifty years later, he and Ellen are still producing their annual family film, *Current Events*.

We taped a conversation with Ira, who had these interesting thoughts to pass along to prospective moviemakers. The following paragraphs are his actual words, as transcribed from the tape.

"Yes, during the period I've been making movies I've accumulated thousands of feet of film—mostly family things—that I haven't thrown away. What I like to do is to go looking through the movies because they're a gold mine. There are so many scenes which I didn't attach much significance to at the time. But as I look at them in later years, I realize that they're more interesting than ever. It's very hard to establish, at the time you're taking pictures, how they're going to impress you in five, ten, or more years.

"You see, the scenes recreate things you have forgotten. It's a thrilling rediscovery process. Why, I've known lots of people who have shot movies and stuck them on the shelf and forgotten all about them. But I daresay that if these people would go back and look through their movies, they would be very surprised at what they see.

"For example, my sisters and brothers used to do all kinds of crazy clowning for the movies, and at the time I felt there was nothing worthwhile in such scenes, that it would be better to throw them away. But I didn't throw

The Currents' basement has strict humidity control to help assure archival storage conditions for their 50-year collection of more than 100,000 feet of film.

them out, and when I dug up the scenes years later they had a kind of entertainment that I didn't see in them originally.

"The same is true of many old friends, buildings, and railroads. Perhaps the movie footage I have isn't always the greatest, but it serves to bring back memories of the many people, places, and things that are gone or changed —and I'm happy that I took the movies.

"Mostly I take family stuff. One of my current objectives is to edit the old footage so that each of our four children is starred in a roll of film. That is, we'll be able to see each one grow up in a single movie. I'll do the editing, have each reel reduced to super-8 size (because that's the format of the modern projectors all our grown-up children have now), and give them the films as Christmas presents.

"I take still pictures, too, but mostly I make movies. It's hard to do justice to more than one camera at a time; so let me tell you why I like movies the most. I think movies are more

dynamic, more entertaining to see. You'll find that company would rather see movies—just don't make it too long a show. I even think that children behave better for movies than for stills. The movie results look less posed, more natural, and that's how you really want them to look.

"Movies or stills? You just have to ask yourself if you'd rather have the motion—that's what it comes down to.

"But, really, it's more than motion. You can tell stories, and you can present things much more dramatically with movies than you can with still pictures. In movies you can create interest, suspense, and much more. For example, take Thanksgiving when the turkey is being taken out of the roasting pan. It's usually stuck a little bit on the bottom. The problem is lifting it out without dropping it, and in our movies you don't know for a while whether or not the turkey is going to make it safely. You never could create the same type of suspense with stills.

"Family events can be told from be-

ginning to end very nicely in movies. But add careful editing to this general coverage, and you can greatly improve what I call the "fluid aspects" of the movie. For instance, you can show the response of individuals to each other or their response to what's going on, and that helps to retain good audience interest during the screenings.

"Our children are all adults now, but they come home on occasion. Every time we get together we have several lengthy sessions just looking at movies that they haven't seen in some time or perhaps not at all. We may have taken them and not projected them—at least not that they remember. So I dig out some oldies but goodies and my grown-up children become hysterical laughing at seeing themselves as they were long ago.

"You know, these old films are such an important part of our lives that Ellen and I have agreed that if the house should catch fire, one of the first things we'd try to save would be our movies."

Other Occasions

SPORTS

Is there a Little Leaguer in your family? A cheerleader? golfer? swimmer? sailor? racer? football player? Anyone for tennis?

Sports activities surely are an important time of your life, and they can provide great picture-taking opportunities. But don't overlook the fact that they are probably temporary situations. People grow and their interests change. A bicyclist today is going to drive a car next week. A basketball player has to give up the game to devote more time to homework. Don't put off until tomorrow what you can photograph today.

What's the best way to take sports pictures? There is no simple answer because of the variety of sports situations. But at least let's look at a few typical sports pictures and see how they were taken. Armed with the basic information, you'll be able to cope with many sports activities.

Subject Control

A casual, lucky snapshot? Not at all. First came the selection of the location. Next the clothing. Bright solid colors are best. See how the white sweater helped to separate the subject from the background? (The poorest sweater color would have been dark green, like the trees.) Next came the route-planning for the ride. Note that this was selected so that the sunlight would backlight the subject's hair. Then rehearsals—that's right, rehearsals. The cyclist was asked to take a couple of practice rides past the photographer's position. Several impor-

tant things were learned from this: (1) what pose the girl should take (standing up on the pedals seemed the most dramatic), (2) how fast she should go, (3) where she should be looking as she rode by, and (4) what was the best camera angle.

A small stick was placed in the path at the exact position where the subject would be the right image size and the camera was focused for that distance. When the oncoming rider's front wheel touched the stick, that was the precise moment to squeeze the shutter release. Fill-in flash was used to

lighten shadow areas. An exposure of 1/125 sec. was used to "stop" the moderate speed of the subject toward the camera. In addition, a faster shutter speed would not have allowed the electronic flash to synchronize with the focal-plane shutter of the camera.

Let's give it a try now—do it again— make it three. This is actually the best shot out of several attempts.

You can use this same technique for a child on a scooter, a jogger, someone practicing a track or field event, a soapbox-derby racer, or any similar solo sport.

Motor Drive

Contrived? Set up? Arranged? Yes, all these descriptions apply, but the father of the ball carrier got this terrific picture he wouldn't have caught otherwise. The fact is that you just can't take a picture like this during the game. Good pictures of a game are the combination of a long-focal-length lens, a high shutter speed, a good vantage point, some luck, and perhaps even a motor-drive camera. The fantastic sports pictures you see in magazines are almost invariably the best shots selected from a motor-driven burst of pictures taken of some promising action.

Motor drives or rapid winders aren't necessarily the sole domain of professionals. Here one was used for a high-school practice session. The photography was done, of course, with the coach's permission and the players' cooperation. The camera operator was on the ground, shooting upward to utilize the blue sky as a background. He used a wide-angle lens and, to make it look more real, was careful not to include any part of the empty stands. The play nearly came over on top of him as he shot at 1/250 sec. at a three-picture-per-second rate. This was the luckiest shot of the series, when framing and player positions were just right.

Consider using a motor-drive camera for any fast sports activity in which you can't control the action—track events, swimming meets, basketball, football, hockey, skiing, and similar fast-action events that may go right down to the finish line before the winner is established.

Panning with Moving Subjects

This was not taken with a high shutter speed and could have been taken with the simplest of cameras. The actual shutter speed was only 1/60 sec., but the secret was to follow, or pan the camera, synchronously with the motion of the car. This provided an interesting effect of a sharp car and horizontally blurred surroundings that tend to intensify the impression of very high speed.

Try this with motor boats, bicyclists, motorcyclists, runners, even a child on a swing. For the best compositional effect, leave a little more space in front of the moving object than behind it. Also, the subject should be fairly close to you and moving *across* the field of view, not toward or away from you.

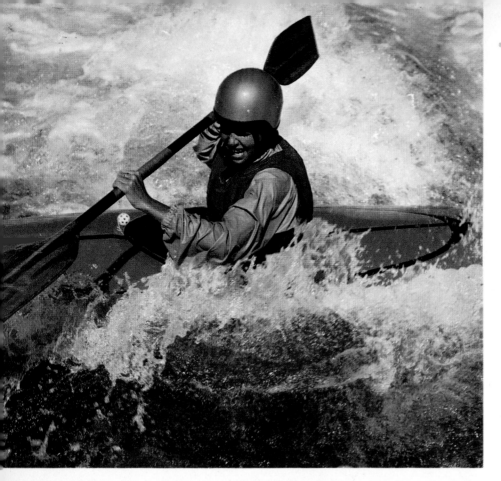

Telephoto Action

For a picture like this, use a telephoto lens, the highest possible shutter speed, and alert reflexes to take the shot at the best possible instant of action. Be sure to prefocus your camera on the exact spot, since with a high shutter speed and a long lens your depth of field will be quite shallow. You can't follow-focus for a rapidly moving subject like this. You just have to be sure you're ready for your one chance.

Try this for high jumpers, running horses, steeplechasers, finish-line situations, or any fast-moving subjects where you are close to the action.

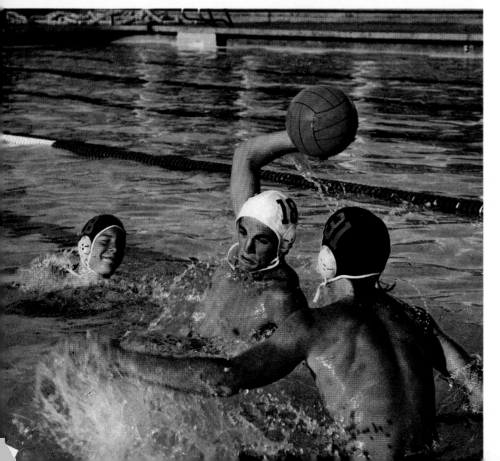

Available-Light Pictures

Modern high-speed color negative films provide an entirely new series of indoor stop-action possibilities, such as for this daylight shot of a water polo game. Don't worry about what color balance will be provided with the illumination available. Use every bit of film speed for the highest possible shutter speed consistent with proper exposure. It's possible to improve any color imbalance when the prints are made.

With high-speed transparency films, it's even possible to get action pictures of nighttime indoor sports. This is because of the availability of push-processing. Specify the degree of pushing when submitting the films to

Electronic Flash

the photofinisher. Just keep in mind that this processing technique increases graininess and contrast. It should be used only when there is no other choice.

Try high-speed available-light shooting for swimming meets, basketball games, hockey, indoor track, boxing, gymnastics, wrestling, and other indoor sports.

It's fun to be a picture detective! Try it.

- Is this picture posed, candid, or directed?
- What distance was the camera from the floor?
- What do you think were the photographer's directions to the subject?
- How did the photographer achieve such great depth of field?
- What types of light sources were used, how many, and where?

All the evidence is in the picture awaiting your deductive talents.

This picture just didn't happen. It was conceived, controlled, and directed. A camera with an extreme-wide-angle lens was used almost at floor level and the action was stopped by high-speed electronic flash. You can tell how many lights were used by looking again at the bowling ball. The reflective surface of the ball and the lighting on the people show that two lights were used: one to the left of the parents and the other to the left and somewhat in front of the boy. If you deduced that it would be most convenient to trigger the farther light as a slave unit, you were right.

And the probability that the photographer wasn't wearing shoes was elementary my dear Watson, wasn't it?

Available window light is doing more here than you might suspect. It provides not only general illumination but also reflected light from the white sheet of music to the girl's face.

The same girl and violin presented a different photographic approach to commemorate the recital. This time the illumination is supplied by two diffused floodlights. The main light is high on a stand to the right of the subject. Its reflector is aimed downward so that the top of the girl's head won't be overlighted, and the attention is directed toward her face.

RECITALS

You can't take pictures during a recital. Even if you could physically, you shouldn't. To the performer, it's a time of tension. Every moment calls for intense concentration. Any distractions, such as people in the audience taking pictures, would be most unwelcome—a breach of concert etiquette.

Opportunities for photographing actions approximating those of the recital are usually available at the dress rehearsal. Distractions caused by picture-taking will not detract from that performance as they would with an audience present.

Other good occasions for taking interesting pictures occur after the recital. Curtain calls, dressing room, post-recital well-wishing, receptions, and parties are worth considering.

There are two kinds of photo coverage of a recital, as shown on these two pages: formal, as taken with a portrait-type multiple lighting setup; and informal, as typified by the two available-light snapshots.

Don't forget that rehearsals may offer better picture-taking opportunities than the dance recital itself.

THE SOLO FLIGHT

Words and Visuals by Bob Bartels,
Paul's Father

"My son Paul has always been wild about airplanes. His interest extended from building models when he was a kid to working at the flying school on weekends since he has been in high school. So it didn't surprise me when he decided to trade his labor at the flying school for lessons. His lessons continued until several weeks later, when he announced that the next Saturday would probably be the day of his first solo flight. 'Let's not tell Mom until it's over,' he said, 'and then she won't worry until she sees me come home with my shirttail cut off.' This is one of the traditions of the local flying school. Three walls of the pilot's lounge are decorated with an assortment of shirttails, each giving the

name of the soloist and the date of the accomplishment.

"'No, Dad, I don't mind if you come to the airport with me; you might even want to bring your camera.' Paul winked as he said this because he knew how much I'd want to document the event.

"There are two ways I could have approached the project. The first was with sketches, because I'm a fair artist and adept at making quick field sketches that I intend to translate into paintings at my leisure. Somehow this latter step never seems to get done. In view of this, I often resort to my camera for note-taking as well as for recording the final pictures.

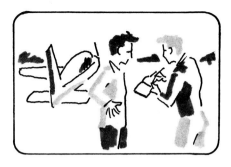

"The first picture in my storyboard sequence of the solo flight was a long shot of the instructor signing Paul's solo permit."

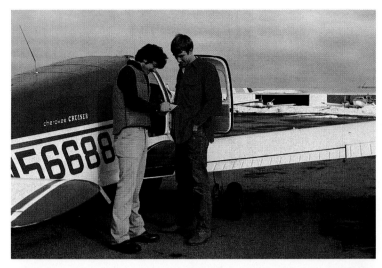

"It's easy to move in for a closeup to provide a better look at the action shown in the establishing long shot."

"The best way to record this scene was to use fill-in flash to brighten the cockpit area. I admit I made a series of bracket exposures to be sure of getting a good picture."

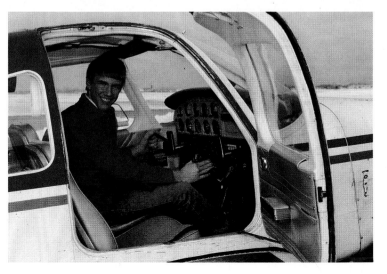

"But for a time-of-your-life moment like that, when it seemed that realism was the essence and things might happen too fast for sketching, I wanted to do it right. Surely it required a sequence, one without gaps, that could be planned beforehand. So I decided to storyboard the fairly predictable events.

"For those of you who haven't used them, storyboards are boards holding small rectangular file cards with a space on each reserved for a sketch or a picture description and an area for brief captions, directives, or explanations. In other words, storyboarding is a system of organizing a series of illustrative ideas. You can be sure you

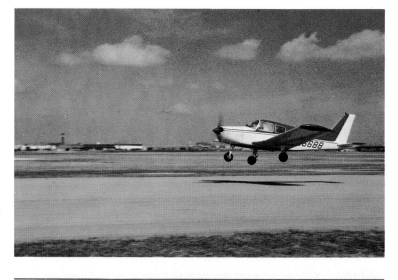

"Takeoff was the *big moment*. The control tower had given me permission to take pictures near the runway. The plane directions in the sketch and in the picture don't match because when I prepared the storyboard I didn't know which way the wind would be blowing."

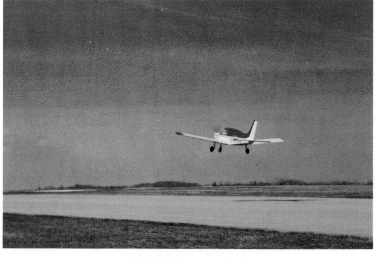

"And there he goes! I tried to take several shots here, but the plane took off so fast that it was quickly only a small speck in the sky. It was almost like trying to photograph a flying bird from a distance."

haven't left anything out, that you're not trying to present more than one idea at a time, and that the picture sequence is arranged in a logical order.

"Storyboard cards should be taken along in your gadget bag on a shooting project or assignment. They can be consulted in establishing shooting angles and deciding how much to include in the scenes, and also as compositional guides, for example: 'Keep the horizon extra low in the frame because the sky story is the important thing.' They can be used to keep track of the progress of the project and checked off when each shot is

"Touchdown! I asked Paul to try to land opposite me, but I'm sure he had other things on his mind at the moment. I suddenly saw the practicality of owning a long-range zoom lens."

"I know the shot doesn't match the storyboard at all, but that's the way it is sometimes. You have to adapt to the situation. I ran back to the hangar, put a wide-angle lens on the camera, and used another airplane as a frame as Paul taxied to the parking strip."

"I like the storyboard action better than the real shot. But this was the real thing."

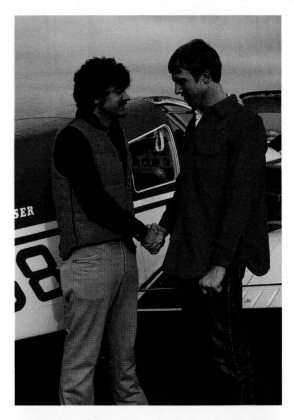

"Cutting off of the shirttail took place in the lounge instead of outdoors, as I had imagined. However, that didn't matter since I had brought flash along. I asked Paul to stand on the brick wall for a more interesting pose."

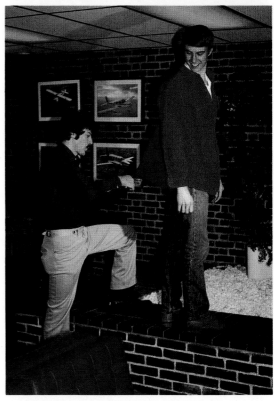

completed. If for some reason I hadn't been able to go to the airport with Paul on that important Saturday, I could have given the storyboard cards to my photography-oriented neighbor and he would have known exactly what pictures I wanted him to take.

"Of course I realize that storyboarding isn't a realistic approach for many people who might regard it as a time-wasting nuisance. (I don't accept 'can't draw' as an excuse—even a crude stick-figure sketch will suffice.) But at least they should consider making a list of 'must' shots for similar predictable situations. Well, anyway, that's the way I planned the pictures. The storyboard cards actually proved helpful in making me remember to take along flash for the inside shots, a long telephoto lens for the takeoffs and landings (where I couldn't get too close), plus other accessories. You know, too, the sketches helped me enjoy the event. It really became fun!

"P.S. The shot that I missed and wished I had taken was the one I forgot to storyboard. It was the look on my wife's face when Paul walked into the house with his shirttail cut off."

"Don't you think it was lucky all this happened with a *red* shirt? 'Paul,' I had told him, 'wear any color shirt you want, as long as it's red.'"

"So that's how Paul became a member of The Shirttail Squadron. Like so many of life's memorable moments, it happened only once, and I'm glad I was there to record it."

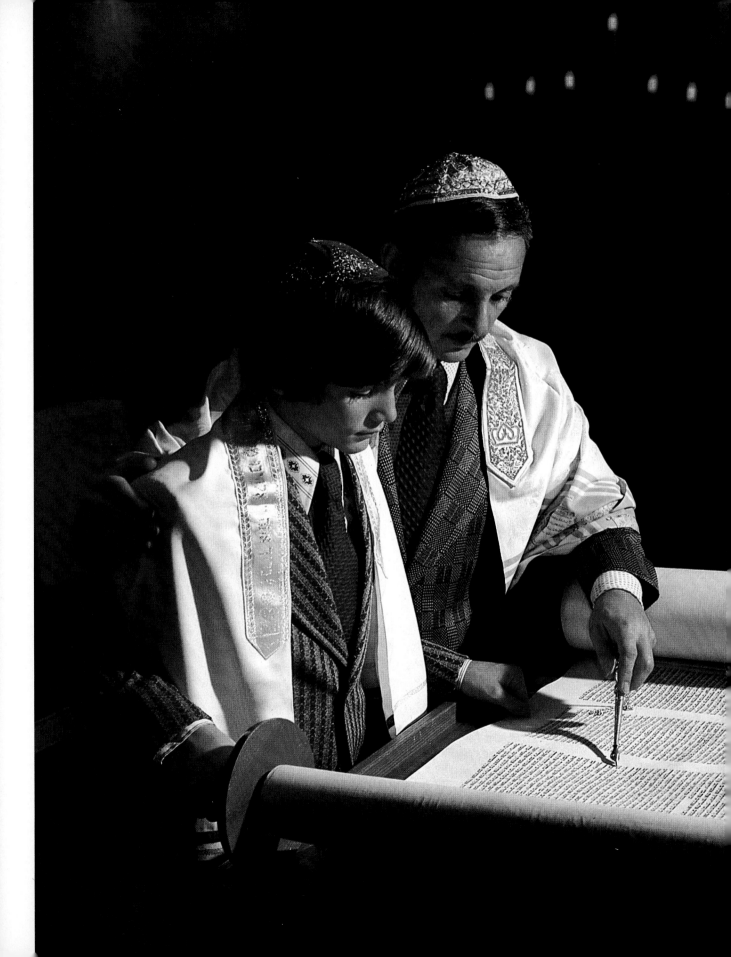

RELIGIOUS MILESTONES

Days that will never come again surely include occasions of great religious significance, such as baptism, first communion, confirmation, bar mitzvah, ordination to the clergy, and others. These once-in-a-lifetime holy days are such important personal milestones that perhaps you might wish to consider restaging the highlights after the guests have departed, during rehearsal, or on the day after the Sabbath, if local custom decrees.

Which is not to say you should neglect the before-and-after sequential coverage for your album. The preparations, the arrival of guests, the buffet, the celebration festivities, and the informal portraiture of the initiate or principals, all are good picture possibilities.

In addition to the personal coverage you give these *times of your life,* you may want to consider a professional portrait to commemorate the occasion.

181

This picture was taken with a single automatic-exposure-controlled flash on the camera.

THE VISITOR

Here's a situation: You're going to have a rare but welcome houseguest, perhaps a relative who lives 2,000 miles away, or an old school chum you haven't seen for years. In this case it was a lifelong friend from overseas —surely an extra-special occasion for everyone concerned. Definitely a time to be commemorated with pictures. There can be a double reward to the pictures: They can be printed twice and the duplicate set mailed to your guest to enable his or her family and friends to see you and your life-style.

The basic guidelines call for you to document the arrival, the visit activities, and the departure as completely as possible. Pretend it's a royal visitor and you are a newspaper photographer, and that this is your chance to impress your editor with a really outstanding sequential coverage. This

Three identical electronic flash units provided the answer to illuminating this huge living room. Units equipped with photocell auxiliary remote-control units were placed on stands at left and right of the picture area and fired by the on-camera flash. By using the side units, the photographer didn't overlight the foreground.

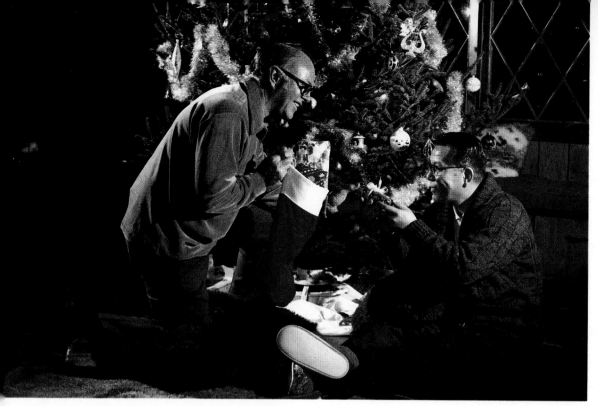

Notice that zippy lighting. It's from the same three flash units, one from each side triggered by the camera light, as in the previous picture. However, the camera flash was adjusted manually to be the weakest of the three and to provide only frontal fill-in light.

way you'll know what kind of pictures to take, and how many.

The airport shots were simple flash on the camera and the outdoor pictures were snapshots that included the locale, but the interiors were photographed with three electronic flash units. Why go to the trouble of *multiple* flash? Well, we like pictures with pep—pictures that have a three-dimensional snap and natural-appearing shadows. Really, for the ultimate in flash-picture quality you can't beat multiple flash.

Multiple Flash

It takes three identical flash units: one on the camera and the other two outfitted with a photocell so they can be triggered without wires by the camera

Take a careful look at the lighting—dramatic, wouldn't you say? The figure is well separated from the background and objects appear three-dimensional and natural. The effect was achieved with backlighting from two slave-actuated flash units plus a weak fill-in flash on the camera. A single flash on the camera would have overexposed the nearby tree ornaments and flattened out the entire scene.

light. Synchronization is no problem: All three lights will fire simultaneously. The simplest arrangement is to place each light at the tip of an equilateral triangle (all sides equal) with the subject in the center. Use the two lights that will be behind the subject two or three feet above the subject's head, where they'll be out of your background area and won't flare into the camera lens. These lights will serve as skid, or kicker sidelights, and help to separate the subject from the background, delineate subject textures, and in general provide a three-

How many flash units were used here? Two: one from the right, the other on the camera. When you employ this versatile and dramatic lighting technique, be sure to use the off-camera unit as the main light. Use it closer to the subjects, place it high, and aim it down toward the faces.

Two flash units again. But let's honestly point out a lighting mistake, so that this won't happen to you: The person holding the auxiliary flash unit at the left should have held it considerably higher. It should have been kept away from the closest person and aimed at the farthest person so as to help equalize the illumination for all the faces.

Of course you'll show your visitors the local
scenic spots; but don't just photograph the
scenes—include the visitors. Everyone wants to
show friends a print and say, ". . . and here I am at
Niagara Falls . . ."

Good-bye, Kazuhiko. We sent him a set of prints and soon
received a letter that said, in part, "I showed many pictures to
my family and friends, and they are pleased to share with me
the remarkable remembrances of my visit which I shall always
keep."

dimensional lighting effect that one
flash on the camera never could give.

Exposure. If you use three of the
popular and modern automatic
thyristor-controlled electronic flash
units, you won't have to mess around
with calculations. Thyristors are
miniaturized computer circuits that
automatically shut off the flash when
the proper exposure level has been
reached. Just set all three units on
"automatic" and place them at equal
distances from the subject. You can't
miss a dramatic lighting effect with
such a setup.

Vacations

It's difficult to imagine a vacation without a camera, isn't it? Regardless of the kind of vacation—fishing, camping, traveling, skiing, or whatever turns you on—those precious days of freedom to do as you please are worth remembering. And a picture can remember better than you.

We selected three idyllic vacation examples to illustrate the role that pictures can play in a vacation: fun with a recreational vehicle (RV), Walt Disney World, and a once-in-a-lifetime overseas trip.

FUN WITH A RECREATIONAL VEHICLE (RV)

Did you know that in the United States there are 29 national parks, 33 national nature monuments, and 18 archaeological monuments you can visit? In addition, there are more than 20,000 campgrounds in the United States, Canada, and Mexico being used by hundreds of thousands of people who own tents, trailers, campers, and other recreational vehicles with which they are discovering an entirely new leisure life-style. If you own a recreational vehicle, such as a motor home, no matter how you decide to use it—as a penthouse under the stars or as a bring-your-own guest room when visiting friends—it would be a big mistake if you didn't include a camera with the rest of your gear for fun and fellowship.

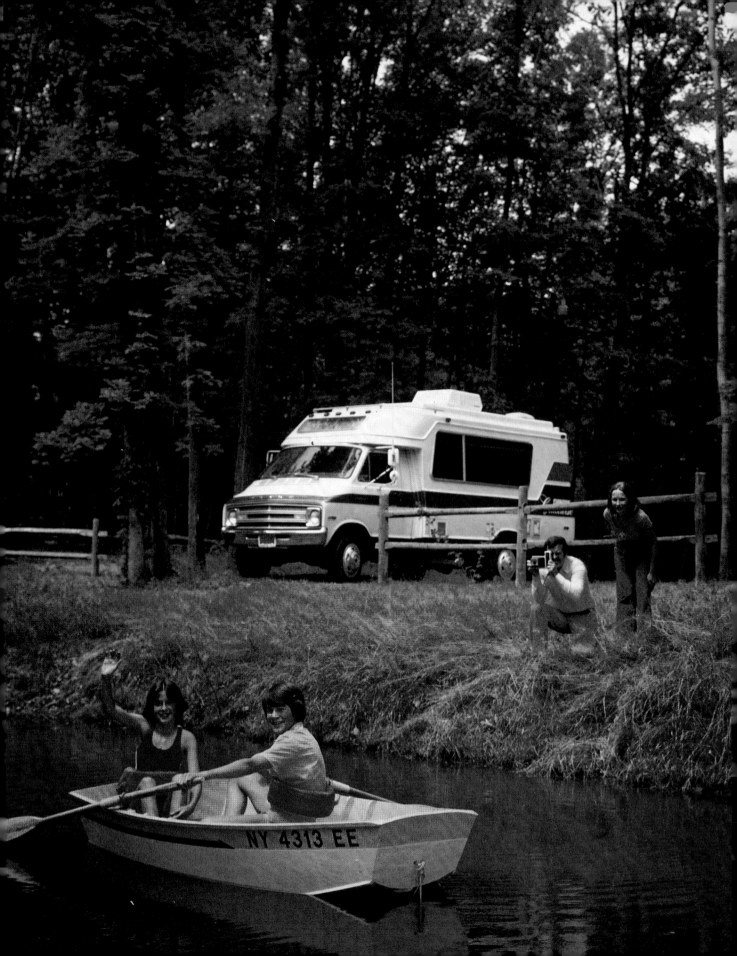

An RV can be a handy camera platform for shooting over foreground obstructions. Here we are at the Kennedy Missile Center.

It's those magic moments at dusk when the best evening pictures can be taken. This time we turned on the RV's lights and used a wide-angle lens. A tree was used to brace the camera for this 1/5 sec. exposure.

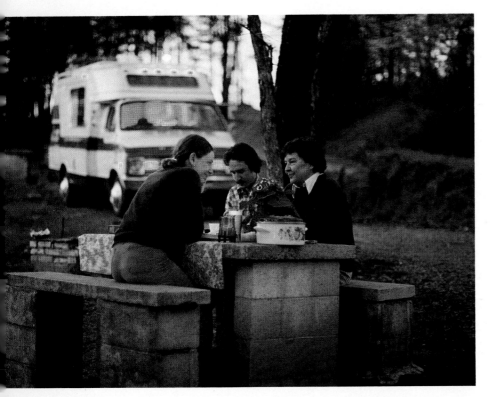

It's obvious that you should document a vacation camping trip, but have you ever thought of using your RV as a high-vantage-point camera platform? Or of inviting your campground neighbors to an evening slide show to share your Yellowstone Park adventures? Or that your RV is like a member of the family and should be photographed next to a national park entrance sign or with a scene such as the majestic Grand Teton mountains in the background?

If you've just acquired your first RV, try especially to take pictures of your get-acquainted attempts with the

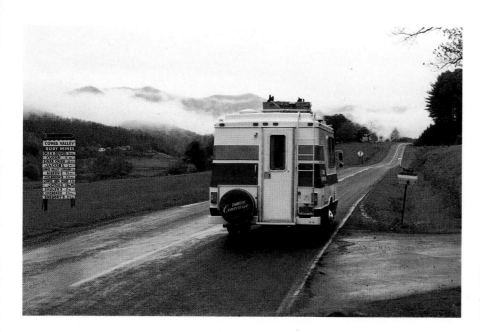

Early one morning we arrived at Cowee Valley in our RV with our daughter and son-in-law to hunt for hidden treasure.

Did you know you can find genuine rubies at Cowee Valley near Franklin, North Carolina?

equipment. There will be the first time you sleep in it (probably parked bravely in your driveway) followed shortly by your first weekend sortie, the first time you back it into a campsite and make the hookups, cooking your first meal, meeting your RV neighbors, and so on. Rain or shine, first occurrences are prime camera subjects. In deciding whether or not to photograph a particular subject, just put the question to this test: Ask yourself if someday you'll want to look back fondly on these moments. If the answer is yes, you'll need the pictures to help you remember the good times.

Here's all there is to it: Pay a modest entrance fee, buy some buckets of gravel, and make like a Forty-niner sitting on a hard sluiceway board.

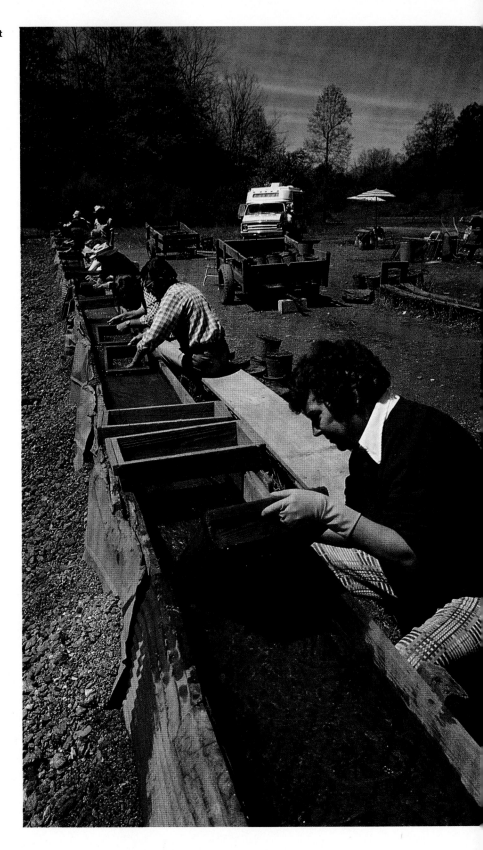

Let's watch (and photograph to re-
member these moments for years to
come) our daughter and son-in-law.
Will they find any rubies?

"No, no," said Claudio to Jean, "you'll never find a ruby
as big as a golf ball—but keep looking!"

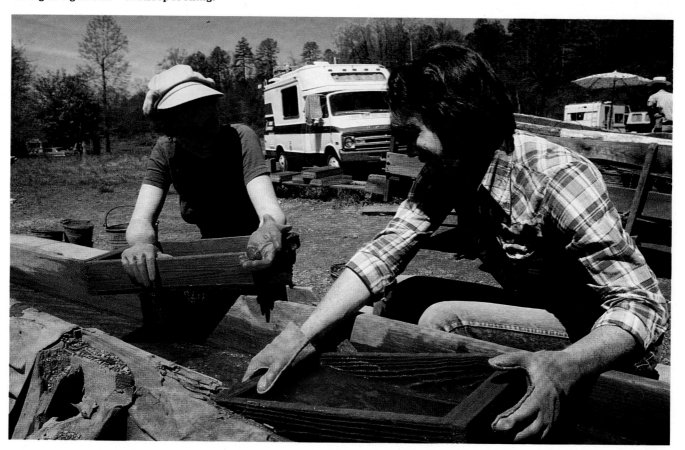

But it *is* possible to find a valuable stone. This ruby weighed 37 carats! (Unfortunately, someone else found it.)

However, they did find these genuine rubies. They were small, but they were all theirs! The pencil was included in the picture for a size comparison.

Perhaps not fitting for a Sultan, but to Jean and Claudio it's a treasure. On their RV vacation trip they actually found the rubies for this ring. They have the pictures to prove it.

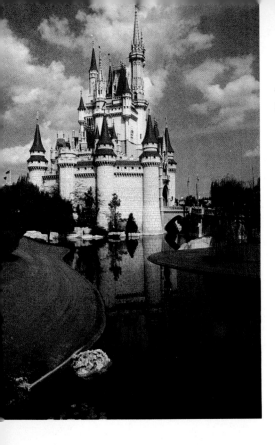

This is the place! The Magic Kingdom!

WALT DISNEY WORLD

All scenes are reproduced by courtesy of Walt Disney Productions © Walt Disney Productions, 1980

Don't make the mistake of thinking this fantastic wonderland is for children only. It's also for the young at heart, maybe more so. Children have so many brand-new experiences crowding into their minds every day that the recollections of even once-in-a-lifetime events are quickly dimmed by newer experiences. The older a person becomes, the fewer really new experiences there are, and the "Disney experience" is one you shouldn't miss. Just think of the unmatched picture-taking opportunities.

We can do no better than suggest that you follow your kids with a camera through the fascinating world of yesterday, today, and tomorrow, of adventure and fantasy, of thrills and excitement. Magic Kingdom, here we come!

Equipment

What equipment is needed to photograph a day's worth of fun at Walt Disney World? We've photographed this popular tourist attraction three times (plus numerous other amusement parks). Here are our recommendations:

Don't take

- A tripod
- A flash
- Filters
- Close-up attachments
- Telephoto lenses

Do take

- A small over-the-shoulder gadget bag—ideally, one with separate compartments for unexposed and exposed film.
- A versatile 35 mm camera with normal and wide-angle (20-24 mm) lenses.
- Fast film (to accommodate dim-light situations) such as KODAK EKTACHROME 400 Film (Daylight) for color slides and KODACOLOR 400 Film for color prints.

Amusement-park photography is essentially extreme-wide-angle photography. The rides and other attractions are large, the area usually crowded, and space limited. Under such circumstances, a normal lens would be limited in its effectiveness. This is where the wide-angle lens and its versatility will be invaluable.

As indicated, a wide-angle lens allows you to photograph a wider field of view than a normal lens at a given camera-to-subject distance. This means that you can photograph an extremely large subject, such as the Magic Kingdom castle, from a close (and probably less obstructed) distance. It also means that you can readily include your family and foreground objects in pictures of the many

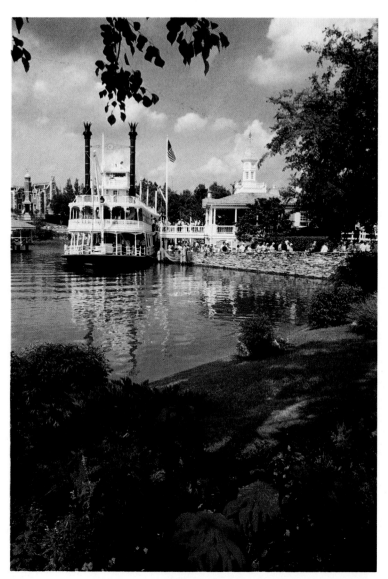

It has paddle boats, rides, excitement,
fantastic friendly characters, like tigers,
parading bears, banners, colors . . .

and strange carvings to look at or to photograph.

There are beautiful restaurants,

or sidewalk cafés.

Meet the Thurmonds—John, Carol, and Christy.

attractions for pictures with better subject interest, composition, and perspective.

In addition to its ability to encompass a larger area than a normal lens, an important characteristic of a wide-angle lens is that it provides greater depth of field. This is the characteristic that makes it possible for you to have sharply focused foreground *and* background subjects for better composition, interest, and perspective.

Another advantage of this increased depth of field is that focusing errors are virtually eliminated. With lenses in

All aboard! They found a front-row seat on the monorail.

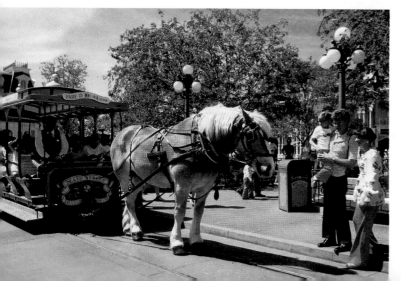

Main Street transportation is slower than the monorail!

Who could refrain from taking a picture with such colorful surroundings?

And here's John's spectacular result; he couldn't miss!

What's an occasion like this without a balloon? It can't escape—it's tied on.

There are wonderful picture opportunities on the Jungle Cruise ride,

such as a hippopotamus that really moves.

Hey, what a fun ride! Can we do it again?

John used a high shutter speed and panned his camera to freeze the movement of his family.

the range of focal lengths mentioned, set for an aperture of *f*/8 and a distance of ten feet, everything from three feet to infinity will be in focus.

Many of your picture opportunities will probably be grab shots because of the crowded conditions. If you back too far away from your children posing with Mickey Mouse there will be a continuous stream of people walking in front of you before you can get set for the picture. This is a typical situation in which your wide-angle lens can be utilized effectively by presetting the focus to save time and by not having to back up so far.

This is almost a mob scene; but shooting quickly and using a wide-angle lens solves the problem.

Time for the tired trio to head home,

but it was a wonderful day to be remembered in pictures.

You won't want to miss the expressions of delight and amazement on the faces of family members as they view the unusual events and situations that abound at Walt Disney World. In such instances your normal lens is a better choice, because an extreme-wide-angle lens used too close to a subject can distort the image.

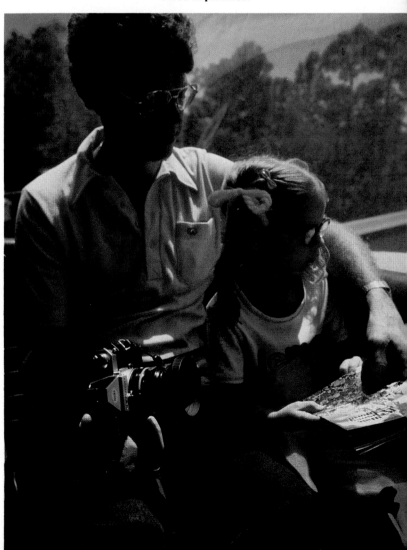

I shot about a half hour too soon. The sky hadn't taken on its full evening color and all the electric lights hadn't been turned on yet.

This was taken during that brief period called dusk, when everything was just right for night photography. Sky and foreground brightness were in perfect balance.

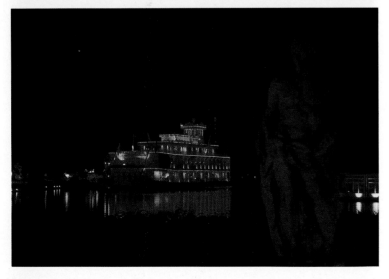

It was too late, here: The sky was inky black, and the lighting was too contrasty. The tungsten lights registered on the daylight-balanced slide film as an objectionable orange color.

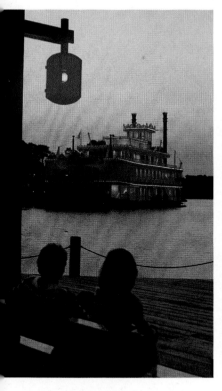

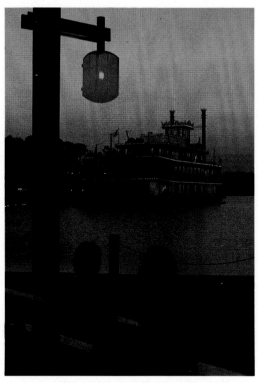

Even if you take the picture at the ideal moment at dusk, it's important to use the right exposure, especially with slide film. This is a one-stop overexposure for the optimum pictorial effect.

The exposure here is right on the nose. The only way you can be absolutely sure of achieving a perfect exposure of a tricky subject like this is to bracket.

Where did the couple go? They're still there, obscured in the foreground darkness caused by a one-stop underexposure. A slide like this would actually project fairly well, but the extreme density range can't be retained in a print.

Night Photographs

Night pictures, which are not difficult to take, can add beautiful variety to your picture collection. So let's have a brief lesson in outdoor night photography. (This information applies not only to amusement parks and tourist attractions but also to illuminated streets, signs, storefronts, and even downtown buildings.)

Actually the best night pictures are not taken at night but at dusk, when for a brief magic time there is enough light still in the sky to provide sufficient separation between the buildings and their background, and between the sky area and the land. If all night pictures were taken when it was truly

dark, primarily the lights—the illuminated signs, windows, streetlights, and automobile lights—would be recorded. The outlines of the buildings could be lost and the resulting photograph might be excessively contrasty and unpleasing.

Remember, the film—any film—will record the scene with more contrast than your eye sees it, and it is therefore best to take these night scenes a little *before* you think the time is just right.

This best time is a relatively brief period lasting not more than 20 minutes. It is a function of the season and varies from week to week.

There is another reason for not waiting too late in the evening to take this kind of picture. If you're shooting slides you're probably using daylight-type color film and are a little fussy about the color balance of your shots being just right. Tungsten lights will record with a yellowish cast. They are pleasingly warm if there is still enough bluish daylight left in the sky to counter this effect, but they become objectionably orange if they are the sole source of illumination. Negative color film pictures can be corrected somewhat for this during the print-making process.

Photo by Ira Current.

Night Exposure Suggestions

Because the light is dim, night pictures, even with a high-speed film, require a short time exposure with the camera either hand-held *as motionless as possible* or braced *firmly* against a pillar or other firm support. Any camera movement can mean blurred, ruined pictures.

Adjustable cameras. Because of the variety of lighting conditions, no exact exposure can be recommended. However, as a starting point, for an ASA 400 film, try 1/60 sec. at *f*/5.6 Even expert photographers utilize a bracketing technique to be sure of obtaining a good exposure. They make a series of exposures, varying the shutter speed by one increment each way. For example, at *f*/5.6 exposure would be at 1/30 sec., at 1/60 sec., and at 1/125 sec. Only one of these will be truly best. (Throw the others away, never to be seen by your friends.)

Automatic exposure-control cameras. Many of the newer cameras are equipped with an automatic exposure-control system. The user simply pushes the shutter-release button and, usually by means of an electronic shutter mechanism, the camera shuts itself off when it senses the exposure is adequate. However, such devices are calibrated for normal daylight scenes, and night scenes might deceive the system somewhat. If bright light sources are included in a nearby scene, the tendency is for the exposure-determining system to conclude that the scene is too bright and it may underexpose the area you consider to be most important. For optimum pictorial results, you might wish that more or less exposure had been given. In some cameras it is

204

◀ **For best results for slides at night, switch to high-speed tungsten-balanced slide film to keep the artificial light from being too orange. Exposure here was 1/60 sec. at *f*/2.8 with KODAK EKTACHROME 160 Film.**

Yes, you can make excellent pictures at night, provided the subject illumination delineates itself as delightfully as does this night-parade dragon.

Photo by Ira Current.

possible to bracket the automatically determined exposure, but the technique of doing this will vary according to the make of camera and the design of its exposure-control system. For example, you can bracket exposures with some cameras by changing the ASA setting. If you are using ASA 200 film, you can double the exposure by setting the speed at 100, or halve it by setting the speed at 400. *Don't forget to reset* to the correct setting for subsequent picture-taking.

Night pictures can be made successfully with pocket cameras, such as KODAK Pocket INSTAMATIC Cameras equipped with an electronic shutter. Place the camera on a railing or against a post and depress the shutter-release button for about ten seconds. Try another exposure by releasing the shutter button after only two seconds. Try a third exposure by allowing the camera to shut itself off. One of these should be just right.

P.S. Because of the brief shooting period when the lighting is at its best, you'll really have to hustle from one subject to the next if you're going to try for more than a couple of nearby locations. (A little preplanning can be helpful in a situation such as this.) But the pictures will be worth it. Just don't forget to bracket your exposures.

THAT ONCE-IN-A-LIFETIME OVERSEAS TRIP

No one will deny that a trip to a foreign country is an outstanding event in one's lifetime and surely should be well documented with a camera. Imagine the pleasure of being able to recreate this vacation trip for yourself and your friends whenever you desire in the comfort of your own home. So what we're interested in here is how to take good travel pictures.

To us this means slides, not prints; it means films such as KODAK EKTACHROME or KODACHROME, not KODACOLOR. The object is to come as close as possible to the trip's experiences, and you can do this much better in a darkened room with big, brilliant, projected images with a density range close to the original scene than with small-sized prints seen in room surroundings with distracting shapes and colors all around.

A projected slide of a castle is more "castle size" than a print you can hold in your hand.

Yes, slides can give you much more of the feeling that *you are there.* Slides and vacation trips; vacation trips and slides!

Before You Go

Research is the answer to what's next. Where to look? Every country has a tourist commission, board, or department loaded with illustrated literature they'd be pleased to send to you on request. Transportation companies will be glad to help, as will travel agencies. You must read about the place you're going to visit and look at the illustrations, because this alone will have a profound influence on *exactly where you'll go, what you'll see, and the pictures you'll take.* Think of your research notes as a shooting script—paragraphs to be illustrated.

Now we can't go everywhere in one short chapter, so we'll just have to single out a place and see what we can do with it. The one we've chosen is the central part of Spain, known as Castile.

But even with a single location, we can only hit the high spots and give you our best general suggestions—good basic travel-picture ideas that can apply to a trip to anywhere.

Okay. First the research. Here's a typical, but only partial, portion of our research notes. *And see how it controlled our picture-taking activities.*

The topic we selected had its beginning in 1492 with the fall of the Moorish empire at Granada. Following one of the world's most dramatic religious wars, the Catholic kings reigned over Spain. Under their patronage the arts were developed to new heights.

The sixteenth century, known as "the golden century" because of its cultural flowering, brought fourth great universities, such as the one at Salamanca;

huge Gothic cathedrals;

decorated flat edifices and
fantastic polychrome wood
sculptures;

famous mystics, like Teresa of
Avila; and great painters.

About these captionlike words you
have just read, we'd like to erase any
doubt in your mind that the words
were conveniently written around the
existing pictures. No, the research and
the picture ideas came first, *before* the
trip to Spain.

We hope you can feel the structural
flow of a basic trip sequence. Of
course these are only the highlights to
give you the idea; the research notes
were much more extensive. And ob-
viously you saw only typical pictures
from a large collection available on
each subject. For example, you saw 2
pictures of polychrome statues out of
53 in that particular subject category.
Are the other 51 extras? Not at all!
They're all different and together
make absolutely fantastic segments of
a two-projector, single-screen slide
show.

The geographic center of
Spain, the Castilian plateau,
was also the political and cul-
tural heart of the Spanish
kingdom. Its name comes from
the Latin *castellum* and was
given to it because of the
numerous strong castles built
to withstand the Arab invasion.

The castles recall the times of
battle and stand witness to the
tragic hours of history in the
conquest of the Moors. It was
on this violent land that Spain
blossomed out.

Castile is diversified, with dry
plateaus and abundant green-
ery. The heart of Castile throbs
among the deserts of sand and
stone that surround Madrid. It
is the domain of sun and wind,
of dusty roads, low houses of
the same ochre yellow—a land
without relief and without
shadow but striking in its very
roughness. Severity and de-
spoiling on one hand, gaiety
and freshness on the other.

Brown and dry country alternates with fertile valleys that are covered with a tawny carpeting of wheat . . .

. . . sprinkled among the sparse villages.

A large portion of the province of Segovia extends over the slopes north of the Sierra de Guadarrama, which hide picturesque mountain villages.

◄ Then there are the soaring Sierra mountains, stripped of earth and covered with rocks. All is rugged, clean, serene.

Around the capital of Madrid rise the guardian cities of history. The road to one of these cities, Avila, rises to 1100 metres. The scenery provides harsh vistas. The mountains are like gray and black chains across the horizon, and the chaotic masses of enormous stones add to the impression. Avila is one of the highest and most ancient cities in Spain. Dominated on the west by the powerful black Sierra de Gredos, the city is built on a dry plateau.

Its surrounding ramparts are battered by winds. These ramparts are among the most extensive military works of the Middle Ages.

The Convent of St. Teresa, a famous mystic, built upon her birthplace. Also there is the Church of St. Vincent, built outside the walls, with its beautiful Roman door.

Made in the same image as the Spanish soul—grandeur, violence, and purity—are 2500 granite bastions and 88 towers.

The St. Thomas Monastery. Its beautiful cloister has a rare elegance.

Segovia, a very lively city with smiling inhabitants, has streets teeming with life. Its houses rise upon the steeply sloping hills.

The Roman aqueduct, with its two levels of arches, has the appearance of fragility in spite of its strength. Built in the second half of the first century, it still carries water as it did when it was completed.

The cathedral is a majestic structure built in sixteenth-century gothic style, a true forest of stone.

You'd really think you were in Castile!

Then think how you wouldn't have had this experience if I hadn't first read about the National Museum of Sculpture in Valladolid, and been triggered to go there and take these pictures.

That's how important trip research can be.

Should you take along flash? A decade or two ago the answer would have been yes, otherwise you'd have missed some people pictures, such as at a party or a nightclub, and some low-light close-up to medium shots. But today the availability of extremely fast color films has reduced the need for flash. Also, the naturalness of available-light shooting is "in"—especially for travel pictures.

Imagine seeing these marvelous works of art projected *almost life-size* in my living room. One gilded or polychrome masterpiece fades into the next as I listen to the mighty Baroque organ music I use as a sound effect for this segment.

Segovia reminds us of a ship riding at anchor, its prow formed by the graceful towering silhouette of the alcazar, castle among castles.

Should you take along a tripod? We like a tripod on a trip better than we like flash. And it almost goes without saying that a cable release will be used with the tripod-mounted camera to make steady time exposures.

What will the tripod do for you?

1. You'll definitely want it for almost all building interiors. Isn't fast film the answer here? No, because it usually isn't only a question of getting enough light into the camera to make an adequate exposure—it's usually very desirable to do this at a small lens aperture and to get *ev*erything sharp, and this means a long, tripod-steady exposure. Interiors of churches, cathedrals, castles, palaces, museums, craft shops, restaurants, auditoriums, stores, and public buildings can best be photographed using a tripod. Don't try using flash on the camera in

cavernous interiors. With its limited range, flash just isn't up to the job.

2. Cities at dusk and lighted streets at night—take them with a tripod if possible.

3. Does your camera have a self-timer? Put the camera onto a tripod and take your own picture as part of a group. Or get in front of the camera and act as a compositional bit of interest in the foreground.

Are you SURE your camera is working properly? A once-in-a-lifetime trip is not the place to *practice* picture-taking nor the place to find out your camera shutter was stuck all the time you were there.

This will probably be your only opportunity to take these pictures, so don't take chances on the results.

It's a good idea to expose and have a roll of film processed *before* you leave home. This is especially good advice if you have a new camera and you're not completely familiar with it. On this roll, include a distant view, a picture taken in the shade, and a close-up portrait taken from about three feet away. Also try some *backlighted* shots to be sure you won't be underexposing with the same subject conditions on your trip.

Are you going to want pictures of castle interiors or cathedral stained-glass windows? It makes good sense to take your camera, tripod, and cable release to a local church and make a few practice exposures. The photographic situations, the determination of exposure, and the light are the same at home as abroad. If you can do it here, you can do it there. Why not be sure?

After You're in the Target Area
Getting good pictures is a question of attitude, determination, and persistence. Merely wanting them is not enough, is it? So you may have to run, stoop, squat, sit, climb, even waylay people in order to get the best pictures. You may even have to appear undignified on some occasions.

Is all this effort really necessary to take good pictures? Well, it all depends on how important the pictures are to you.

Yet there should be a wide middle ground where most of us fit. Most of us really want good pictures to remember the trip by, but to implement this desire does require some effort. The thing to avoid is being offensive to those around you. There *is* a happy medium.

Think of it this way: There is probably no such thing as a good *dignified* photographer.

Pictures of the family. Remember that in this chapter we are emphasiz-

ing *travel* pictures and not family portraiture. Travelogue audiences do *not* want to be subjected to pictures of the family standing stiffly in front of a scenic attraction.

But family members can be used to add color and human interest, act as space-fillers and centers of interest, and give added depth to scenes *if you do it right.* Perhaps you will find it helpful to be guided by the basic principle that family members in the scene should be *doing,* not *being.* By doing, we mean doing something that will help add interest to the picture or acting as though they were unaware that a picture was being taken. No full-length police lineup pictures here, please.

There are plenty of natural situations to be found while traveling that will make family pictures easy to take and fun to look at later. They can be the main compositional center of interest some distance from the camera. For example, suppose you wanted to take a picture of the corner turret of a castle. This means you'll have to back away some distance to include the entire object in the viewfinder. Here's where the rest of the family can be a big help. Group them casually about the base of the tower, where their sweaters and jackets of various colors can add a desirable spot of warm color to the dull browns of the castle rock. Subsequent viewers of this slide will subconsciously use the figures as a

measuring stick and the huge castle will seem even bigger. Should the family be looking at the camera? NO! They can't have good portraits taken at that distance. Better to have them looking at each other or upward at the battlements, or checking a travel brochure.

You have to control this sort of action. Just don't make it look too posed. Shots of the family climbing cliffs, riding horses, taking pictures, walking down paths, exploring ruins, watching boats, leaning against a boat rail watching the scenery go by, and bargaining with vendors are all examples of how to fit people naturally and interestingly into travel pictures.

◄Where's the driver? He's taking the picture!

When the Sun Isn't Shining

There is no bad picture-taking weather—just different kinds. It used to be that sunshine was the ideal picture-taking weather. (And for aerials, distant scenes, and building exteriors, it's still our preferred lighting.) But in general this is no longer true, for two reasons. The less important reason is that faster films aren't hindered by shaded or overcast-day illumination. The big thing is the trend toward soft, natural photography. There are even some instances when you want shallow depth of field; for example, where bright illumination would actually be a hindrance.

So if the sun doesn't shine, don't despair. Don't put away your camera. *Look for other subjects.* Nearly all close-up subjects are best if taken in the shade, on overcast days, or when the sun has gone under a cloud. (Which it does about 200 times a day in the sunny tropics!)

A hazy sun means a soft, highly desirable type of lighting for faces. People don't squint under this illumination. Forests and long avenuelike roads through the woods no longer have unbearably high brightness ranges.

Fog, rain, or snow can implement your camera artistry—if you find the right subjects for these conditions. Imagine a mountaintop wrapped in clouds, a fishing fleet being devoured by the mist, tall buildings disappearing into the fog, closeups of flowers sparkling with raindrops, and city lights mirrored on wet pavement.

Anyway, it's dry and warm inside, so go shoot there.

One word of advice on shady versus sunny scenes: *Don't combine these lighting extremes in the same scene,* so that half is sunny and the rest in shade. No film can record both extremes in the same exposure.

Sequences and Picture Collections

We don't know where you're going on your trip, so we can't tell you specifically where to aim your camera. But we can re-emphasize the basic building-block principle of good slide shows, and that is to make sequences and picture collections. These pictures can be planned ahead of time, or you can stumble onto them as targets of opportunity. The key to success here is to select subjects that are intriguingly different from what you see at home. Everyone is interested in seeing how other people live, especially if they live differently. Incidentally, go easy on statues and monuments; audiences generally find these dull. The same is true for excessive numbers of waterfalls, flowers, sunsets, and similar subjects. These are not people-oriented subjects and could be taken anywhere—not necessarily in the unusual country you're visiting.

On a trip to anywhere, consider the items on this checklist:

- Antiques (paintings, furniture, tools)
- Animals (oxen, herds, unusual species)
- People* (children, pretty girls, faces with character)
- Crafts (production and products)
- Picturesque vocations (shepherd, woodcarver, etc.)
- Scenery (landscapes, seascapes, aerials)
- Interesting buildings (exteriors and interiors)
- Signs (identification and humor)
- Trees (unusual patterns and lightings)
- Flowers (extreme closeups)
- City views (main thoroughfares, shoppers, city lights at dusk)
- Villages (local architectural styles, typical pedestrians)
- Markets (general long shots, vendors, produce)
- Festivals (parades and pageants, costumes)

*If you're especially interested in how to take good pictures of people on your travels, consult *Picturing People,* Kodak Publication No. E-99, available from your photographic dealer and bookstores.

You should regard the foregoing illus-
trations as typical ones from a particu-
lar subject collection.

And finally, to inspire you to "sally forth and do likewise," we give you an available-light example in "shining armor" taken in the Castilian fortress of Alcázar de San Juan. Naturally the camera was placed on a tripod and a cable release utilized for the time exposure.

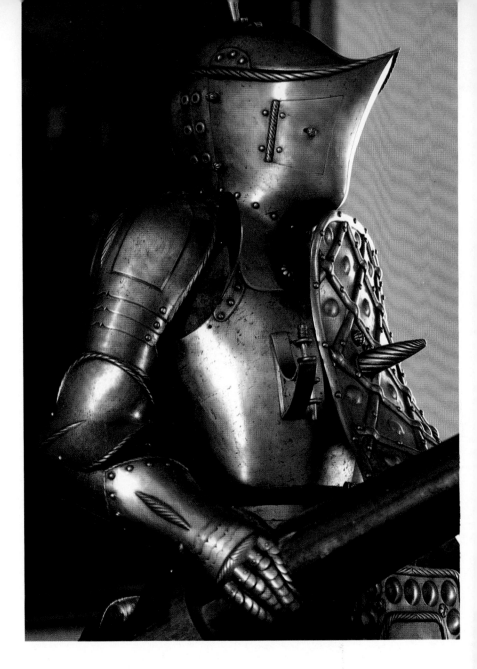

Imagine these pictures as the finale of a fade-and-dissolve slide show, with a sound track of ghostly footsteps echoing down the empty stone corridors of history . . .

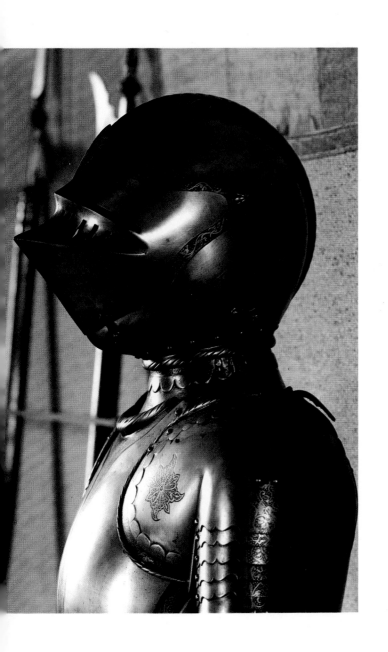

After the Pictures Have Been Taken

You're especially fortunate if you've been taking pictures throughout the years. Think of the wonderful memories your collection of snapshots, slides, and movies holds for you. For instance, there was that vacation last summer—you can really remember what it was like to be a kid—and there are Grandma and Grandpa who have been gone for decades . . .

You just can't get that kind of feeling any other way. Even going back and discovering old letters or other memorabilia up in the attic doesn't have the impact of being able to see some of your old pictures.

But you wouldn't just cram your valuable pictures into a drawer, now would you? Of course not. But it's a rare home that doesn't contain envelopes or boxes of photos languishing in a dark closet or desk drawer, unidentified, unused, *but usually not really unwanted.* In all likelihood when the pictures were taken the intent was to create albums to preserve and display them for easy reference. But somehow this project fell to the bottom of the priority list and no one ever thinks any more of the treasure lying in the dark place. Think forward to 40, 50, or 60 years from now when your grandchildren or other family members come across this "family history" trove. Much as they may want to, *they probably will never be able to reconstruct the story the pictures are telling.* "Who is that small girl with the big hat? Where do you suppose they were when these pictures showing the tent were taken? Do you think those two people are friends of Uncle Harvey's or are they family?" It's too bad if this happens. However, it doesn't have to be that way.

Even if you have 5, 10, or 15 years' worth of pictures in your closet, it can be a fun family project to sort, organize, identify (you might even have trouble identifying every person in various situations) and arrange into albums, *along with captions,* this treasure of memories. In order to ensure completion of the project it would be a good idea to set up a worktable at a place where it can be left undisturbed, so that any family member can put in time whenever convenient. Don't, for heaven's sake, start working at the kitchen table where you'll have to pick up and put everything away to prepare the next meal. The project could die an untimely death right there.

With the fruits of many years to work with, arrangement will probably be one of the most difficult decisions. However, the options are endless. Chronological order would probably be the simplest, but don't rule out subject categories, such as *Family Pets, Vacations, The Boys at Camp, Birthdays, The St. Louis Contingent*, and winding up with *Miscellaneous* for those shots that don't fit anywhere else. Even these decisions can be fun when working with hundreds of photographs.

The answer to completing a prodigious project like this? Begin it now. You'll enjoy looking at your older pictures so much that it will be far more fun than work.

But don't let the drawer-file system begin again!

One thing you can do is patronize a photofinisher who will return your prints already inserted in album pages. You buy the album covers and add the new pages; and at least this way you'll have a chronological record of your camera-worthy events.

But albums should be better than that.

Better than a yearly chronology is an album bookshelf with individual volumes devoted to recurring events—a remarkably rewarding organizational system. A stamp collector doesn't indiscriminately put each new acquisition onto the next empty page of a stamp album. Instead there is a purposeful organization according to country or subject specialty. So, in addition to the event-chronology volumes, why not start special volumes with titles such as *Ann's Birthdays, Holiday Seasons, Vacations,* and so on. Imagine turning the pages of one such treasure and watching your children grow bigger and older continuously. Don't forget the grandparents! We know one young family who gave each pair of grandparents a large looseleaf scrapbook minus the pages. Then twice a year (one of these times being Christmas) they would give them the next installment of the captioned photo pages. And you can believe that this was the most welcome and the first-opened present under the Christmas tree.

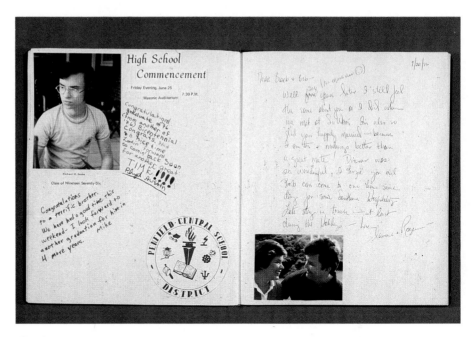

Our friends Bob and Barbara Beeler have the most delightful photo album we have ever seen. It's perhaps more aptly described as a photo scrapbook. They take pictures of their dinner guests, for example, and leave space on which the guests can write their comments or impressions of the evening. Barbara, in charge of the design, adds appropriate bits of memorabilia, such as corsage ribbons, invitations, newspaper clippings, sketches, and even photographic greeting and business cards. What a great place for instant prints!

YOU ARE THE ALBUM LAYOUT ARTIST

It's a mistake to cram all the prints that you possibly can on one page or spread. If you do, you'll limit your layout possibilities. You're likely to find yourself crowded for caption space—but worst of all, you'll be in the "diluted picture trap." Let's explain:

The more prints on a spread, the less individual viewing attention any particular one receives. A lot of prints jammed together invites the viewer (and this includes you) to skim the group hastily and be impatient to turn the page.

No! The idea is to savor them.

So let's start over and do it right. First consider the layouts not as individual pages but as facing double spreads because this is what the *eye* will perceive—*both* of the facing pages as you turn to the next section. In a well-laid-out picture book, the layout artist strives for variety—something that will continually intrigue the *eye* from a design standpoint as the pages are turned. Try to arrange your layouts so that no two spreads are the same, *so that you cannot anticipate the picture arrangement in the following spread.*

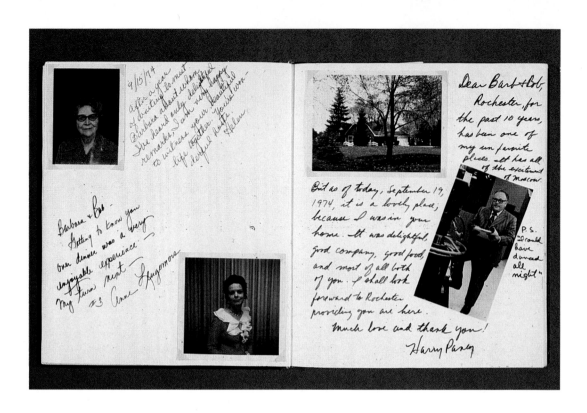

9/15/74
after a year
of waiting to meet
Barbara about whom
I've heard only delightful
remarks, I am very happy
to witness your beautiful
life together. Yours was
derful both
Helen

Barbara + Bob,
Getting to know you
over dinner was a very
enjoyable experience -
My turn next
x3 Anne Sugimoto

Dear Barb + Bob,
Rochester, for
the past 10 years,
has been one of
my un favorite
places. It has all
of the excitement
of Macon.

But as of today, September 19,
1974, it is a lovely place,
because I was in your
home. It was delightful,
good company, good food,
and most of all both
of you. I shall look
forward to Rochester
providing you are here.
Much love and thank you!
Harry Paxny

P.S.
"I could
have
danced
all
night"

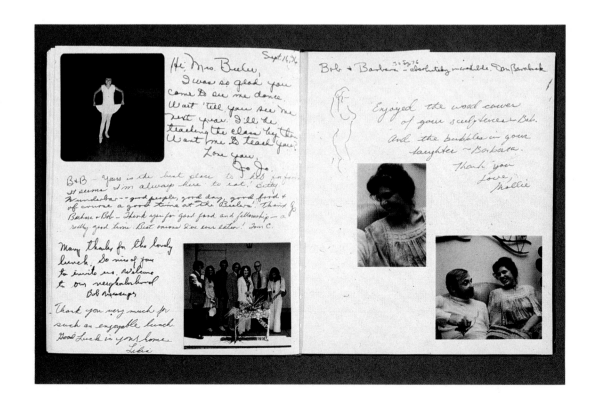

Sept 16,76
Hi, Mrs. Beeler,
I was so glad you
come to see me dance
Wait 'till you see me
next year. I'll be
teaching the class by then
Want me to teach you?
Love you,
Jo Jo

B+B - Yours is the best place to B&B for food
It seems I'm always here to eat. Betty
Wunderbar -- good people, good day, good food +
of course a good time at the Beeler's! Thanks Jo

Barbara + Bob - Thank you for good food and fellowship - a
really good time. Best meal I've ever eaten! Tom C.

Many thanks for the lovely
lunch. So nice of you
to invite us. Welcome
to our neighborhood
Bob Messinger

Thank you very much for
such an enjoyable lunch.
Good Luck in your home.
Libro

Bob + Barbara - absolutely incredible. Don Bavahak

Enjoyed the wood carves
of your sculptures + Bob.
And the bubbles in your
laughter - Barbara.
Thank you
Love;
Mollie

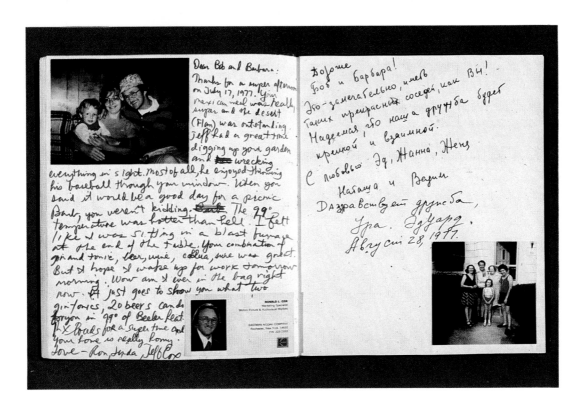

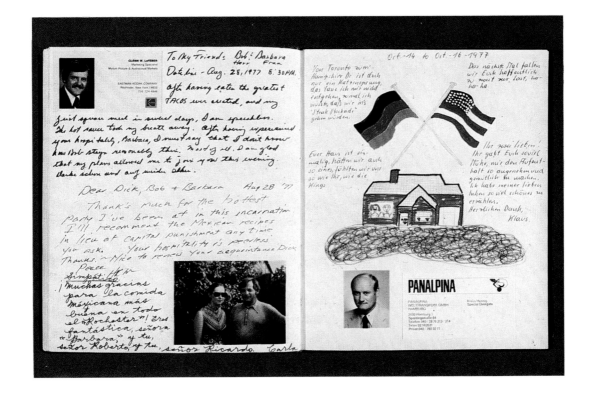

Sort and Arrange the Prints

How do you proceed? Easy. Let's say that a couple of rolls' worth of prints you have taken of a particular event—a party, prom, or graduation—have just been returned from the photofinisher. Of course you'll zip through them hurriedly for those first impressions. Then, too, there are those jubilant moments of sharing the best ones with family or friends and (who hasn't done this?) showing them to any stranger you can corral at the club, the lunch counter, on the bus, or wherever you may be.

But now it's time for organizing these memories (that's what they actually are) into a convenient and permanent form.

Clear a desk top or a kitchen table and arrange *all* the prints in left-to-right and top-to-bottom rows in a chronological sequence; that is, in the order in which the events occurred or the action took place.

Now, should you keep them all, or are there some throwaways? To help you decide, just remember that each picture you retain should add some new or different information. If there are, for example, two nearly identical versions of the same person, from nearly the same viewpoint and with nearly the same expression, the two prints together don't tell you any more than one of them does. One is an extra. It would be redundant to include it. It's

better to send it to the subject as a keepsake than to put it into *your* album.

What about pictures that are a technical failure—those that are too dark, too light, blurred, or otherwise inferior? Well, look at it this way. *It doesn't matter!* You aren't trying to produce pictures for publication, for salon use, or even to impress somebody with your photographic expertise. The purpose of these prints is to serve as memory-retrieval devices, and even a somewhat blurred picture can do this job better than no picture at all.

Here's another way to consider it. Marketing people are fond of making statements such as, "People don't want drills; they want holes." The photographic equivalent is that people don't want cameras; they want pictures. But let's keep the real objective even more clearly in mind: It's not pictures per se that we want; it's memories.

Don't put any prints in yet. There are a few more interesting considerations.

Alternate Print Sizes

First, one of the layout faults of most albums is that all the prints are the same size, usually 3″ × 5″. Although you may find the idea initially appalling, you can cut these prints into different sizes and shapes to add variety and perhaps even improve them by cutting out an undesirable

section.* Use a trimmer or a razor-sharp craft knife and a steel-edged ruler. Actually you'll be doing a creative thing that's fun and that will help develop your artistic abilities.

Where to cut? Use a pair of L-shaped croppers to help you decide. Lightly mark the area to be retained with a very soft pencil (4B) as a trimming guide.

Can you make two pictures out of one? It may be that you didn't get close enough to the person you were photographing and the resulting image is small in the midst of meaningless surroundings. If so, trim it! If extra, meaningless area adds nothing to the picture, cut it off!

A small lesson in people cropping: If you are dealing with a picture of one person, it may be artistically advisable not to leave an equal amount of space on both sides of the figure. In other words, consider placing it off center. Would that be better? Usually there should be a little extra space in the direction the person is facing or looking. It avoids the impression that the subject is about to leave the scene. Also be wary of cutting off the print too close to the top of the head. A close cropping here makes it look as if

the person is going to bump their head.

Enlargements. Next consider enlargements*, which can add great variety to your layout.

There are two reasons why you may want to consider having a few special shots enlarged. Remember, again, that pictures are memory-retrieval devices. The more realistic they are in color and size, the more efficient retrieval agents they become. It may seem obvious, but big prints are simply a step nearer to the actual subject size than are small prints. *Close your album and you'll more easily remember the enlarged pictures than the small ones.* The second aspect peculiar to enlargements is that they are more realistic than small prints because they cause the viewer to position his or her eyes closer to the center of perspective. (For the technically minded, this is the distance from the center of the print equal to the focal length of the camera lens times the degree of enlargement magnification.) Let's give a practical album-type example: Suppose you had an 8″ × 10″ print made from a 35 mm negative that was taken with a 50 mm normal lens. The degree of enlarge-

ment of about 8 times multiplied by 2 would give you an optimum viewing distance of 16 inches.

Try this: Take such a print as described above, cover one eye, and now view it from 16 inches away. You'll be amazed at the three-dimensional quality of the print—the added realism, the almost stereo effect. You cannot achieve the same viewing realism with small prints. For a 3″ × 5″ print made with the same camera, the center of perspective distance would be only 6 inches. You just couldn't get your eye to focus effectively that close. You would normally hold the print farther off for comfortable viewing, in this way you would lose the special effect.

Enhance the Layout

There are unlimited ways you can make your layouts attractive. For example, use a colored paper background. Can you draw? Can you decorate the pages artistically? Little kids plus crayons make a terrific illustrative combination! (Of course you must look at this last idea from a future or a grandparent's point of view.)

Add newspaper clippings, dance programs, Christmas stickers, wedding invitations, award certificates, a corsage ribbon . . .

And most important of all, add captions.

*Do not cut *instant* prints. There may be small amounts of residual processing chemicals between the layers that could ooze out when the print is cut, causing stains or other problems.

*For a comprehensive treatment of this subject, see *Bigger and Better Enlarging in Color and Black-and-White,* Kodak Publication No. AG-19, available from your photographic dealer and bookstores.

CAPTIONS

As fantastic as they are as memory aids, photographs do an even better job if they are titled and/or captioned. With appropriate words, the recall of a situation or event can improve dramatically. Even brief titles are good (you'll probably remember the picture longer than you'll remember the title), but captions of a sentence or two are better.

Putting a caption with a picture in your album makes it easier for you to remember the circumstances surrounding the picture than if you saw the picture alone. In other words, the caption enhances your memories of a scene. It jogs your memory with details long forgotten that are not evident from the picture alone.

So obviously you should write captions for your album pictures.

Adding Interesting Words

How do you write the best, the most meaningful, words? Well, let's first tell you *how not to.* Don't ever say, for example, "Grandma at the family reunion." Such words are unnecessary, as you can probably see just by looking at the print. You need to add other *related information that isn't apparent, to supplement the picture:* place, date, names you might otherwise forget. But try to keep this information short and simple. Use simple words, phrases, and quotes; captions need not be grammatically correct sentences. Use colorful words, action-filled words, humorous words. Use descriptive adjectives to help create word pictures. On-the-spot impressions are especially good.

Humorous anecdotes, as captions, can help make the pictures especially memorable. They make the album much more enjoyable for other people to see. For example:

"It took Uncle Joe two days to recover from Aunt Margaret's 40th birthday celebration."

Or how are you at corny couplets? Remember how much a rhyme aids memory recall, and it may seem worth the slight extra mental gymnastics to compose something as follows:

Storks who bring babies
And docs who sell pills,
Have one thing in common—
They both have big bills!

(This might accompany an album picture of the obstetrician posing with your new baby at the hospital.)

Or for a picture of your kids hoeing the corn in the garden:

We kids can hardly wait
To count the cobs from which
 we ate!

DECORATING WITH PICTURES

Although albums are perhaps the most widely accepted way of saving and displaying photographs, by no means should you limit yourself to this one medium.

Surely you've seen homes where there are only a very limited number of photographs on display: a picture of Grandmother and Grandfather, maybe a few wedding or graduation portraits of the family children, and usually a picture of the family taken five, ten, or even fifteen years ago. These are usually mounted in stand-up frames marching across the top of the upright piano, a desk in the living room, or a bedroom bureau top.

The pictures were probably put there when conventionality reigned in the decorating world for a majority of homes. And it was fine for its day.

But in today's world of the "do your own thing," "mix and match," and "whatever turns you on" philosophies there is no longer a need to be bound by passé conventions. The possibilities for decorating your home with photographs are as wide open as your mind is. The mood you wish to create is only for you to decide. From conventional frames to exciting mobiles, there are no limits to the ways in which you can decorate your home with pictures. You can add color and interest to every room and even liven up hallways, dead corners, and other areas that often receive little attention. Many of these possibilities can be relatively inexpensive, or you can go to the other extreme and spend a considerable amount of money to achieve the effect you want. So why not customize your home with pictures unique to you, and at the same time personalize it by displaying an attractive arrangement of pictures that say something about yourself, your interests, and your life?

That's the way to do it.

Some Possibilities for Small Pictures

The bulletin board, a time-tested medium, is found in schools, offices, factories, homes, and many other locations. It doesn't have to be the familiar framed cork rectangle, although in the right place that could be quite appropriate. But try covering it with felt, burlap, velvet, wallpaper, or whatever imaginative alternative you can come up with. Whoever said cork couldn't be pink, green, or red? The advantage of this cork base is that the pictures can be changed at will—once a day, five times a day, twice a year, or every five years—whenever your needs dictate. Decorate the board for its locale and you will have a versatile picture

Decorating with photographs can be especially rewarding if you yourself have taken them. The display possibilities are practically unlimited. We suggest you send for a complimentary copy of the idea brochure titled *How to Decorate With Photographs*, Kodak publication No. AM-14. Single, free copies are available from Eastman Kodak Company, Photo Information, Department 841, Rochester, N.Y. 14650. Ask for the publication by name and number and enclose a self-addressed business-size envelope. *No return postage is required.*

frame that will accept whatever you want to show or see. Any time you feel like making a change, pull out the tacks, arrange the new show, and fasten it on. This is an unbeatable medium for your kitchen or den. A hallway might benefit from this versatility. And just think how much this could pep up a utility room—it might even make you whistle while you work.

As always in a display of pictures as a grouping, a variety of print sizes and shapes will add visual interest.

Casual Framing

A formal print display need not cost very much if you apply a little imagination and time to the problem. Here are a few low-cost mounting and framing ideas.

Pictures on placemats. Placemats come in a variety of shapes, colors, and textures, and some of them make an excellent background for pictures. For example, you can attach an enlargement to a plastic placemat in a matter of seconds with double-faced tape. To finish the mount, cover the edges of the print with thin rickrack or ribbon edging. You may want to make several of these for the kitchen or dining room and change them to suit the season.

Mounting prints onto wood. Mounting prints onto wood is an unusual way to display them, and the wood provides a sturdy, rich-looking mount. There's a variety of wood finishes and shapes that are suitable for mounting pictures. For example, a picture mounted on distressed wood fits well with an Early American décor. If you have a chance to hunt for driftwood

along a beach, you might find weather-beaten boards that can make good mounts.

If you prefer finished wood but don't want to do the finishing job yourself, look for an inexpensive cutting board in the housewares section of a department store. Cutting boards come in many shapes, from round to rectangular, and often have an attractive wood grain.

If the wood you have selected has a smooth mounting surface, you can mount the print directly to it with a white glue, such as Elmer's Glue-All, Tite-Bond, or Kodak Rapid Mounting Cement. If the wood has indentations, as in distressed wood, you can use a wet-mounting process and press the wet print into the indentations to make it look similar to découpage.

To wet-mount prints, use a white glue, such as Elmer's Glue-All. Use the following procedure: (1) Soak the print in clear water until it is limp. (2) Sponge excess water from the print and use a paint roller or sponge to apply an even coating of adhesive to the back of the print. (3) Use a damp sponge to press the print to the mount. Work from the center of the print toward the edges to remove air bubbles. (4) Rinse the sponge and wipe off any traces of adhesive. If you're mounting a color print, swab the entire surface of the print with a sponge that has been soaked in stabilizer, such as Kodak Ektaprint R-500 Stabilizer, available in a one-gallon size from photo dealers. The print will take about three hours to dry.

You can achieve a three-dimensional effect by mounting your print onto a one-inch-thick board cut to the same size as the print. If you wish, apply strips of one-inch-wide wood veneer

to the edges of the board with a white glue. Veneers come in an eight-foot roll, are very thin, and can be cut easily with scissors. They are available in a variety of wood finishes and are sold at such places as lumber dealers and hardware stores.

Flush-mounting onto thick mounting board. For a simple, modern look, flush-mount your print onto a ¼-inch mounting board (¼-inch Masonite board can also be used). Cut the print a little larger than the mount and then use a sharp knife, razor blade, or paper cutter to trim the excess after mounting. Finish the edges of the mount with a felt marking pen.

Découpage. Découpage is the old craft of gluing cut-out images onto wooden surfaces and subsequently covering them with as many as ten layers of varnish. The assemblage can be antiqued and given a semimatte finish, making it a very attractive treatment for boxes, wall plaques, and other wooden-surfaced objects. There is no reason why color prints can't be used as an excellent image source. The thinner the image, the more artistic the effect. Color prints are especially suited for découpage if the entire resin-coated backing is peeled off the print. This is easy. Lay the wet print face down on a flat surface, use a knife at one corner to start separating the backing from the image, then grasp the backing and pull. This can be done with any size print. Pressure applied with a neoprene pad will help in gluing the flimsy print image to an uneven wood surface.

Invest in one of several inexpensive books on découpage for how-to-do-it information and ideas for its use.

Some Hows for Big Pictures

Of course we're talking about enlargements, which raises the question of how large is large? Aside from filling a given wall space artistically, the only answer can be that the size of any print, such as a portrait, should be in direct proportion to the importance you place on that time of your life. The greater the occasion the picture represents, the larger the portrait should be. And now let's frame it.

Traditional frames. Frames, like mounts, help separate a picture from its surroundings. Select a frame that adds to the impact of the picture and avoid frames that draw so much attention that they detract from the beauty of the print. Frames come in many sizes, styles, materials, and prices. A frame can be as simple as four aluminum strips that finish off the edges of your mount, like the frames used in some modern-art museums, or they can be as ornate as Victorian furniture, with many carved designs. Large department stores, art-supply stores, and small specialty shops usually have a good selection of frames. Many of these offer framing service for a fee.

If you're a do-it-yourself person, you might prefer to buy an unfinished frame and do your own finishing. You can also buy a framing kit or choose from a variety of wood framing materials available in eight-foot lengths from hardware and lumber dealers. This will allow you to frame a print in any square or rectangular format. If you enjoy hunting for antiques, you may come across antique picture frames that you can refinish yourself. Then you can add your color enlargements and display the products of two hobbies at the same time.

Those who prefer the sleek lines of modern design may want to make some shadow-box frames from one-inch right-angle molding. Most lumber yards carry this molding, and it's relatively inexpensive. Miter the corners of the frame and use heavy-duty staples across the joints on the flat side to hold the pieces together. This will be the back of the frame. Finish the wood and then glue your mount into the frame from the front—it will rest against the right angle and not need any other backing. This type of frame is very light and quite easy to make.

If you want to use glass in a frame, be sure to provide a slight separation between the picture and the glass. You could insert a mat or shim between the borders of the print and the glass to protect the print emulsion from sticking to the glass under humid conditions.

Glass-sandwich frames. With two sheets of glass and four mirror-holders, you can create an almost invisible frame that will hold an unmounted or mounted print. The glass goes on each side of the picture (it is similar to mounting a slide in glass) and is held together and attached to the wall with mirror-holders. A glass-sandwich frame is simple and inexpensive to make and you can change the print as often as you like with very little effort. If you mount color prints in this manner, however, put several small pieces of felt between the glass and the borders of the print. (You can hide the felt behind the mirror-holders.) The felt will create a slight separation between the print and the glass and keep them from sticking together under humid conditions.

Free-standing frames and room dividers. Another effective way to display a number of large prints that you would like to change often is with a free-standing frame that can also be used as a room divider. The frame is suspended between the floor and the ceiling much like a pole lamp. A frame of this type can become the focal point of your living room, and your guests will always be anxious to see what new prints you have on display. The vertical supports and crosspieces of the frame are usually made of two-by-twos. The flat pieces that hold the picture are glued on the rear edge so that the pictures can be slid into position easily. Because the frame is held between the floor and the ceiling by pressure, you can easily convert it into a room divider by adding some additional strips of molding and displaying prints back to back.

Whether you've chosen mobiles or elegant salon-style displays, your friends will notice and admire the creative use of your photographs. And you, too, will have the daily pleasure of enjoying these personal treasures, whether they be of a moment in your life that you want to savor or of people or things you love.

The Legacy

*Pictures by Jennifer and
Bob Gibbons*

You remember Jennifer—of the
"Jennifer and How She Grew" chap-
ter earlier in this book? A very interest-
ing aspect of those pictures is that she
had a toy camera and took almost as
many pretend pictures of her mother,
father, and baby brother as were actu-
ally taken of her. The real pictures
were chronologically organized into
family albums that now occupy more
than a foot of shelf space.

These are frequently-looked-at vol-
umes. And who's the best customer?
We'd like to have Jennifer's father tell
you.

"You know, every child has dozens of
books scattered around the house.
Jennifer's range from fairy tales and
nursery rhymes to the story of an
elephant whose parents were very
proud of him because he was toilet
trained. But of all the books around,
her favorites by far are the photo al-
bums that we've been making ever
since her birth. Jennifer, who is now
three-and-a-half, often likes to sit
down and look at these pictures and
talk about when she was a *little* girl.

"It occurred to me that Jennifer al-
ready realizes that visual images
communicate far better than words
and that perhaps we ought to give her
a real camera. Why not my first cam-
era, which I bought a number of years
ago? It still worked, and I always got a
lot of nice pictures with it.

"So at Christmastime we tried an ex-
periment. We put some slide film into
the camera and provided flash. She
took the camera down town when she
went to visit Santa and took pictures
of Santa, his reindeer, and some of the
family after we came home.

"A few days later we had our first slide
show of everything that Jennifer had
taken. How did the pictures turn out?
Well, they were really nothing you
would ever show to company (if I can
put it that way). There were blurred
pictures, dark pictures, tilted pictures,
a closeup of her fingers in front of the
lens, and Santa with his head chop-
ped right off.

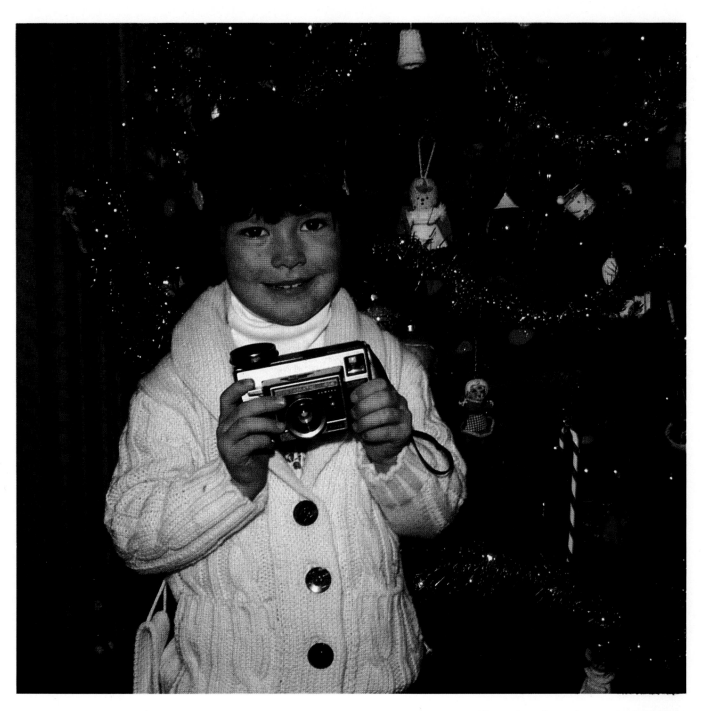

This is Jennifer at three-and-a-half, with her dad's old camera. The other pictures are the results of her first roll of film.

A headless Santa Claus was a tremendously successful picture!

Somehow, all reindeers become Rudolph for Jennifer.

"Her reaction? It was completely unpredictable. She was thrilled beyond belief! I tried to tell her that the next time she shouldn't cut off Santa Claus's head. But it didn't matter one bit if Santa had a head or not. 'That's Santa Claus! That's Santa Claus!' she kept shouting. 'I took him! There's Rudolph!' (Really, it was only Blitzen.) 'And there's Timmy!' (Her brother's picture was so dark we couldn't really tell who it was.)

"Even after looking at the pictures three or four times we couldn't put the tray of slides away. 'What if Grandma comes?' asked Jennifer. 'Then we'll have them ready to show her.'

"She thought the slides were absolutely wonderful. It was so important to her just to sit there and look at them. It was all so great that we're going to do it again.

"I really didn't give the camera to her as just another toy; she's got tons of toys of every description. I gave it to her as a kind of magical box that remembers—something she could use to record things she sees or likes. Of course she's still pretty young, and I am too for that matter, but I'd like to think that this magical box and the knowledge of what it can do are part of my legacy to her.

"It seems natural for us, as parents, to pass on a lot of things to our children—beliefs, convictions, and even our attitudes on life. Well, the whole idea of photography seems to me something that's very natural to pass on, because it's really a wondrous way to save smiles and memories and to pass them on realistically like a living legacy. It's great to pass on the family photo albums to our children as other albums were passed along to us.

She didn't have any trouble deciding what to photograph. The only guidance she received was the suggestion of how far away to stand from the subject.

"The important thing with Jennifer is that the experience helped to give her a sense of accomplishment and, I hope, a sense of self-confidence or self-worth. That's great for a child to have at any age. I want her to grow up not only with a love of looking at pictures but with an enthusiasm to go out and take them and to express herself. I think that's probably one of the greatest gifts I could ever give her."

Jennifer's lucky. She has a father who realizes that communication, especially with visuals, is not just a sending process—it's really a two-way street; that seeing is not just scientific perception—it's also understanding,

knowing, and caring. And that's what it's all about today—this language of visuals which we all understand so well. It follows that if we understand it, we also should be able to speak it. Unfortunately many of us speak it infrequently or poorly.

Surely it's the responsibility of today's adult to help impart to the next generation the desire and the know-how to communicate visually.

When do you think this process should start for *your* children?

252

Her brother, Timmy, was a favorite
target. We couldn't see his eyes, but
at least he didn't have his head cut off
like Santa Claus.

Index

Albums, 39, 236
 layout suggestions, 241
 captions, 243
 mounting, 246
All about me (teenagers), 82
Amusement parks, 186, 194
Angle, camera, 69, 156
Anniversaries, 136
Aperture, high speed, 49
Architectural interiors, 71, 152, 229
Audience considerations, 44, 206
Automatic shutters, 204
Available light considerations, 46, 65,
 70, 108, 116, 160
 exposures, 47, 67, 108, 204
 filters, 66

Backlighting, 55
Blue flood lamps, 155
Blurred results, 33, 117, 241
Bounce lighting, 95, 116, 138
Bracketing exposures, 161, 204
Brightness range, 153, 160

Cable release, 229
Camera care, 27
Candid approach, 35
Caption writing, 242
Christmas, 51, 56, 57, 112, 122
 Christmas cards, 122
 Christmas card ideas, 123
Circus World, 40
Closeups, 33, 93, 94, 118
Color-compensating filters, 66, 71,
 155
 blue, 66, 155
 magenta, 66, 68
 yellow, 72
Color imbalance, 66, 72, 203
Color negative (print) film, 66
Color temperature, 67

Communicating with pictures, 248, 252
Composition, 33, 158
 controlled approach, 32
 cropping pictures, 242, 246
 in the viewfinder, 33
Contrived pictures, 35
Converging lines, 156
Cropping, 242, 246

Decisive moments, 32
Decorating with pictures, 244
Depth of field, 158
Diffusion attachment, 48
Disney World,Walt, 194
Dramatic lighting effects, 183

Electronic flash, 171
 fill-in, 167
Engagements, 124
Enlargements, 242
Event photography, 28, 31, 32, 138
Existing light, 46, 65, 229
 color quality, 65, 71, 203
 direction, 73
 distribution, 73, 153
 level, 67, 108
 room lighting, 67, 70
Exposure meters, 47, 67, 161
Expression, 34
Eye-socket shadows, 69

Family and travel shots, 201
Fill-in flash, 167
Film, 46
 color negative film, 65
 high-speed film, 46
 slide film, 65, 206
Film storage, 37
Filters, color-correction, 71
First moments, 28
Flash photography, 138
 control, 138
 electronic, 167, 171
 fill-in, 167
 multiple, 182
 on-camera, 141
Flood lamps, 108, 155
Fluorescent lighting, 64, 66
Foreground objects, 33, 138
Formal portraits (professional), 81,
 181
Frames, picture, 247
Framing the subject, 33, 138
Fun with recreational vehicle, 186

Grab shots, 32
Graduations, 88
Greenhouse effect, 37
Greeting cards, 122
Group photographs, 138

Halloween, 100
Hand-held photography, 32, 47, 69
Heat damage to film, 37
High camera angle, 33, 69, 138, 141
Houses and homes, 146
 moving, 146
 renovating, 152

Instant photography, 37
 dark pictures, 37
 light pictures, 37
 temperature effects, 37
 trimming, 242
Insulated film container, 37
Interchangeable lenses, 60, 64
Irradiation, 153

Layout ideas, albums, 236
Lens aperture,
 small, 158, 162
 wide, 170
Lens hood, 48
Lenses, 64
 interchangeable, 64
 normal, 64
 telephoto, 64, 170
 wide-angle, 64, 158, 194
 zoom, 64
Level of illumination, 47, 67, 116, 170
Lighting, 47
 available lighting, 153, 170
 backlighting, 55
 bounce, 74, 95, 116, 138
 contrast, 66
 distribution, 153
 existing, 64, 73
 falloff, 138
 fill-in, 167, 171
 flash on camera, 138
 flood, 71, 116, 153
 fluorescent, 64, 66
 indoor, 67, 71, 108, 153, 170
 mixed, 160
 multiple flash, 182
 outdoor, 49, 55, 59
 placement, 72, 160
 skylight, 67, 153

supplementary, 94, 108
 window, 66, 160
Low camera angle, 69

Memory aids, 30
Memory machines, 31, 241
Memory power, 31, 39
Mental images, 31
Minisequences, 43, 70
Mixing light sources, 160
Motor-drive camera, 168
Mounting pictures, 242
 bulletin boards, 243
 découpage, 246
 framing, 247
 glass sandwich, 246
 on wood, 247
 placemats, 247
 room dividers, 247
Motivating audiences, 39
Moviemaker's technique, 32, 161, 165
 closeups, 33
 long shots, 32
 medium shots, 32
Movies, 32, 164
Multiple flash, 182

Natural-looking pictures, 35
Nighttime picture taking, 203, 205
 exposures, 203, 204
 time of evening, 203

On-camera flash, 138
Overseas trip, 206

Panning with subject movement, 169
Parties, 138
Perspective, 156
Photocell, 182
Photo essay, 39, 40
Photojournalism, 32
Picture collections, 44
Picture display ideas, 247
Picture series, 28, 34
Picture stories, 39, 40
Planning sequences, 43, 65, 68
Pocket cameras, 205
Posing, 33
Proms, 76

Recall devices, 30
Recall mechanism, 30
Recitals, 172
Recreational vehicle, 186

Reflection problems, 67, 152
Reflector, 94
Rehearsing subject action, 35, 117
Religious milestones, 180
Restaging scenes, 35, 117
Room lighting, 67, 70

School photography, 64
Self-timer, 81
Sequences, 43, 69, 70
Sharing pictures, 39
Shooting angle, 69, 156
Shutter speeds, 34, 49
Sidelighting, 59
Single flash, 138
Slave light, 171, 182
Slide shows, 65
Slide transparencies, 65
Slides versus prints, 65
Solo flight, 174
Sports photography, 166
Stopping action, 34
Storing memories, 28, 31, 43
Storyboards, 174
Storytelling pictures, 28, 40, 69, 174, 190
Subject control, 34, 167
Subject coverage, 35, 69
Subject distance extremes, 158
Suspense with movies, 165

Teenagers, 82
Telephoto lens, 170
Thanksgiving, 104
Travel photography, 206
Tripod, 110, 155, 215
Tungsten lighting, 203

Vacations, 186
 Circus World, 40
 fun with an RV, 186
 overseas trip, 206
 researching, 206
 using the family, 190
 Walt Disney World, 194
Variety in pictures, 33, 69
Vertical lines, 156
Visitors, 182

Walt Disney World, 194
Weddings, 128
Wide-angle lens, 90, 156, 194, 200
Window lighting, 66

Zone of sharpness, 170, 194